Yani
The Brush
of Innocence

Over the past decade, United Technologies has sponsored many exhibitions of unsurpassed artistic importance, including the huge Degas retrospective and a show of American paintings from the Manoogian Collection.

We chose to sponsor Yani: The Brush of Innocence because we find the work so appealing—and because we believe that American museum-goers will be as awestruck as we are by this Chinese child's amazing creativity.

We hope Yani's paintings bring you much pleasure.

ROBERT F. DANIELL
Chairman and Chief Executive Officer
United Technologies Corporation

ESSAYS BY

Wai-Ching Ho

Dawn Ho Delbanco

Julia F. Andrews

Lynn T. Goldsmith and
David Henry Feldman

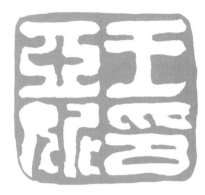

Yani
The Brush of Innocence

WAI-CHING HO
Editor and Project Director

Hudson Hills Press
New York

in association with the
Nelson-Atkins Museum of Art
Kansas City

This book was published on the occasion of the exhibition

Yani: The Brush of Innocence

organized by the Nelson-Atkins Museum of Art with the sponsorship of the Ministry of Culture, People's Republic of China.

The exhibition is made possible by United Technologies Corporation.

Arthur M. Sackler Gallery
Smithsonian Institution
Washington, D.C.
June 25–October 22, 1989

Nelson-Atkins Museum of Art
Kansas City, Missouri
December 16, 1989–January 28, 1990

Asian Art Museum of San Francisco
San Francisco, California
March 7–April 29, 1990

Published in the United States by Hudson Hills Press, Inc., Suite 1308, 230 Fifth Avenue, New York, NY 10001-7704.

Distributed in the United States, its territories and possessions, Canada, Mexico, and Central and South America by Rizzoli International Publications, Inc. Distributed in the United Kingdom, Eire, Europe, Israel, and the Middle East by Phaidon Press Limited. Distributed in Japan by Yohan (Western Publications Distribution Agency). Distributed in South Korea by Nippon Shuppan Hanbai.

Editor and Publisher: **Paul Anbinder**
Copy Editor: **Kathleen Preciado**
Indexer: **Gisela S. Knight**
Designer: **Binns & Lubin**
Composition: **Trufont Typographers**
Photography: **Melville McLean**
Manufactured in Japan by Toppan Printing Company

Cover illustration: *A Hundred Monkeys* (detail)

88-34805
ISBN 1-55595-016-7 (pbk. : alk. paper)

Contents

Colorplates

Foreword

For a Buddhist the first step toward enlightenment is the elimination of the distinction between the concepts of Self and the Other. In everyday life such spiritual harmony and mental equilibrium can be found only in what is known in Chinese philosophy as *tongxin*, the "child's mind." Only a child seems to have the ability to ignore and transcend the boundaries separating the different spheres of realities: man and nature, real and imaginary, concrete and abstract, old and new, here and there. When this is translated into art in the rare form of a child prodigy, the result is not only astounding, it is revelation and inspiration. In the exhibition *Yani: The Brush of Innocence*, we encounter the brush of non-differentiation. It addresses all eyes and all hearts.

I first learned of the young painter Wang Yani through Mrs. Virginia Rau, a member of the Society of Fellows of the Nelson-Atkins Museum of Art, who met the little girl and her father, Mr. Wang Shiqiang, at the house of Vice Minister of Culture, Mr. Ying Ruocheng. Through the introduction of Mrs. Rau, arrangements were made to meet the young artist when I was visiting Beijing in the fall of 1985. My thanks go to Mrs. Patricia Wilson, now of the University of East Asia, Macao, who helped in those early days as our initial contact with the Wang family.

The first impetus, as well as the idea of organizing an exhibition, came from one of our University Trustees, Mr. Herman R. Sutherland, who became so enthusiastic after seeing some examples of Yani's paintings that he immediately offered to fund the initial stage of the project. With this motivation and blessing, the organizational work began in 1986. Dr. Wai-Ching Ho was invited to become project director. A statistician, developmental psychologist, and educational researcher by training, and for many years director of a research department for the evaluation of new programs in education in America, Dr. Ho is uniquely qualified to undertake this enterprise, the boundaries of which embrace art, psychology, and education. From the very beginning the Yani exhibition has been a "crusade of love" for Dr. Ho. She has tackled, under difficult circumstances, the entire gamut of tasks associated with an international exhibition. She has brought persistence and meticulousness to every phase and so has ensured not only an

exhibition notable for excellence at every turn and in every component, but also one far more ambitious than originally envisioned. Our gratitude is thus compounded by the result and effort.

Our thanks, too, must be extended to Dr. Ho for her editorship of the catalogue. We are pleased that the authors of the essays immediately understood the rich possibilities to be found in the subject of Yani herself as prodigy and in her works as excellent examples of visual creativity in the long tradition of Chinese painting. This rare combination was also recognized by our colleagues at the other institutions that will host the exhibition.

Our colleagues in China made the organization of the exhibition a pleasant and most agreeable undertaking. Their cooperation was unstinting. First Secretary for Cultural Affairs in the Embassy of the People's Republic of China in the United States, Mr. Liu Haiming, facilitated contact with agencies and officials in China throughout every stage of the exhibition. We are especially indebted to Mr. Yu Wentao, Deputy Director of the Bureau of External Cultural Relations, and Mr. Chen Shuyu, Deputy Director of the Division of American and Oceanian Affairs of the same bureau, for their enthusiastic response. They were instrumental in helping secure the sponsorship of the Ministry of Culture.

I personally enjoyed working with Mr. Hao Zhan, Managing Director of the China Exhibition Agency under the Ministry of Culture. He and Dr. Ho provided a model of cooperation.

Rights and regulations pertaining to publications were speeded along by Mr. Jia Bin, General Manager of China Peace Publishing House, under the patronage of the Song Qing-ling Foundation. Mr. Qiu Anman, Deputy Director of the Chinese National Copyright Administration, was instrumental in solving delicate problems and moving matters along at critical junctures.

It has been a joy to work with the publisher, Mr. Paul Anbinder, whose patience and understanding made a complex and difficult task ever so much easier.

A special thanks must be extended as well to Dr. Milo Beach, Dr. Esin Atil, and Mr. Patrick Sears of the Arthur M. Sackler Gallery, Washington, D.C., for their enthusiastic help with the variety of matters pertaining to the overall exhibition, including publicity, installation, shipping, and conservation. They have worked hard to make the inaugural venue in Washington, D.C., a success. Mr. Rand Castile, Director of the Asian Art Museum of San Francisco, and Mr. Clarence F. Shangraw, Chief Curator, have worked steadfastly with their colleagues in both the Chinese Art and Education departments to make the exhibition a success in a city well known for its resources in Chinese art.

The project owes its existence to the initial funding from Mr. Sutherland, whose interests were spiritually reinforced by Mr. Wood Arnold II, both of Kansas City.

The scope and quality of the exhibition would not have been possible without the generous financial support of United Technologies Corporation and its very enlightened program of philanthropic support of cultural and arts activities. We owe that firm our most profound thanks and deepest appreciation. It has been most rewarding to work with United Technologies on a project whose goal is to foster enjoyment and understanding of mankind's creative process.

Marc F. Wilson, Director
Nelson-Atkins Museum of Art

Yani: The Brush of Innocence is an unprecedented exhibition of the works of a Chinese child artist organized by a major museum and exhibited in the leading museums of Far Eastern art in the United States. This retrospective exhibition of the works of Wang Yani spans a period of eight years and includes paintings executed from age three to age twelve. (She had just turned twelve when works for the exhibition were selected.) Not only does the exhibition introduce the artistic achievement of an amazingly gifted Chinese child prodigy, but no less importantly, it offers an unusual opportunity to integrate art, art education, developmental psychology, and art psychology. From the outset we had decided to make the exhibition as comprehensive as possible to represent Yani's achievements in all thematic categories, her constant experimenting with various techniques, and her continuous search for different modes of expression. It is hoped that this approach will provide an interesting basis for study from both educational and psychological points of view. I am deeply honored to have been asked by Marc F. Wilson, Director of the Nelson-Atkins Museum, to organize the exhibition and produce this accompanying catalogue.

The realization of this project has depended on the efforts and contributions of many individuals as well as institutions. There is an old Chinese saying: "Opportune time is not as important as an advantageous environment; an advantageous environment is not as important as harmonious human relationship." The exhibition is a beautiful example of successful teamwork. In addition to the acknowlegments in the Foreword, I wish to add some of my own words of heartfelt appreciation.

I owe special thanks to the Embassy of the People's Republic of China in the United States of America, particularly Liu Haiming, First Secretary for Cultural Affairs, who has been instrumental to the success of this project and has always made himself available to help at every stage. I am deeply grateful to Yu Wentao, Deputy Director of the Bureau of External Cultural Relations, and Chen Shuyu, Deputy Director of the Division of American and Oceanian Affairs, both of the Ministry of Culture of the People's Republic of China, for their personal interest in realizing the exhibition,

Acknowledgments

and to Hao Zhan, Managing Director of the China Exhibition Agency of the Ministry of Culture, for the very smooth working relationship and for his high standards and professionalism in the project implementation.

Acknowledgment must also be made of the help and cooperation of Wang Shiqiang, Wang Yani's father, in providing information, materials, and Yani's works for the exhibition and catalogue. We are grateful to him, to Jia Bin, General Manager of China Peace Publishing House, and to China Peace Publishing House, which is the appointed agent of Wang Shiqiang and Yani for publishing rights to Yani's works, for granting the rights to the Nelson Gallery Foundation to reproduce Yani's paintings in the catalogue as well as in educational and publicity-related materials. Thanks are also due to Qiu Anman, Deputy Director of the National Copyright Administration of the People's Republic of China, for granting permission to reproduce illustrations from Chinese publications.

The success of the exhibition is also due to the support of the Trustees and the help of many members of the staff of the Nelson-Atkins Museum of Art, from whom I have learned much about the innumerable facets of exhibition organization and installation. This extraordinary exhibition would not have been possible without the insightful backing of the Trustees. To them and especially to Herman R. Sutherland, University Trustee, who generously helped to initiate the project, I express my profound indebtedness. I wish to thank Marc F. Wilson for helping me to charter the major course of the exhibition and for guiding me through the knotty passages. I am indebted to his unfailing encouragement and support. I greatly appreciate the expert opinion of Wai-kam Ho, Laurence Sickman Curator of Chinese Art, who helped me to select the paintings for the exhibition. I am most grateful to Henry Adams, Samuel Sosland Curator of American Art, and Ellen R. Goheen, Coordinator, Thomas Hart Benton Project, for their generosity in sharing with me their wisdom and experience concerning every aspect of planning an exhibition. I owe to them inspiration and the example of high standards that I have tried to pursue. I am immensely indebted to Roger B. Ward, Curator of European Art, a friend indeed in helping me with the most critical judgment at the most critical moment in the production of the book. My deepest appreciation goes to Robert A. Layton, Business Manager, from whom I have learned much about financial matters and contractual writing, and whose competence, accessibility, and perspicacity have made him indeed a great pleasure to work with. I wish to acknowledge the effort of Michael Churchman, Director of Development, who engineered and acquired for the exhibition the generous funding and national corporate sponsorship of United Technologies Corporation. I am thankful to Ann Brubaker, Director of Education, who started me on the project with her ideas about exhibiting children's art and who has shared with me her enthusiasm in the educational aspects of the project. I owe special thanks to Ann E. Erbacher, Registrar, and Cindy Cart, Assistant Registrar, for handling the condition reports and arranging the shipping, insurance, and related issues; to Melville McLean, Photographer, for photographing Yani's works; and to Linda Dost, Administrative Assistant to the Registrar, for scheduling the photography and ensuring that the transparencies, slides, and black-and-white photographs were ready in time to meet publication, publicity, and other deadlines. I am greatly appreciative of the advice on copyright and other publication matters of George L. McKenna, Curator of Prints, Photography, and Drawings; the prompt response to special photographic needs of Janice McKenna, Slide Librarian; the public-relations work of Lisa Massoth, Public Information Officer; the advice on conservation by Christine Young, Associate Conservator of Paper; the valuable assistance on many occasions of Joseph Chang, Research Assistant in the Oriental Department; the efforts of Michael R. Hagler, Curator of Exhibitions and Design, in designing and installing the exhibition for its opening at the Nelson-Atkins Museum in December 1989; and the installation work of Bobby Hornaday, Superintendent of Collections, and his staff. To Roberta Morris, Executive Secretary to the Director; to Nancy Straight, Curatorial Secretary; to Helen Sheely and Debra Anderson; and to other members of the museum staff who directly or indirectly have contributed to the exhibition, I wish to express my sincerest thanks. I am thankful to Paul R. Lamoree of Watson, Ess, Marshall and Enggas, legal consul-

tant to the museum, for his legal advice and for the pleasure of working with a brilliant mind.

The extraordinary event of having the opening of the exhibition at the Arthur M. Sackler Gallery, Smithsonian Institution, has offered an exceptional opportunity for forming a close working relationship between the staffs of the Sackler Gallery and the Nelson-Atkins Museum. I am most grateful to Milo Beach, Director of the Arthur M. Sackler Gallery and the Freer Gallery of Art, for his enthusiastic support; to Esin Atil, Head, Exhibition Programs and Collection Management, who has planned and coordinated with me the task force from the two museums; and to Patrick Sears, Assistant Director for Exhibitions and Facilities, who has handled many preparatory problems related to the design and installation of the exhibition, including matting and framing the paintings. I am thankful to Lucia Pierce, Head, Education Department, and Jan Stuart, Museum Specialist, Chinese Art, who have overseen the exhibition at the Sackler Gallery. I am also grateful to other members of the staff of the Sackler Gallery: Susan Bliss, Head, Office of Public Affairs; Karen Sagspeter, Head, Publication Department; Thomas Bower, Registrar; Nancy Green, Development Officer; Ryo Nishiumi, Head, East Asian Painting Conservation; and John Zelenik, Assistant Head, Design Department. To the Sackler staff I wish to express my admiration for their inspiring dedication and commitment to the highest standards.

We are also proud to have the privilege of working with the staff of the Asian Art Museum of San Francisco. I owe special thanks to Patricia Berger, Curator of Chinese Art, and to Richard Mellot, Curator of Education, who were instrumental in the museum's decision to participate in the project. For the support of Rand Castile, Director, and Clarence F. Shangraw, Chief Curator, I wish to express my great gratitude. To So Kam Ng, Associate Curator of Education, who, with Patricia Berger, is overseeing the presentation of the exhibition at the Asian Art Museum, and to other staff members who have aided in the project, I would like to express my indebtedness.

One of the most enjoyable experiences in the entire course of the project has been working with Paul Anbinder, President of Hudson Hills Press. I am profoundly grateful to him for his enthusiasm, understanding, patience, and above all, his faith in the book. I would like, in addition, to extend my warm thanks to freelance editor Kathleen Preciado and Virginia Wageman, Senior Editor, for their dedication and skillful editing.

The publishing of the catalogue would not have been possible without the valuable contributions of essays by Julia F. Andrews, Assistant Professor, Department of History of Art, Ohio State University; Dawn Ho Delbanco, Lecturer, Department of Art History and Archaeology, Columbia University; David Henry Feldman, Professor of Developmental Psychology, Eliot-Pearson Department of Child Study, Tufts University; and Lynn T. Goldsmith, Visiting Research Scientist, Eliot-Pearson Department of Child Study, Tufts University. They brought to the essays insight, expert scholarship, and superb writing.

Wan-go Weng, the former President of China Institute in America, has kindly agreed to make a videotape of Yani's life and works from age four to age twelve, which will be shown at the exhibition venues. I am particularly grateful to him because of the extremely demanding production schedule required to finish the videotape in a short time. The videotape would not have existed without his imagination and expertise. To him I extend my heartfelt thanks.

Finally, I wish to express my profound gratitude to United Technologies Corporation for its national corporate sponsorship and for the generous funding that has made the exhibition a reality. My deepest personal indebtedness goes to Carol F. Palm, Manager of Cultural Programs for United Technologies, and consultant Gordon Bowman for their interest and faith in the exhibition. To Herman R. Sutherland and to Wood Arnold II, President of Package Development Corporation, I wish to extend my sincerest thanks for their generous assistance in the financial support of the exhibition.

Wai-Ching Ho

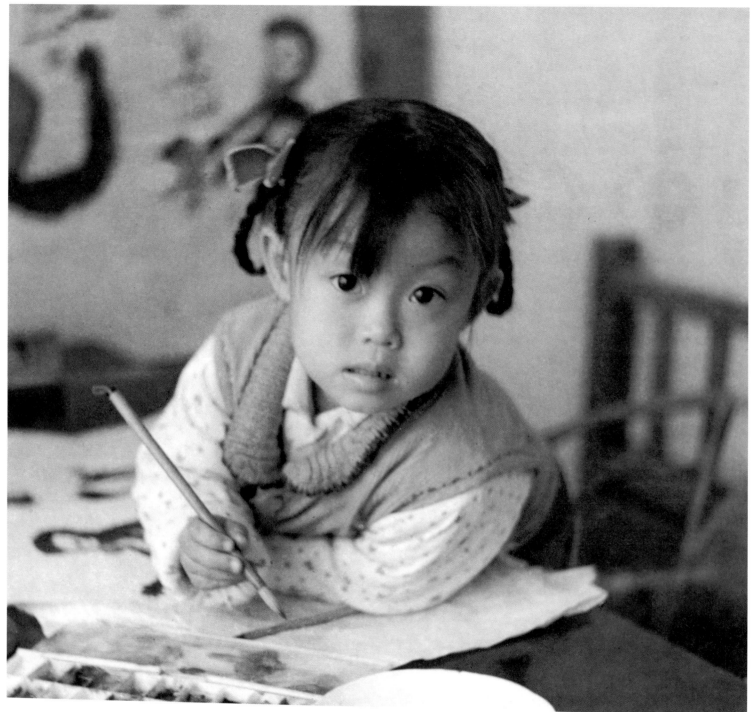

Figure 1 *Wang Yani at age three.*

5 March. It has drizzled all week, preventing Yani from playing outside. This evening she said to me in a serious tone of voice:

"Post a letter for me, [Daddy]."

"[To whom?]" I enquired.

"I'll paint a picture to be sent to the sun."

"The sun?" I repeated in surprise.

"Yes. He'll follow my advice and go with me. And so will the moon: didn't it go with me to Shanghai?" Yani went on: "The sun will take me up with him to play in heaven. He'll carry me on his shoulder and fly at great speed!"

"What is heaven like?" I asked.

"White everywhere. Do you want to go there too, [Daddy]?"

"I wouldn't dare to."

"But I will! And I'll come back, too." Then she whispered in my ear: "The lazy sun! He only cooks his meals at night, and makes the sky black with the smoke. He cleans it up in the morning, and it becomes light again."

On hearing this, I roared with laughter, but Yani gazed at me in amazement and insisted, "Yes, [Daddy], that's how it is."[1]

This diary entry written by Wang Yani's father when she was four years old offers us a glimpse into the extraordinarily imaginative world of Yani, to whom the gold-tinted clouds of evening become flames from the fire used by the sun to cook its meals (fig. 1).

In reality, Yani lives in an equally enchanting world. Daughter of the oil painter Wang Shiqiang, she was born on May 2, 1975, in the small town of Gongcheng in Guangxi Province. Gongcheng lies on the Li River (Lijiang), about fifty miles from Guilin, one of the most scenic areas of China, renowned since Ming times for "the most beautiful mountains and waters under heaven" (fig. 2). Yani's house is flanked by two Ming temples: a *wen-miao*, temple of Confucius, and a *wu-miao*, temple of Guan Yu, a highly respected general of the Three Kingdoms period (220–65). At the back of the house are lawns and hills covered with tall pine trees, and in the front is a lotus pond, beyond which stretch orchards and rice fields up to the Cha River, a tributary of the Li.[2]

From a very young age Yani was introduced to the enchantment and complexity of the natural world. Frequently riding on her father's shoul-

The Brush of Innocence

WAI-CHING HO

ders, she would roam with him among mountains and fields or stroll along the riverbank. They would observe the changing moods of the seasons, golden radiance of the sunset, and morning mist retreating from the mountains. They would also visit the zoo to admire the ever busy and lively monkeys, the harmlessness of the sleeping tiger, the fierceness of the lion, the beautiful plumage of peacocks and storks.

Yani loved to gather pine bark and visualize in them shapes of the dragon, dog, chicken, or the Immortal.[3] To her, the pebbles she picked up on the riverbank were monkeys. She would tell her father: "This is a monkey looking at dragonflies, and there baby monkeys are cuddling in their mother's arms to get milk."[4] Very often Yani and her father lay on the grass to enjoy the changing shapes of the passing clouds and to weave together whatever fancies came to their minds. Once, during an eight-hour trip to Guangzhou, the father and daughter continuously improvised stories to amuse each other to the great astonishment of fellow passengers, who were awed by their seemingly fathomless enthusiasm, wit, and imagination.

All these observations, improvisations, and fantasies were translated by Yani into emotionally arresting expressions. Painting became for her a device for expressing and recording experiences, feelings, and dreams.

Born to Paint

Yani started painting rather accidentally on a trip with her father to Nanning, the capital of Guangxi, when she was two and one-half years old. While he was at work in the studio with some colleagues, Yani was busy looking through children's books. After a short while she became bored, picked up a piece of charcoal and began to draw on the wall. Then, imitating her father, she stepped back with her eyes half-closed, left arm akimbo, and studied her creation with great satisfaction. Everybody roared with laughter. Her father did not take her efforts seriously until she proudly scribbled on his *nien-wa* (a special kind of folk-art painting for New Year's), a work that he had just completed and planned to send to the publisher immediately. Out of sheer desperation and panic, he spanked her. Yani

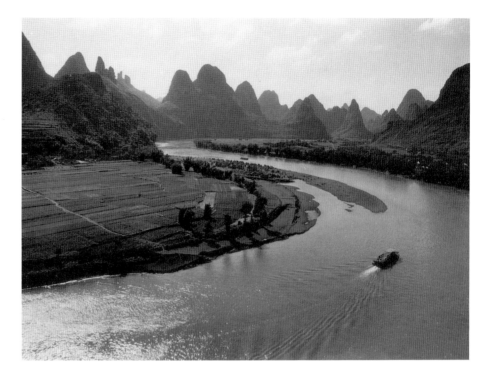

sobbed and cried aloud: "Daddy, I want to paint like you!" These words immediately brought to mind his own boyhood. As a child, he used to dream that his parents had bought him a lot of paint and paper and that expert artists were teaching him, but, in fact, his parents only complained and always punished him for messing up the floors and walls. He decided at that moment to give Yani the chance he never had.[5]

From that day Yani began her painting career with paper and brush. She painted the flowers in front of the house; the pine trees at the back; the chickens and ducks and dogs and cats in the yard. She loved most to paint portraits of her father. In his eyes, her paintings consisted only of dots, circles, and unintelligible lines. He termed this earliest art, "painting in symbols": "A circle might represent a person, a still-life, a bird, or some other animal, while an apple could stand for fruit in general."[6] Yani's father decided not to teach her how to paint nor to ask her to imitate the great works of the past for fear of stymieing her creativity but to let her learn by herself through observation and trial and error and develop her own style. To him, his role was to be a good friend and enthusiastic supporter and listener but not a critic. He even gave up his own painting in 1983 so as not to influence her work and artistic development. On hearing his deci-

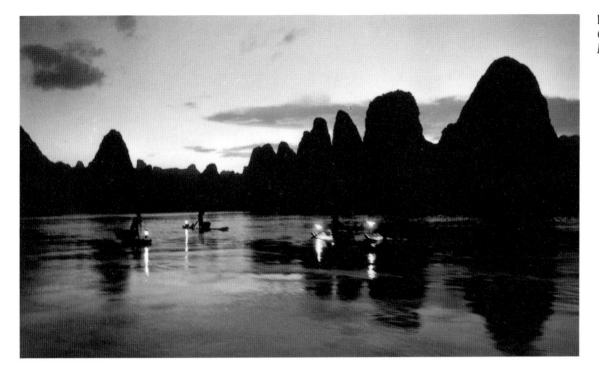

sion, a painter-friend sent him two lines from "Li-sao," one of the greatest Chinese poems written by Qu Yuan (343–c. 290 B.C.): "It is a long, long way that I have to go, / but high and low I will search."

For Yani, painting became an amusement and precociously deep emotional involvement. Everyday she painted without pause until she was completely satisfied. Once, when she was four, she worked almost until midnight. Despite her mother's repeated urging, Yani refused to go to bed until, she insisted, she got "the best painting." Only after completing more than ten paintings was she willing to go to sleep.

It is not easy to ask Yani to give up painting. At age four she once had a temper tantrum during a demonstration because someone had wet her table. She refused to paint and did so only halfheartedly after she was offered ices. On returning to the hotel room, her father told her never to paint again, for an artist must be serious about her work and must not be arrogant. He then went out for a while, and when he returned he found the whole floor covered with her work. Teary eyed, she raised her head and said, "Daddy, I will never paint again." Then she started to sob. Her father accepted her apology and offered her comfort and encouragement in the end.[7]

Yani is exceptionally observant, and her visual memory is astounding. Wang Shiqiang taught her Chinese characters by writing them in the air once with his finger. In this manner she learned to memorize characters of twenty-five strokes when she was only four years old. On one of their trips to the zoo, Yani was much affected by the beauty of the peacocks. Her father told her to find out why they were so lovely. She studied them for several hours, and as soon as they arrived home she rendered beautiful images of the birds. *Three Peacocks* (no. 21) was probably painted not too long afterward.

Yani has the ability to create the most poetic improvisations on the spur of the moment. Once, she accidentally tipped over the brush washer, and the overflowing water stained most of her paper. She emptied the rest of the water on the wet paper, skillfully painting pumpkins and vines over it, and made use of the blurring effects to suggest that the pumpkins and vines were lost in a morning mist.[8]

In fact, Yani can, and always does, start her painting without any sketch or predetermined theme. Depending on the color of the paint that she picks up on her brush, she then decides what subject is most appropriate, executes her first stroke, and develops a story simultaneously as she paints. It is a wonderful experience to watch

Yani paint. She keeps the brush moving unhesitantly, with occasional pauses only to inspect the overall composition.

By the time she was four years old she painted monkeys so well that an artist who had specialized in painting the animal decided to give up his lifelong pursuit and presented her with his personal seal, which depicts a monkey holding a peach (fig. 3).

By the age of six Yani had produced four thousand paintings. Her work was exhibited in Shanghai, Guangzhou, Beijing, and Hong Kong and won national acclaim. Yani's international fame has continued to grow through recent exhibitions in Japan, West Germany, and England.

The World of Monkeys

From age three to six, Yani was obsessed by monkeys, the subject of most of her paintings in this period. She fell in love with these lively animals when she first saw them in the zoo at Nanning. She leaped and shouted with great joy as soon as she spotted them, blinking her eyes as the monkeys blinked theirs, making faces as they made theirs, shrieking as they shrieked, and running as they ran. She insisted on going into the cage to play with them. When not allowed to do so, she lingered for hours to watch them swing, pick lice, and climb rocks and finally was forced to leave in tears. She frequently visited the monkeys with her father until she was six years old, each time for several hours and always leaving with great reluctance. It is very likely that her unfulfilled dream propelled her to create in her paintings a wonderful world of monkeys— a world with the monkeys as her friends and playmates, a world that could never be.

Moved by Yani's deep affection for these animals, her father bought her a pet monkey. She called her "darling pet" Lida and wanted to spend every moment with her. She fed her, gave her candies, combed her hair, dressed her in beautiful clothes, and invited neighborhood children to sing and dance around her. A few months later, however, Yani declared that she did not love her pet anymore. "Lida," she said, "when I talked with her, did not understand; when I told her stories, she simply stared at me; she did not

Figure 3 *Seal of a monkey holding a peach, given to Yani by a fellow artist.*

know how to steal fruits; and she could not tell jokes."[9] Indeed, what Yani loved and painted were the monkeys she herself created. These imaginary monkeys represented her friends, her parents, and even herself. Through them she recorded her experiences, thoughts, and feelings in pictorial form. One day her father bought her a lovely red umbrella. Too impatient to wait for the rain to come, she painted a monkey holding a little red umbrella and playing happily in the rain.[10]

Yani painted monkeys to the exclusion of almost all other subjects after she saw them for the first time, and she begged her father to tell her monkey stories everyday. Her first monkey pictures simply consisted of circles: small circles within big circles. After her father bought her Lida, her painted monkeys began to take shape. First, a round head, then hands and a tail, then feet were added. When someone pointed out to her that the monkeys would not be able to hold the fruit without fingers, she added fingers and toes—the wrong number at first until she had learned to count. Within a short time she made her monkeys pick fruit, catch lice, grasp branches, and even play tug-of-war.

Since the age of three Yani has displayed admirable technical virtuosity (no. 23). Although she has not imitated any style, old or new, the mere fact that she has used the same medium, paper and brush, as traditional Chinese painters makes it almost impossible for Yani to depart completely from tradition and the past. As the Qing (1644–1911) master Dao Ji stated in the opening of his treatise on Chinese painting, "A single brushstroke is the origin of existence and

the root of myriad phenomena."[11] Throughout the history of Chinese painting the brushstroke has been the central focus. What strikes us first of all in Yani's paintings is the unusual, expressive, and compelling power of her single stroke—whether it be the forceful lines, sometimes heavy and wet, sometimes semidry, that suggest the fur of a monkey (nos. 6–7), the feathers of a rooster (no. 18), the leaves and trunk of a coconut tree (no. 22); or the swift, precise lines that delineate a flying fishing line (no. 10); or the broad, wet strokes that define the structure of an animal (nos. 14, 23); or the dry strokes that describe the texture of bark (no. 17). Yani has developed and built a rich repertoire of marvelous brushstrokes and has applied them well.

Yani is equally accomplished in the use of washes. When she first started to paint she used short strokes because of the limitations of her small arms. Then one day while she was painting rocks, she accidentally dripped some color onto the paper. Instead of throwing the work away, she quickly squeezed the remaining fluid on the brush onto the painting, brushed over it, and transformed the disaster into a success in her first experiment with washes. This story brings to mind the eighth-century "ink splasher" of the Tang dynasty (618–906) who used to splatter ink freely onto silk and then add strokes to the spontaneously formed shapes, thereby rendering his landscapes. Regardless of how Yani arrived at her wash technique, the use of washes is a fundamental element of Chinese painting. Yani seldom uses flat washes except to fill in an area defined by a contour. She does make good use of the looseness and spontaneity of the ink and watercolors as well as the special absorbent quality of the rice paper. Her ink and colors are sometimes applied so wetly that as they spread outward the edges blur, creating a soft, fuzzy impression. By cleverly manipulating varied tones of ink and color, Yani deftly captures the texture of the monkeys' fur and the volume of their bodies (no. 8).

Yani likes bright colors. The way in which these colors are used is most striking and effective: the red face of a monkey immediately commands the attention of the viewer (no. 1). Yani also skillfully contrasts tones of light and dark and adopts the latter to emphasize facial

expressions or movements and gestures (no. 3).

According to the Chinese ideal, technical skills are only the means necessary to the end of imparting a feeling of stirring animation. In the fifth century the painter and critic Xie He set down the so-called Six Canons of Painting, which Chinese artists have pursued for centuries. The first principle, *qiyun shengdong*, sometimes translated as "rhythmic vitality," is of the greatest importance. Other principles such as proper use of brushwork, ink, color, and composition are chiefly subservient to this ultimate goal of imbuing the painted form with "the special kind of movement, rhythm, or life characteristic of all things in the world of nature."[12] *Qiyun shengdong* is equivalent to what art historian Benjamin Rowland calls "magic realism." To the Chinese, "it is better to paint a distorted tree that seems to grow than a naturalistic one that is dead and lifeless as a photograph."[13] Su Dongpo—the great Sung (960–1279) poet, prose writer, calligrapher, and statesman as well as founding father of the literati painting movement—stated that those who discuss painting in terms of likeness deserve to be classified as "children."

By this definition of magic realism the artist should infuse a vibrant life into a re-creation through the action, pose, gait, and other characteristics specific to the species so that the representation of a flying bird is not merely the picture of a bird but an "ideograph of flight itself."[14] Yani has the marvelous ability to identify these qualities and to distill their essence in her highly expressive forms. In her treatment of monkeys, her images are conceptual, abbreviated, and expressionistic. With the greatest economy of brushstrokes, accenting only a few key points, in combination with washes and colors, her animals are not only realistically represented but also seem capable of imminent action or caught in the middle of swift movement (no. 12).

Most moving are the humanlike feelings and personalities with which Yani endows her monkeys. *This Is for Mommy* (no. 7), which shows a baby monkey kneeling on the back of its mother and feeding a fruit to her, is absolutely delightful. *Let Me Paint Something* (no. 14) makes us wonder whether this is a story about Yani and her father, who attentively watches over her shoulder as she paints. The playful monkeys

portrayed in the pictures remind us of her playmates, perhaps idealized, or even of herself.

By the time she was five or six, birds and animals began to appear with increasing frequency in Yani's paintings. They were created as companions for her monkeys as she herself ventured into the broader world and made more and more friends of her own. In *Hurry Home!* (no. 15) a monkey rides happily on the back of a pink camel, and in *Don't Fight!* (no. 18) a monkey tries to save its rooster-friends from a stormy confrontation. The roosters, portrayed with such prowess and with such intensity that they seem ready to strike out at any enemy, recall *The Rooster,* a 1938 pastel by Pablo Picasso (1881–1973; p. 82). Despite the different techniques employed by the two artists, both Yani at six and Picasso at fifty-seven succeeded in capturing the fighting spirit of their subjects.

Like most Chinese artists of the past, Yani does not paint directly from life, or *xiesheng,* nor does she try to record any particular monkey, peacock, or tree. She absorbs and accumulates sensory impressions from nature, analyzes and synthesizes these impressions, and paints from the universalized images thus conceived in her mind. Yani's painting is a result not only of a praiseworthy mastery of the medium but also of her ability to capture the essentials observed in nature and have them so fixed in her mind that she can re-create them in her painting, endowing them with life, emotions, and personalities and projecting into them her thoughts, feelings, and dreams. It is through Yani's brush of innocence that we are introduced into an immensely wonderful world of warmth and delight and the playfulness of a child's mind.

> Set forth your heart, without reserve,
> And your brush will be inspired.
> Writing and painting serve a single aim,
> The revelation of innate goodness.
> Here are two companions,
> An old tree and tall bamboo,
> Metamorphosed by his unreined hand,
> Finished in an instant.
> The embodiment of a single moment
> Is the treasure of a hundred ages,
> And one feels, unrolling it, a fondness
> As if seeing the man himself.
> —TANG HOU *(active fourteenth century)*[15]

The Horizon Beyond

The expansion of Yani's horizon beyond the world of monkeys was both inevitable and natural. The period from seven to eleven signifies Yani's awakening to the beauty of nature and her exploration of a broader world. She now shows interest in the beauties of mountains and waters, flowers and birds, fish and animals, the legendary dragon and beautiful girls. Her paintings intertwine fantasy with reality, the reality that she artfully rearranges through the brush and ink.

According to traditional criteria, it is in the category of flower and bird painting that Yani displays her most brilliant brushwork, from the rapid flying curves of ink that define twigs (no. 54) to the forceful, calligraphic lines and washes that represent the banana tree (no. 26); from the striking contrast of ink tones enlivening the plum (no. 29) to the vigorous strokes realistically describing the form and texture of pine (no. 47). Yani's brushstrokes are accurate, well controlled, bold, and free. It is said that her father, to train her to paint with the full force of her whole arm, time and again tried to snatch her brush away from behind when she was not noticing. She was thus trained to hold her brush very tightly, execute her lines with her entire arm, and use all four "sides" of the brush by twisting her wrist appropriately to produce the desired brushstrokes.

The art of calligraphy has long exerted a profound influence on Chinese painting technique. Since the mid-Tang many artists have learned to rely more on the descriptive and expressive power of line than on color. Particular effects of form, structure, texture, and animation can be realized by alternately thinning and thickening the brushstroke, manipulating the amount of ink and water, calculatedly using the tip and sides of the brush, and carefully controlling the speed of the movement of the line.

In brushwork and style, Yani's flower and bird paintings are closer than her other works to traditional Chinese painting and reflect particularly the influence of such contemporary masters as Wu Changshi (1844–1927), Qi Baishi (1863–1957), Pan Tianshou (1897–1971), Tang Yun (born 1910), and others. Yet Yani develops a new direction, a new expressionistic style of her

own by infusing her paintings with human qualities, a sense of life and of growth.

An illuminating comparison may be made between *A Small World* by Yani (no. 57) and *Towel Gourds and Bird* (fig. 4) by Tang Yun, which bear a close but superficial resemblance. Although both seem to be similar in composition as well as theme, Yani distinguishes herself in the admirable vitalization of her subject. The vigorous, angular strokes of the vines, forcefully counterbalanced by the rhythmic, sweeping curves of the melons rendered in blue wash, combined with the lively modeled leaves of variegated tones, make us aware that these are growing and living things. The baby chicks convey a human quality, a childlike quality characteristic of her monkeys. While three of them are engaged in an intensive search for food on the ground, one is gazing greedily at the closest melon in an attempt to get to it as a companion looks on. *Waiting (for the Young Ones)* (no. 50) may look similar to *A Break in the Journey* (fig. 5) by Pan Tianshou, but Yani's birds again are full of human warmth. They are waiting expectantly, like any parents, for the little ones to come home before dark. Unlike Pan, Yani uses ink blotches not to suggest the texture of vegetation or of a rock but rather to counterbalance, together with the cleverly placed inscription, the emptiness of the bare, sketchily contoured rock on the right.

A most unusual and significant work is *Last Night I Dreamt I Saw the Racing Egrets* (no. 55). What strikes us is Yani's extraordinary skill in handling a most intricate design and, above all, her ingenuity in evoking convincingly and yet implicitly a feeling of movement in her subjects. The silhouetted forms of twenty-nine egrets are arranged in overlapping layers in an asymmetrical design, in which the concentration of form at the upper right contrasts with the empty space at the lower left to give an impression of spaciousness. Each egret, although executed with great immediacy in the fewest possible strokes, has its own distinct character and posture. Most wonderful is the way in which a sense of movement is suggested—not through the running legs of the birds, most of which are hidden from view, but by means of a rhythmic pattern of the sharp beaks and curving necks, all pointing emphatically to the left.

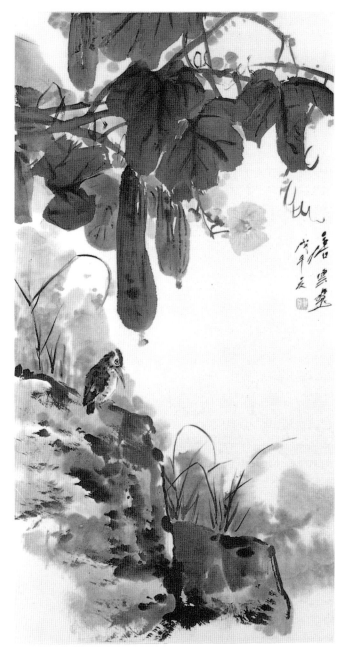

Figure 4 *Tang Yun (born 1910),* Towel Gourds and Bird, *1978 (from* Contemporary Chinese Painting, *ed. Hua Junwu [Beijing: New World Press, 1984], pl. 22).*

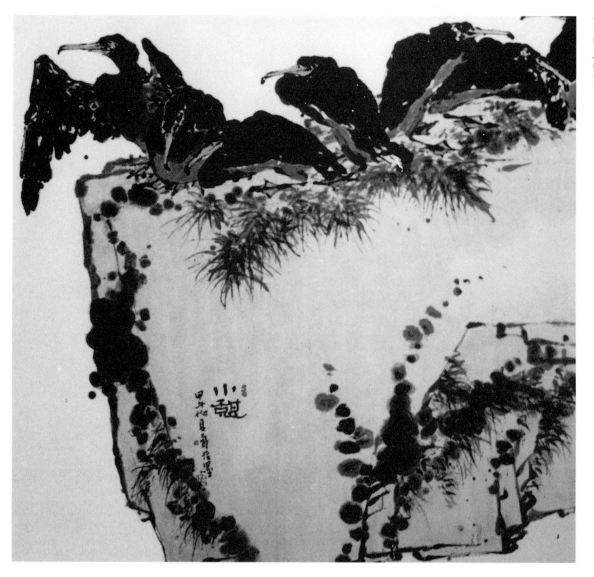

Figure 5 *Pan Tianshou (1893–1971),* A Break in the Journey *(detail), 1954 (from* Contemporary Chinese Painting *1984, pl. 6).*

Yani's fondest subject in her flower painting is the lotus, not only because of the fragrance and sensuous beauty of the blossoms but also because of her intimate knowledge of these flowers from her daily observation of their growth and decay in the pond in front of her house. *Raining on the Lotus Pond* (no. 46) represents an intuitive and symbolic approach, where rain is literally depicted as drops of water, while the leaves and blossoms are described in full view and in profile respectively. *The Lotus Flowers Are So Pretty!* (no. 51) endeavors toward decorative beauty and visual truthfulness. The most romantic and perhaps more traditional in approach is *Oh! It Smells So Good!* (no. 53), executed in monochrome ink with the exception of a few touches of light blue. These three paintings form an interesting study of Yani's treatment of the lotus in different styles from ages seven to eleven.

Yani's landscape is a lyrical interpretation of nature. She is not so much concerned with truthful visual appearance but rather translates her impressions of and feelings toward nature into spontaneous splashes of ink, color washes, and loose brushwork. What she strives to convey is the changing moods of the seasons (nos. 32, 41–42) and different times of day (nos. 31, 39), the serenity of country life (nos. 34, 44), and pleasant scenic spots (nos. 40, 43). *Clearing after Rain* (no. 36) poetically records the fleeting moment when the retreating clouds are momentarily arrested among the mountains and the sun starts to break through the clouds and warm the water and earth with its brilliant rays. The verdant colors of mountains and new foliage

herald the reawakening of spring (no. 41), while the red, orange, and yellow hues are reminders of the warmth of the autumnal glow (nos. 32, 42). Dark tones emphasize the sharp contrasts and strong shadows created by a blinding sun (nos. 39, 45). Yani's landscapes are intimate, cheerful, and inviting, with touches of naïveté. Red and orange flowers, foliated trees, rows of whitewashed houses with black roofs, lively boats moving along the river help convey such beautiful feelings and moods. It is a delightful experience to lose ourselves wandering among the mountains and waters that dwell in Yani's mind (no. 37) and to enjoy details such as the delicately waving lines of the water and skillfully delineated passing boat (fig. 6).

Yun Cai Mountain (no. 35), the mountain of clouds, is Yani's only monumental landscape. The very softness of the contours, indefiniteness of the forms merging and emerging in a veil of clouds, minuteness of the boat and trees, and towering summits that almost reach the edge of the sky recall the grandeur of Northern Song (960–1127) landscapes. Special mention should be made of *Autumn in a Hamlet* (no. 42), painted by Yani with a piece of crumbled rice paper.

Yani's figure paintings are characterized by a childlike simplicity. She has explored and experimented with various techniques in their linear definition. *The Little Mushroom Picker* (no. 59) is defined only by a bare minimum of strokes, yet the emotional state of the little girl is clearly revealed. The wide-open eyes staring directly into the viewer's and the proud, firm stance with left arm akimbo suggest an air of self-assurance, but at the same time her slightly lowered head implies that she is a little shy. The figures in *Our Dance* (no. 61) and *A Beautiful Dance* (no. 62) are reduced to flattened decorative shapes of subdued tones, arranged to create a mood of delicate elegance. An impression of movement is aroused by the rhythmically repeated curves of the winglike sleeves that also provide an arresting aesthetic attraction. The dancers in *A Beautiful Dance*, however, seem to be dancing to a melody, while those in *Our Dance* seem to be frozen in motion.

Yani's special feelings toward animals and unusual ability to project these feelings into emotionally arousing pictorial terms continued to blossom during this period. This extraordinary trait was already manifest in *Kitty* (no. 23), painted when she was only three. With a few

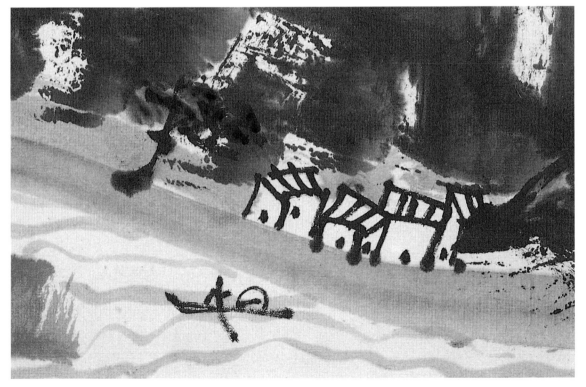

Figure 6 *Wang Yani*, You Can Never Finish Painting the Mountains and Rivers in Guilin, *no. 37 (detail)*.

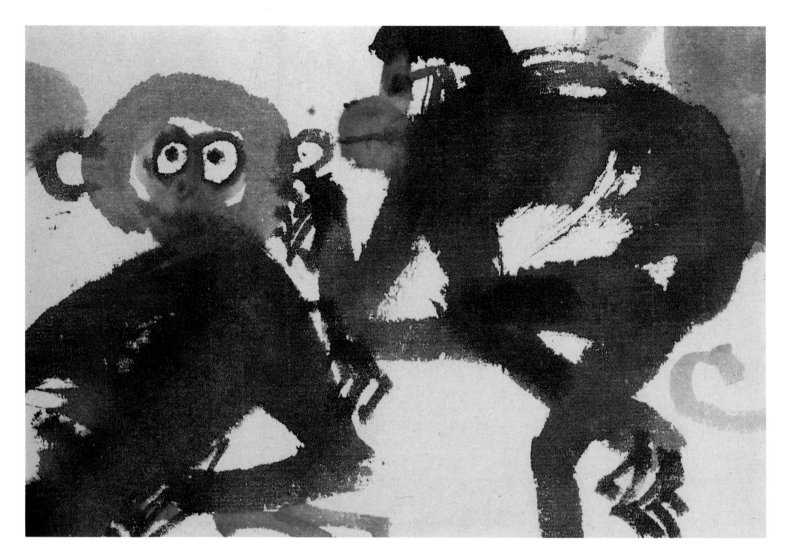

bold strokes and the simplest rendering of the eyes, the kitty's sweet, curious, and innocent nature is movingly transmitted.

Her achievement in portraying monkeys reaches its culmination in *A Hundred Monkeys* (no. 28), in which she depicts the animals in an infinite variety of poses and engaged in different kinds of activities typical of school children at recess: running, talking, chasing, playing, whispering to conjure up a naughty trick or small scheme (fig. 7). This handscroll is a significant milestone attesting to Yani's bidding final farewell to early childhood passions and dreams. Other animals gradually take the place of the monkeys and become increasingly dominant during this period.

The Lion Is Awake! (no. 63) is a powerful ideograph of dignity, ferocity, and prowess, expressed through the overpowering and over-sized mane, wide, blood-red mouth, forceful whiskers and eyelashes, powerful body and legs, emphatically raised tail, and sharp nails. Yani injects a sense of humor into this painting in her depiction of the eyes—one open and one closed—implying that the lion is pretending to be asleep while the monkeys are throwing fruit and trying to climb on its back. The symbol of fierceness is again illustrated in *Close Brothers* (no. 67), executed with just a few strokes and simple washes. The suggestion of ferocity now depends on facial expressions and postures. The intense, penetrating gaze, tightly closed, down-cast mouth, lowered head, and arching back of the tiger in front indicate that it is waiting to pounce on a lurking enemy or prey. A mood of happiness and leisure is created in Yani's painting of galloping horses, rendered in stylized, abstract forms (no. 64). The horses with flying manes and streaming tails are moving at great speed, but the others seem to run along merrily.

Figure 7 *Wang Yani*, A Hundred Monkeys, *no. 28 (detail).*

The Horizon Beyond has been a period of exploration and experimentation for Yani, not only in reference to the physical world but also in terms of her artistic endeavor. She records her experiences, feelings, and zest for life in all the major painting genres through a variety of expressive modes, using different kinds of washes and brushwork. She adapts the styles of the Chinese painting masters, both old and new, in her rendering of flower and bird themes; leans toward the work of contemporary Chinese artists in landscape but creates a new expressive direction of her own; paints stylized dancing figures that reveal the influence of the decorative mode of Japanese art; and enlivens her animals with special feeling. But most marvelous is the magic realism of her paintings.

Nature and Nurture

Yani clearly exemplifies a case of both nature and nurture. It is extremely rare to find a child like Yani with so great a range of precocious artistic achievements at such an early age. The closest parallel may be the widely published case of Nadia Chomyn. Her situation, however, is greatly different from that of Yani. Nadia is an autistic child suffering from severe emotional disturbances and cognitive deficits. Yani paints mostly from images of live models instilled in her mind, while Nadia seemed to draw mostly variations on pictures that she had seen weeks earlier (figs. 8–9). To be sure, both share an astounding visual memory and amazing spatial perception. An interesting question still remains: Could Nadia have translated a live model, such as a rooster, into animated, abstract terms of line if she had not first seen a picture of a rooster? As art psychologist Rudolf Arnheim stated: "Seeing the shape of a human head means seeing its roundness. Obviously roundness is not a tangible perceptual thing. . . . If the child makes a circle stand for a head, that circle is not given to him in the object. It is a genuine invention, an impressive achievement, at which the child arrives only after laborious experimentation."[16] Perhaps in the unusual case of Nadia, the relationship between the artist and her model, either in books or in life, is so complex and involves such diverse psychological and technical factors that a simple answer may be impossible.

Figures 8–9 *Roosters drawn by Nadia Chomyn at about age six, based on her memory of a book illustration (from Selfe 1977, pls. 33–34; reproduced with permission of Academic Press).*

It is well documented that a young child goes through certain developmental stages in drawing—from scribbling to a "schematic" and a "tadpole" stage and so forth.[17] Yani has proven to be no exception. What distinguishes her is the incredible speed at which she has raced through these stages in her early childhood. The environmental factors have been all in her favor. She has an artist-father who has always been encouraging, supportive, and enthusiastic about whatever she paints, whether it be a scribble, a drawing of lines and circles, or a monkey with a round head, a tail, and two hands but no fingers or legs. He has stimulated her imagination and widened her perceptions by conjuring up stories with her and exposing her to various elements, different aspects of nature. He has guided and trained her in proper use of the brush and other painting techniques and has provided her with opportunities to meet and learn from his painter-friends. This rare combination of talent and favorable environment enabled her early to create paintings that may be compared favorably with the early art of Paul Klee (1879–1940; figs. 10–11).

A similar child wonder in the visual arts was the Japanese prodigy Tokai Okon, born in 1816, who was extremely gifted in calligraphy (fig. 12). She was so distinguished in "grass" (cursive) script at the age of nine that she was invited to demonstrate her skills to the imperial court at the invitation of the emperor of Japan. Unfortunately, she was born into a traditional society that believed any intellectual or artistic achievement would ruin a woman's chance of finding a good husband and leading a normal life. When she married a government contractor in 1832, she gave up her artistic career entirely.[18]

There are no existing examples of very early art by Picasso. Figure 13 illustrates a work drawn by him at age nine. According to developmental psychologist Howard Gardner, Picasso "was a painting genius from early childhood, able before puberty to so surpass his father that the elder painter laid down his brush forever. . . . He received incomparable training, both at the hands of other masters and by virtue of his own sure eye, memory, and hand."[19]

Quite a number of happy parallels exist between the backgrounds of Picasso and Yani. Yet, even for geniuses such as Klee and Picasso,

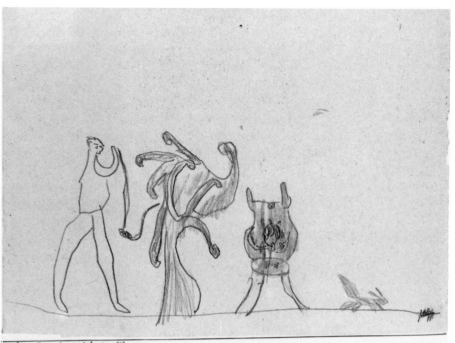

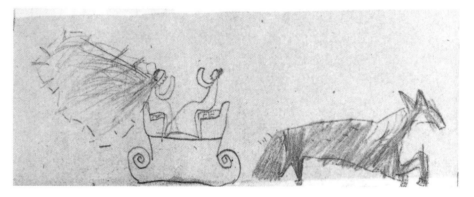

TOP:
Figure 10 *Paul Klee (1879–1940), Man, ? , Chair, Rabbit, 1884, pencil and crayon, drawn at age five. Paul Klee Foundation, Kunstmuseum, Bern. © 1989 COSMOPRESS, Genf.*

BOTTOM:
Figure 11 *Paul Klee (1879–1940), Horses, Sleigh, and Two Ladies, 1884, pencil and crayon, drawn at age five. Paul Klee Foundation, Kunstmuseum, Bern. © 1989 COSMOPRESS, Genf.*

Figure 12 *Tokai Okon (born 1816), Red Cliff, 1827, ink on paper, executed at age eleven. Shoka collection.*

Figure 13 *Pablo Picasso (1881–1973), Bullfight Scene and Doves, Málaga, 1890, pencil, drawn at age nine. Museo Picasso, Barcelona (from Juan-Eduardo Cirlot, Picasso: Birth of a Genius [New York: Praeger, 1972], pl. 6). © 1989 ARS N.Y./SPADEM.*

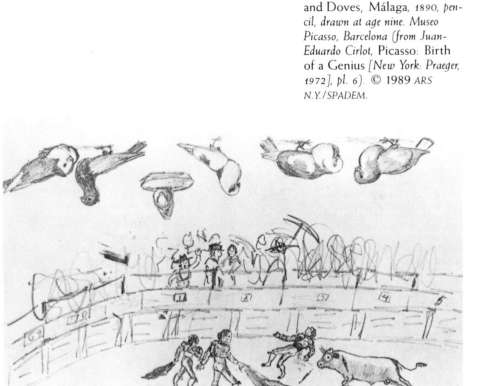

it took many years to bring to fruition their "divine" abilities. What makes Picasso stand apart from other mortals? Gardner has the following answer, which may serve as inspiring advice to Yani:

His perfected technical facility, his ability to render almost instantly the exact image he desires, the capacity to plan ahead for long periods of time and to follow through a project over a great period of time. There is also an incomparable store of knowledge of what other artists have done and how they have done it, as well as an intense awareness of the norms and practices that have guided his and other eras. When an artist of Picasso's caliber violates some sort of norm or practice, he is totally aware of this violation and of its consequences. . . . There is the great pleasure, the compulsive satisfaction obtained from a constant involvement in the process of drawing. There is the willingness to disregard what others are doing, to flout convention, and to pursue one's own ideas and goals, however formulated, to their graphic conclusions. There is an intuitive sense of form or balance which almost never fails. . . . Picasso turns to his cherished medium in an effort to make his own feelings—their form no less than their content—clear to himself and to others.[20]

Yani has demonstrated a glorious beginning. May she have the courage and strength to follow in the footsteps of her great artistic predecessors.

NOTES

1. Wang Shiqiang, "Yani as I See Her" in *Wang Yani: Pictures by a Young Chinese Girl* (Munich: Prestel-Verlag, 1987), pp. 20–21. Changes from the original text are bracketed.

2. Background information is derived from the author's conversations with Yani's father and from Wang Shiqiang 1987, p. 15.

3. Wang Shiqiang 1987, pp. 19–20.

4. Quoted in Huang Qingyun, "The Heart of a Child," in *Yani's Monkeys*, ed. Shufen Li and Cheng'an Jiang, 2d ed. (Beijing: Foreign Languages Press, 1987).

5. See Liu Baofa, "Yani and Her Father," *Bao Gao Wen Xue*, no. 7 (July 1984): p. 25.

6. Wang Shiqiang 1987, p. 16.

7. See Liu Baofa 1984, p. 29.

8. See Wang Shiqiang 1987, p. 22.

9. Quoted in Liu Baofa 1984, p. 26.

10. See ibid., p. 26.

11. Quoted in James Cahill, *Chinese Painting* (New York: Rizzoli, 1977), p. 11.

12. Benjamin Rowland, Jr., *Art in East and West* (Cambridge, Mass.: Harvard University Press, 1954), p. 20.

13. Ibid., p. 67.

14. Ibid., p. 127.

15. Quoted in Cahill 1977, p. 95.

16. Rudolf Arnheim, *Art and Visual Perception: A Psychology of the Creative Eye* (Berkeley: University of California Press, 1966), pp. 160–61.

17. See Howard Gardner, *Artful Scribbles: The Significance of Children's Drawings* (New York: Basic Books, 1980), chapters 2–4 regarding the earliest development in children's art.

18. Pat Fister, "Tokai Okon," *Calligraphy Idea Exchange* 3, no. 4 (Summer 1986): pp. 26–33.

19. Gardner 1980, p. 266.

20. Ibid., pp. 267–68.

Monkeys have long inhabited the culture of China. The young contemporary painter of monkeys Wang Yani is remarkable for her invention of purely personal and fresh images of these creatures, which have been described by so many artists and writers before her. It is astonishing how definitively this child has captured the gestures and postures of her favorite animals in a few sweeping lines of the brush: witness, for instance, the protective yet defiant huddling of a monkey over his fruit in *These Fruit Are Not Yours* (no. 11), the exuberant leaping of several fun seekers in *Hurry Down!* (no. 16), or the bravado of a group of impish daredevils in *The Lion Is Awake!* (no. 63). A few of her themes are traditional—such as the pairing of monkeys with cranes—and may be related to popular ornamental motifs found on everyday items, from pottery to clothing to New Year's pictures. No doubt Yani's parents also recounted to their small daughter exploits of the supernatural Monkey—the beloved Chinese folk hero of the sixteenth-century novel *Xiyu ji* (Journey to the West)—and other popular tales involving mischievous monkey characters, to whom Yani's playful creatures bear some kinship. Unlike them, however, her monkeys do not possess magical powers or evil motives—although they may bicker or whine—nor are they replete with allegorical or literary significance. These are creatures of innocence, the spirited monkeys that a child sees at play in the zoo or that she keeps—as Yani did—as pets. In her immediate and natural fascination with these animals Yani must instinctively have recognized them as perfect soul mates and playmates—if not in real life, then in the imagination. It was through the act of painting that Yani best interacted with her monkeys by giving life and form to them. Just as many children conduct full-fledged conversations with dolls or make-believe friends, Yani would chastise her own creations for their unruly behavior or promise them rewards of fruit. In her monkey paintings she has depicted, in effect, scenes of childhood. One need only read the painting titles, which so perfectly convey childish enthusiasms and concerns—the bickerings, the greediness, the exuberance—to see how Yani has translated the inherent playfulness of monkeys into expressions of a child's world.

Yani's sheer youth is responsible, in part, for the freshness of the images. Although her father,

Monkeys in Chinese Art and Culture

DAWN HO DELBANCO

Wang Shiqiang, an artist in his own right, taught her the fundamentals of brush and ink techniques, she was too young to have studied—and thus to be encumbered by—the old masters. Yani's art is not derivative, therefore, of older painting traditions, but her inventiveness is best seen against the background of these earlier versions, to many of which her paintings bear some relation. Yani was by no means the first to observe closely monkeys or to portray them with humor and sympathy, nor was she the first to paint animals in an expressionistic mode. What makes her painting unique is that Yani alone sees from a child's point of view.

Monkeys have been part of the culture of China almost from the beginning of its recorded history. Allusions to monkeys first appear in Zhou dynasty (c. 1122−256 B.C.) texts, and since the Han dynasty (206 B.C.−A.D. 220) references to these creatures abound in factual accounts, such as scientific, geographic, and historical treatises, as well as in various literary genres, ranging from the novel to lyric poetry.

The prominence of the monkey reflects the general importance of animals in China. The pervading notion of the unity of all natural things, the traditional belief that men, monkeys, and mountains assume equal standing in the greater context of the cosmos, have led Eastern cultures to assign animals a central place in their religions and mythologies, in which the human image does not predominate as it does in the West. Thus, in China the monkey came to be regarded as a kind of Everyman, emblematic of both the best and worst in human nature, whose actions illustrated the highest ideals to which men might strive or the illusions to which they succumb.

From the beginning, then, monkeys represented both positive and negative forces in China. As early as the fourth century B.C. the Daoist classic *Zhuangzi* contrasts the greedy, stupid macaque with the elusive and otherworldly gibbon. This theme culminates in several Tang dynasty (618−906) *fu*, or rhyme-prose compositions, and *sao*, or laments, such as the political allegory by the scholar-official Liu Zongyuan (773−819), which features gibbons "striving after virtue" and "the hateful monkey breed" of pugnacious macaques.[1]

The perception of monkeys as paragons or mirrors of human weakness often varied according to literary genre. Always more desirous of describing good than evil, the ideal rather than the real, writers of classical poetry and prose gave greater prominence to the aristocrats among monkeys—the langurs and most particularly the gibbons—presenting them as models of virtues to which human beings should aspire. More vulgar breeds rarely entered the picture except as a basis of comparison. Wu Yun's "*Fu* on the Dark Gibbon" is representative of this genre:

These gibbons . . . just abandon themselves to their natural manner of living, and therefore they can forever roam about at will in perfect contentment. . . . They are subject to neither taxes or levies, they neither sweat nor toil. . . . I am indeed aware of the fact that man is called the most important of all creatures, but how could one ever gauge the universality of mysterious Nature?[2]

The appeal of the gibbon for the classical writer was not merely moral but to a large degree aesthetic. The graceful movements and distinctive calls of the gibbon inspired many a poetic line: "A gibbon cries in the mist, ah!—a ghost whistles in the rain."[3] The Yangzi gorges were especially famous for the gibbon songs emanating from the steep cliffs lining the river, and these disembodied voices heard by passing travelers came to symbolize the loneliness and melancholy of those far from home: "Wind swift and heaven high—the gibbon's cry is sad."[4] Yet it was potentially the welcome loneliness or detachment of one freed from all worldly enslavements. The thirteenth-century poet-painter Ge Changgeng writes:

In three or five trees the lonely gibbon calls,
One or two calls, yet they pierce my ears.
I thought the gibbon was crying very close to me,
But it was the breeze that carried his call along.
In the gibbon's call there is neither sadness nor hate:
Why should I (unlike him) remain a slave to worldly
 passion?
Late this moonlit night, a chilly breeze rustling in the
 air,
Hearing his call I suddenly feel free of worldly bonds.[5]

The monkeys beloved of scholars and poets were lofty recluses living in the wild, capable of the noblest sentiments even in times of duress.

The monkeys imagined by the novelist and storyteller, however, are far more colorful and down-to-earth—at times greedy, arrogant, wily, and deceitful but nearly always charming and sympathetic. The real-life models for these creations are not so much the elegant gibbons with their mournful song as the trained monkeys—usually macaques—whose clownish tricks provided one of the most popular forms of street entertainment. Designed to amuse as much as instruct, the livelier, less convention-bound literary genres usually endowed the monkey with magical powers, such as super-natural martial skills and the ability to transform itself into many guises. These creatures with their bags of tricks appear in innumerable folktales, such as those included in the Song (960–1279) collection *Taiping guangji*. Here, nuns, wise old men, and beautiful wives turn out to be monkeys in disguise; whether evil or not, they usually get the better of the humans in these stories.

Some of the most enduring monkey images in popular culture were borrowed from Buddhist mythology, many elements of which were incor-porated into Chinese fiction and drama. Most notable is the parable of the greedy monkey, who, in reaching too far for the reflection of the moon in the waters below, falls and drowns. The three-monkey icon—"see no evil, hear no evil, speak no evil"—also has Buddhist origins.

By far the most famous monkey character in popular Chinese literature is the hero of *Xiyu ji*, which recounts the adventures of the super-natural Monkey, culminating in his pilgrimage to India with the monk Xuanzang to bring back the Buddhist scriptures. A complex character, Monkey is first presented as a rebellious figure of immense energy and high spirits, always eager to attain greater power and higher rank, and most of all, eternal life. The Buddha orders Monkey to accompany Xuanzang to India as penance for his misdeeds. The story of the journey becomes, in effect, a chronicle of Monkey's spiritual progress. It is finally Monkey, not Xuanzang, who truly understands how to live according to Buddhist principle. Monkey comes to represent both bad and good, both the wayward human mind when not brought under control as well as the Buddha-nature inherent in all living things. Unlike any other monkey

character before him, he embodies the totality of human nature.

Ubiquitous as they are in the mythology and literature of China, monkeys appear with less frequency and variety in the visual arts. Al-though animals of all kinds ornamented or inspired the forms of the ceremonial bronzes and jades of the Shang (c. 1500–c. 1028 B.C.) and Zhou dynasties, no monkeys appear among the elephants, birds, rhinoceroses, frogs, snakes, and other fauna that enliven these earliest arts of China—perhaps banned from the ornamental repertoire by some ritualistic proscription. Some of the earliest occurrences of a monkey motif are to be found in certain stone tomb engravings of the Han dynasty such as those excavated at Yinan in Shandong province.[6] Here, in some courtyard scenes, monkeys are seen crouching on pavilion roofs. These creatures undoubtedly had a ritual or mythological significance; one wonders if they are assuming their posts as protectors of the household, for in both China and Japan monkeys were said to possess healing powers. Stone monkey-guardian figures appear later at Buddhist sites such as the Kaiyuan temple at Chuanzhou in Fukian province, but monkey images were no more than minor motifs in Buddhist or Han funerary art.[7]

It was during the Song dynasty, which saw the culmination of animal painting, that monkey themes achieved a new status as secular images. The category *lingmao*, "feathers and fur," claimed a small corner in the Chinese painting tradition, eclipsed first by figure painting, then by landscape. But before animal subjects were forever relegated to the minor leagues of profes-sional and academic painters—with certain nota-ble exceptions during the Yuan (1279–1368)—the depicting of monkeys and other animals experienced a brief flowering during the Song.

Chinese artists approached the painting of animals, birds, and flowers very differently from Western painters. Most Western depictions of these subjects fall into the category of still life, or, to use the French term, *la nature morte*, "dead nature," while the Chinese described the rendering of the same themes as *xiesheng*, "drawing life." In the terms themselves the distinction between the two traditions is imme-diately perceived. Most Western still lifes—

beautiful though they may be—portray animate objects turned inanimate through human intervention: flowers cut and arranged in a vase; game shot and bound with rope. Not all living things, of course, are presented in arranged tableaux. Dürer's nature studies, for instance, are amazing in their detail and verisimilitude, his intensely scrutinized flowers and grasses as much the objects of scientific as of aesthetic curiosity.

The Chinese painter's vision of nature was always poetic rather than scientific. In the painting of living things the Chinese artist's task was this: to endow the subject with the breath of life. This striving for an abstraction had little to do with faithfulness to external reality. Rather than record the subtle coloration of feathers, the myriad fine hairs of a fur coat, the intricate patterns of veins in a leaf—painstaking tasks that would distract the artist from primary concerns—the artist sought to distill the inner essence, to describe the "character" of the subjects by understanding them so intimately that he and they become one. Outward appearance was of lesser importance because forms were merely physical containers for the spirit, which was formless. A painter is necessarily tied to the corporeal, that is, to that which can be seen. But the superior artist enabled the spirit to shine through the form by depicting life as a felt sensation rather than envisioned. In this art, beauty exists primarily as the manifestation of a vibrant inner life.

How, then, did the artist capture this spirit or life breath? The third-century scholar Lu Ji described literature—and, by extension, any artistic form—as "the incarnation of many living gestures" and "the embodiment of endless change."[8] Living things must be represented, in other words, as objects of perpetual growth and transformation; painted images must exist as organic entities. The painter cannot capture, of course, an infinite variety of effects. But in the rendering of postures, gestures, and expressions must be implied a latent kinetic energy that provides the potential for limitless change. Animals are often depicted, then, in midactivity or poised for action. Even when still they are not lifeless, for they are vitalized by the more subtle movement of thoughts and emotions at work.

The depiction of sentient beings in solitude finds its highest expression in Chan Buddhist art of the Song dynasty. It was during the Song that animal painters were best able to achieve the ideal of what the art historian Benjamin Rowland referred to as "magic realism." This ability to create a sensation of life declined after the Song, when the best painters were working primarily with landscape themes and animal subjects ranked low in the thematic hierarchy. But it was to reappear at given moments, as in the monkey paintings of Yani.

The best-known Song painter of monkeys was the eleventh-century artist Yi Yuanji, also admired for his representations of deer. He traveled

Figure 1 *Attributed to Yi Yuanji (active eleventh century),* Hundred Gibbons *(detail), copy of eleventh-century hand-scroll, ink on silk. Osaka Municipal Museum.*

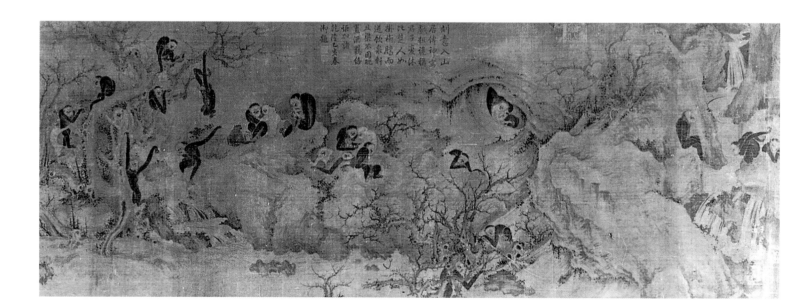

Figure 2 *Attributed to Yi Yuanji (active eleventh century), Gibbon Reaching for Spider, twelfth-century copy?, album leaf, ink on silk. Palace Museum, Beijing.*

widely through the south and gained an intimate knowledge of the habits and characteristics of the animals he was to paint with such sensitivity and understanding. Because of Yi's fame as a painter of gibbons, many unsigned monkey pictures have been attributed to him. Most are later copies, but several may be taken to represent his style, which, in the tradition of Song naturalism, is marked by careful delineation but which aimed finally to capture an essence of spirit rather than a mere realism of appearance.

A faded handscroll in the Osaka Municipal Museum depicting the theme of a hundred gibbons is too worn to give a clear impression of detail or the handling of brush and ink, but it is well enough preserved to convey a sense of how these creatures live in the wild: their playfulness and energy juxtaposed with their intimacy as a family (fig. 1).

A closer view can be seen in a twelfth-century fan-shaped album leaf in the Peking Palace Museum, *Gibbon Reaching for Spider,* which shows a gibbon dangling from a branch in anticipation of a tasty morsel as it stretches its arm to grasp a spider from its web (fig. 2). The artist has truly captured the essence of the creature in its natural surroundings: its graceful yet whimsical appearance, its agility and playful greediness. This painting and others in the tradition—such as an album leaf attributed to Xia Gui (c. 1190–1225; fig. 3) in the Cleveland Museum of Art—represent the best of Song genre painting—so artful in the elegant forms and manipulation of painted and empty space yet so artless in the conveying of the subject.

Yi Yuanji did not paint only elegant gibbons. One of the most delightful compositions attributed to him is *Monkey and Cats* (fig. 4).

Figure 3 *Attributed to Xia Gui (c. 1190–1225), Swinging Gibbon, twelfth or thirteenth century, album leaf, ink and slight color on silk. The Cleveland Museum of Art; John L. Severance Fund* (CMA 78.1).

Figure 4 *Attributed to Yi Yuanji (active eleventh century),* Monkey and Cats, *eleventh century, handscroll, ink and color on silk. National Palace Museum, Taipei.*

Here, a pet monkey clasps a kitten in its arms, while another cat crouches, hissing, nearby. The wonderful expressions of the three animals—the antagonism of the onlooking cat, apprehension of the other kitten, and feigned innocence yet gentleness of the monkey—are unique in the Chinese painting tradition, which rarely allowed for overt expressions of emotion. The subjects of Chinese figure paintings and portraits are usually impassive and restrained. Only the painter of animals could break free of convention and depict all those qualities, such as mischief, greed, tenderness, or despair, which would be unseemly in the portrayal of more formal subject matter.

One of the most effective works in this mode, now in the Tokyo National Museum, is the only extant painting by Mao Song, active in the early twelfth century and also well known for his monkey compositions. His portrayal of an old monkey is not dissimilar to Rembrandt's representations of old age in its sense of weariness and melancholy introspection (fig. 5). Is this the sadness of a monkey long in captivity?

Probably the most famous monkey image in Chinese art is by the thirteenth-century Chan Buddhist monk-painter Muchi, whose expressionistic painting of a mother gibbon holding close her infant now forms part of a triptych preserved in the Daitoku-ji in Kyoto (fig. 6). There are, of course, no Madonna and Child images in Chinese art, with the exception,

Figure 5 *Attributed to Mao Song (active early twelfth century),* A Monkey Seated on the Ground, *twelfth century, hanging scroll, ink and color on silk. Tokyo National Museum.*

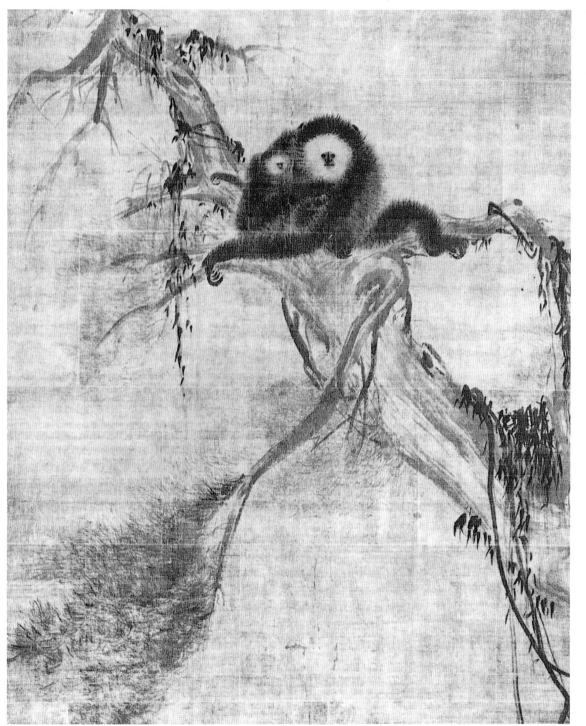

Figure 6 *Muchi (active thirteenth century)*, A Mother Gibbon with Her Baby, *thirteenth century, hanging scroll, ink on silk. Daitoku-ji, Kyoto.*

perhaps, of this extraordinary painting—albeit a secular version—at once abstract and sophisticated in its design and execution and intimate in its tenderness of feeling. Through a most intuitive and spontaneous wielding of the brush Muchi has succeeded in achieving the aim of all Chan art: the expression of a state of higher consciousness. Muchi's impressionistic style, more deeply appreciated in Japan than in his native country, was inherited primarily by the great Momoyama artist Hasegawa Tōhaku (1539–1610) and later Kanō painters such as Kanō Tsunenobu (1636–1713) and his contemporary Kusumi Morikage.

The emphatic brushwork and static poses of Muchi's paintings represent a vivid departure from the naturalist painters' carefully rendered and unselfconscious glimpses of monkeys going about their daily business. Yet both are motivated by the same fundamental belief: that basic truths, whether the law of Buddha or the law of human nature, can be revealed through all natural objects, however humble. These laws can only be known, however, through a close communion with nature, and the immediacy of both form and feeling that thus emerges is what makes Song monkey paintings—and the later paintings of Wang Yani—so special; for the artists, in effect, have transformed themselves into what they are painting. They merit the praise that the great eleventh-century scholar-poet and statesman Su Dongpo bestowed on the Tang horse painter Han Gan (c. 715–after 781): "When Han Gan painted horses, he truly was a horse."[9]

The later history of monkey painting—until the twentieth century—is undistinguished, and its decline derived, in part, from the unitary image of the monkey adhered to in the visual arts. Although they present hints of mischievousness here and there, the best Song painters always idealized their subject; their depictions were the artistic equivalent of the lyric poems celebrating the monkey in its natural environment. Until recently, there were no visual presentations of the monkey's many other faces as perceived in Chinese culture: as superhero, charlatan, entertainer, or mirror of human weakness. Such images were rare in the visual arts because caricature and narrative played little part

Figure 7 *Anonymous,* Gibbons in a Loquat Tree, *fifteenth century, hanging scroll, ink and color on silk. Freer Gallery of Art, Smithsonian Institution, Washington, D.C.*

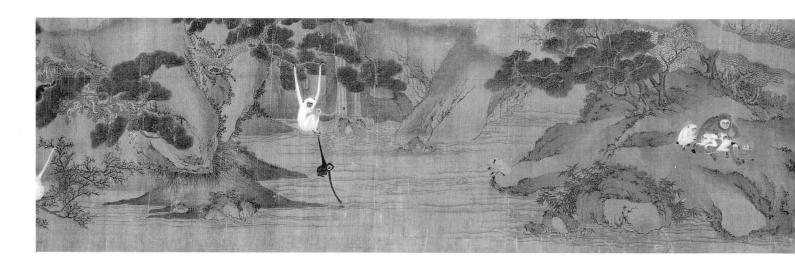

in mainstream traditions, in contrast to the predominant role of fiction and drama in Chinese literature of later periods, where colorful simian characters replaced the ethereal gibbons of Tang poetry. Chinese artists dealt in metaphor rather than action. They aimed to inspire rather than amuse or disillusion.

Such idealizations were effective when based on a keen observation of nature, as in Song painting. Without this direct link to the original models, however, they degenerated into conventional forms—lifeless, affectless, two-dimensional. After the Song, academic and court artists ceased to draw from life but imitated the style of Yi Yuanji, with limited success. By copying art rather than nature they failed to achieve the "magic realism" of the Song (figs. 7–8). These painters often emphasized the picturesque over the moral. One popular theme, for instance, was based on the myth that gibbons hang in a chain from a treetop in order to drink from a river below. Such themes contributed to the largely decorative nature of later monkey painting.

More exuberant monkeys are to be found, in fact, in Japanese art. The monkey was equally important to the cultures of Japan and China, but it never prominently figured as a literary theme in Japan. Although Tōhaku and others imitated the restrained metaphoric images of Muchi, the earthier native artistic traditions allowed for the expression of a broad range of emotions and tended to portray the monkey in more irreverent and down-to-earth terms. Performing monkeys, for instance, appear in *emaki*

narrative handscrolls, ukiyo-e prints, and other genres. Monkeys were also an especially important motif in caricature scrolls. Among the most famous of these are the marvelous twelfth-century *Chōjū Jimbutsu Giga* (Scrolls of frolicking animals and people), which parody human behavior through the antics of animals; here, monkeys fall off stags in slapstick fashion or worship before the altar of frog Buddhas.

In addition to the Muchi-influenced styles and rollicking animal-caricature scrolls, the rise of a naturalistic school of painting during the eighteenth century produced monkey pictures, which, like their Song counterparts, were based on direct observation of nature. The best-known painter of monkeys from this time was Mori Sosen (1747–1821; fig. 9); so in tune was he with his subject matter that legend proclaimed him to be a monkey in human guise. Another painter of this school was Nagasawa Rōsetsu (1755–1799). It is evident from their paintings that Japanese naturalism can often be distinguished from Chinese naturalism of the Song by the presence, however slight, of mannered or stylized touches. The persistence of a lively monkey painting tradition in Japan for more than six centuries depended on the tolerance of eccentricity, which allowed for a variety of expression.

Monkey themes experienced a new life in twentieth-century Chinese art, which was not bound by the idealistic and moralistic framework of earlier traditions. The palpable presence of Gao Qifeng's simian family recalls the vitality of Yi Yuanji's gibbons, but the poetry of the Song

Figure 8 *Anonymous,* Gibbons in a Landscape, *eighteenth century, handscroll, ink and color on silk. Freer Gallery of Art, Smithsonian Institution, Washington, D.C.*

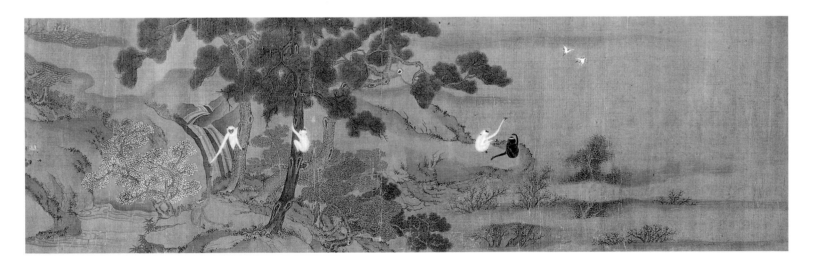

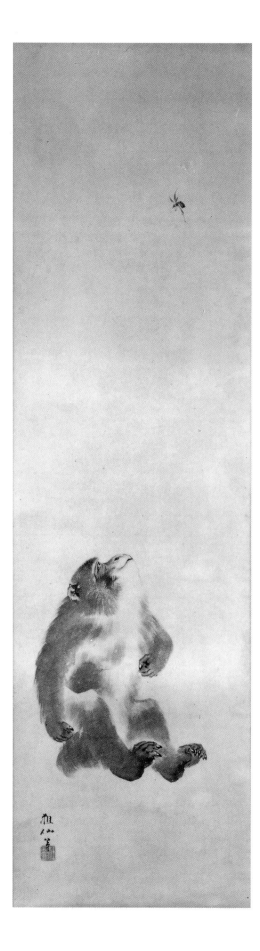

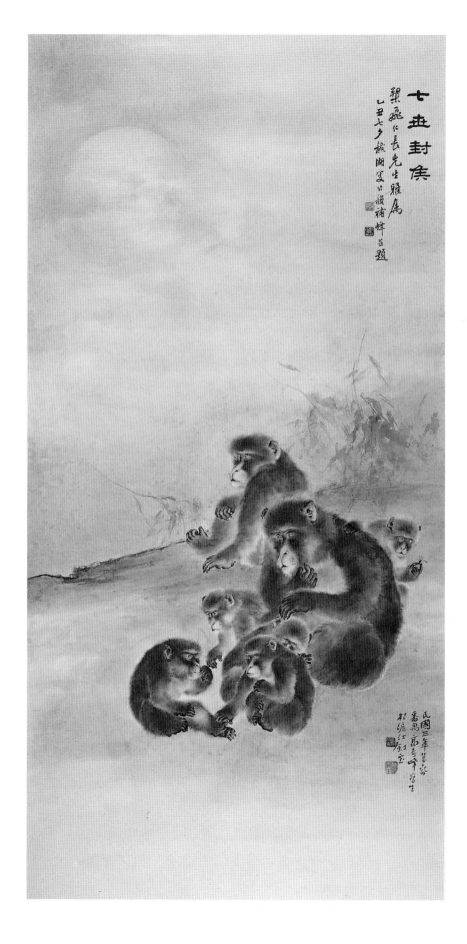

FAR LEFT:
Figure 9 *Mori Sosen (1747–1821), Monkey and Wasp, late eighteenth–early nineteenth century, kakemono, ink and slight color on paper. Shinenkan Collection, Los Angeles County Museum of Art.*

LEFT:
Figure 10 *Gao Qifeng (1889–1933), Seven Monkeys in the Moonlight, 1914, hanging scroll, ink and color on paper. Private collection.*

image has been replaced by a measure of homeliness (fig. 10). Monkey themes also appear in the folk arts. Shadow-puppet and opera companies regularly perform scenes from the vastly popular *Xiyu ji*, and the image of Monkey grasping the peach of immortality figures as a common ornamental motif in folk embroideries and paper cutouts (fig. 11).

There is no doubt, however, that the most vibrant monkey images since the Song belong to Wang Yani. She shares with the Song masters an intimate knowledge of her subject. Like them, she has transformed herself into what she is painting. Her *Hundred Monkeys* (no. 28) or *Let's Have a Party* (no. 12) omit the sylvan setting of Yi Yuanji's *Hundred Gibbons* (see fig. 1) but capture, as does the Song scroll, an unposed moment of monkey life so full of vitality that the participants almost dance off the surface of the paper. These are literally monkey parties in full swing.

The palpable presence of Yani's creatures is yet more keenly felt in those compositions with fewer figures. Compare *Good Harvest!* (no. 30)—a monkey looks up with expectant delight at ripe green melons hanging from a vine—with *Gibbon Reaching for Spider* (see fig. 2); or *Don't Fight!* (no. 18)—a monkey intercedes between two roosters symmetrically poised for battle—with *Monkey and Cats* (see fig. 4). Yani's brushwork is more abstract than the earlier painter's, but both artists have captured the moment before action; one could almost be watching a film rather than looking at still images. And through the skillful presentation of gesture and posture, one perceives the character

traits of these monkeys as surely as if they were human.

This Is for Mommy (no. 7) makes an interesting comparison with Muchi's depiction of a mother gibbon with child (see fig. 6). Yani's painting does not bear the same spiritual weight as the Chan image, whose monkeys embody cosmic principles of unity and harmony. But in its own way *This Is for Mommy* explores the intimacy between mother and child as closely as the earlier painting. It depicts one of those rare and touching moments of childish generosity in which a monkey child playfully offers a piece of fruit to its mother, on whose back it perches. The affectionate irreverence for the subject and down-to-earth tone are similar to those in Japanese monkey images. The note of whimsy is to be expected, of course, from a child, but she shares with Japanese artists as well the sense that there is a story to be told. Yani creates painted scenarios: the viewer can easily imagine the scenes before and after the one she has presented.

Yani's kinship to Muchi lies not so much in the choice of theme as in her fluid, impressionistic style. In the calligraphic intensity of her brushwork, the boldness of her compositions, and the abbreviation of form, she follows in the expressionistic tradition of the great monk painters, from Muchi to the two seventeenth-century individualist artists Shitao (1630–c. 1717) and

Figure 11 *Anonymous, cutout, paper. Collection of Nancy Zeng Berliner and Zeng Xiaojun (from Nancy Zeng Berliner,* Chinese Folk Art *[New York: New York Graphic Society, 1986], fig. 58).*

Zhu Da (1626–1705), whose legacy was inherited in the twentieth century by such painters as Qi Baishi (1863–1957) and Fu Baoshi (1905–1965)—none of whom painted monkeys. Yani's stylistic affinity to such a painter as Shitao comes not from a familiarity with his work but from her intuitive understanding of what Shitao called the principle of "one-stroke painting": "By one spontaneous movement of the hand, mountains, rivers, human beings, birds, animals, plants, trees . . . will assume form in accordance with their characteristics; they will all be drawn as if alive, and their meaning will be revealed."[10]

The success of Yani's art lies in her synthesis of many elements. Her paintings cannot be defined by single terms; they are not simply naturalistic or expressionistic or whimsical. Yani shares with Song painters a keen grasp of the monkey spirit; this she combines with an acknowledgment of both the virtues and foibles of her childlike subjects, which are presented with an exuberance and humor similar to that of Chinese popular fiction or the Japanese *emaki*. The freshness and energy of the subject are expressed through a bold, virtuoso brush style that succeeds in the great Chinese individualist mode. In these ways Yani has continued the traditions of her predecessors.

Yet, in the end, Yani's monkeys are images without precedent. Like the Song monkeys, they are closely observed from life, but in her emphasis on their childlike nature Yani portrays these creatures as if we were seeing them for the first time. And we are: who else has painted monkeys fishing, drawing, or playing tug-of-war? Few artists have succeeded in authentically recapturing experiences of childhood. Wang Yani, precocious in technique but innocent in spirit, is one of them.

NOTES

1. Quoted in Robert Hans van Gulik, *The Gibbon in China: An Essay in Chinese Animal Lore* (Leiden: Brill, 1967), p. 58.

2. Quoted in ibid., p. 55.

3. This line by the Tang poet Li Po is quoted in Edward H. Schafer, *The Vermilion Bird: T'ang Images of the South* (Berkeley: University of California Press, 1967), p. 231.

4. This line by the Tang poet Du Fu is quoted in Richard Edwards, "Hsia Kuei or Hsia Shen?" *Bulletin of the Cleveland Museum of Art* 73, no. 10 (December 1986): 401.

5. Quoted in van Gulik 1967, p. 91.

6. See Zeng Zhaoyue et al., *Yinan gu huaxiangshi mu fajue baogao* (Report on the excavation of the ancient tomb with pictorial stones in Yinan) (Beijing: Bureau of Cultural Relics, Ministry of Culture, 1965).

7. See Gustav Ecke and Paul Demiéville, *The Twin Pagodas of Zayton: A Study of Later Buddhist Sculpture in China*, Harvard-Yenching Institute Monograph Series (Cambridge, Mass.: Harvard University Press, 1935), 2:35 and pl. 26.

8. See *Early Chinese Texts on Painting*, comp. and ed. Susan Bush and Hsio-yen Shih (Cambridge, Mass.: Harvard University Press, 1985), p. 8.

9. Quoted in Osvald Sirén, *The Chinese on the Art of Painting* (1936; New York: Schocken, 1963), p. 56.

10. Quoted in Osvald Sirén, *Chinese Painting: Leading Masters and Principles*, 7 vols. (1956–58; New York: Ronald Press, 1973), 5:171.

Wang Yani
and Contemporary
Chinese Painting

JULIA F. ANDREWS

Wang Yani's paintings first came to national attention in China when she was four years old. Typical of the work that amazed her elders is a painting of 1979, *Gathering Loquats* (fig. 1), made as a gift for a Shanghai artist.[1] In the upper half of the picture Yani painted a richly laden loquat tree, the trunk executed in a single arm motion with a large wet brush. The scraggly branches are painted with black ink strokes, some of which trail off in a dry and scratchy manner traditionally known as *feibai,* "flying white." The roundness of the luscious fruit is described by superimposing several layers of transparent and semitransparent pigment. Slight variations in hue are used to differentiate the fruit at different stages of ripeness and create a pleasing contrast with the wildness and linearity of the branches on which they hang.

The focus of the picture is the intense concentration with which two greedy monkeys in the lower section of the picture go about collecting and dividing the ripe fruit. They are depicted with a few simple strokes. The natural tendency of the ink to bleed on the unsized paper is skillfully manipulated to convey a marvelous sense of the monkeys' furry texture. Furthermore, the contrast between the wary calm of the monkey on the left, who possesses the fruit, and the rather frantic activity of the monkey on the right, who wants to eat it, inspires quiet amusement. Although the painting may have technical flaws when judged by adult standards, such as the somewhat awkward quality of the blue and gray rock in the center of the picture, Yani's artistic vocabulary by the age of four was already the language of traditional Chinese painting. Moreover, the uninhibited techniques and fresh themes in Yani's early monkey pictures make them more compelling than the highly conventionalized works painted by many older artists during the same period.

Some Chinese artists of the past have specialized in paintings on a single theme. Symbolic flora such as plum blossoms, bamboo, and pine trees have been thoroughly explored by generations of literati painters, but more-eccentric subjects have come to be associated with specific artists.[2] The thirteenth-century Chan Buddhist painter Wen Riguan (died c. 1295), for example,

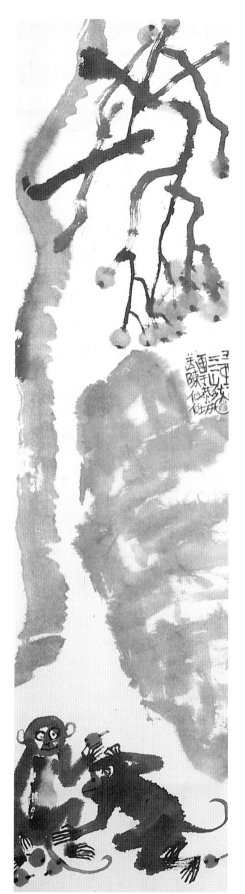

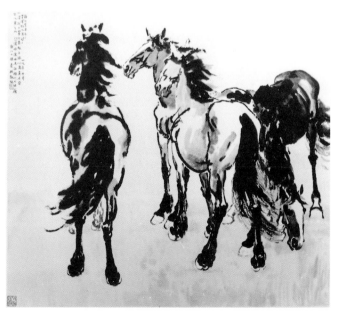

Figure 1 *Wang Yani, Gathering Loquats, 1979, hanging scroll, ink and color on paper. Private collection.*

TOP:
Figure 2 *Xugu (1823–1896),* Goldfish, *from* Album of Miscellaneous Subjects, *1895, album leaf, ink and color on paper. Shanghai Museum of Art.*

BOTTOM:
Figure 3 *Xu Beihong (1895–1953),* Horses, *1940 (from* Contemporary Chinese Painting, *ed. Hua Junwu [Beijing: New World Press, 1982], pl. 3).*

Figure 4 *Huang Zhou (born 1925),* Donkeys, *ink and color on paper. Private collection.*

used bold, wet ink strokes to paint pictures of grapes.[3] The nineteenth-century Buddhist monk Xugu (1823–1896; fig. 2), who lived in Shanghai, is famous for his depictions of squirrels and goldfish.[4] Qi Baishi (1863–1957), the most revered Chinese artist of the twentieth century, painted a variety of subjects but is best known for his pictures of prawns.[5] The prominent art educator Xu Beihong (1895–1953; fig. 3) specialized in painting horses.[6]

Many older artists in China today place particular emphasis on the expressive possibilities of a narrowly defined genre. The Beijing painters Huang Zhou (born 1925; fig. 4) and Wu Zuoren (born 1908; fig. 5) are known for their donkeys and camels respectively. Thus, while Wang Yani's early concentration on monkey paintings may be associated with the limited interests, experience, or technical skill of a small child, such a thematic limitation is widely seen in works of major Chinese masters of our time.[7]

Yani's painting technique, in which wet ink or puddled color defines three-dimensional forms, has a long history in Chinese flower painting. The Ming dynasty artist Sun Long (active late fifteenth century?) used subtle color washes to describe a wide range of subjects, including frogs and insects as well as plants.[8] The early Qing period painter Zhu Da (1626–1705; fig. 6) achieved some of the most expressive effects in the history of Chinese painting in his puddled ink depictions of large-eyed fish and birds. Not until the late nineteenth century, however, with the works of Shanghai school artists, among

Figure 6 *Zhu Da (1626–1705),* Mynah Birds and Rocks, *hanging scroll, ink on satin. Nelson-Atkins Museum of Art, Kansas City (Nelson Fund).*

Figure 5 *Wu Zuoren (born 1908),* Camels, *1977 (Zhong-guohua [Chinese painting], comp. Zhongguo guoji maoyi cujin weiyuanhui and Renmin meishu chubanshe [China Council for the Promotion of International Trade and People's Fine Art Publishing House] [Beijing: Renmin meishu chubanshe, 1980], p. 34).*

whom Ren Yi (1840–1896; fig. 7) and Xugu are the best known, was this technique regularly applied to bird and animal painting. An extremely versatile artist who painted figures, birds, flowers, and animals, Ren Yi made superb use of wet brushstrokes on highly absorbent paper to define the anatomical structures of rare birds and beasts of burden.[9]

In traditional Chinese painting ink and color usually were applied one at a time. The artist waited until each layer had dried before applying the next, so that the colors would not become muddied.[10] Ren Yi's work marks the culmination of a new tendency that had been slowly developing since the eighteenth century of combining different pigments and ink so that forms were defined by richer and more varied colors.[11] The use by Shanghai school artists of complex mixtures of paint is generally similar to techniques employed by Western watercolor painters, and it is probably not coincidental that the technique developed most fully in the international city of Shanghai.

Ren Yi's style of painting spread throughout China and developed in various directions in later years. In flower painting his student Wu Changshi (1844–1927; fig. 8) created an expressive mode of execution combining extremely wet, puddled strokes of pigment or ink with dry, rapid strokes of "flying white."[12] This bold and uninhibited mode of flower painting was perpetuated in the People's Republic of China by such Wu Changshi students as Pan Tianshou (1893–1971; fig. 9) in Hangzhou and Wang Geyi (1897–1989; fig. 10) in Shanghai. Pan Tianshou, in particular, developed new and striking compositions, sometimes with profound emotional resonances. Working in a similar vein in Beijing, Li Kuchan (1898–1983; fig. 11) specialized in birds of prey.

The loose, spontaneous style characteristic of paintings by Wu Changshi, Pan Tianshou, Wang Geyi, Li Kuchan, and Wang Yani is popularly known as *xieyi*, "idea writing," as opposed to *gongbi*, "skillful brush," a term that describes paintings executed in the delicate color and outline manner once so highly prized in the imperial atelier. Qi Baishi, the most highly praised traditional master of twentieth-century China, excelled in both styles. He is best known,

Figure 7 *Ren Yi (1840–1896),* from Album of Figures, Flowers, and Birds, *1881–82, album leaf, ink and color on paper. Palace Museum, Beijing (from* Ren Bonian renwu huaniao ce *[Ren Bonian's album of figures, flowers, and birds] [Shanghai: Shanghai renmin meishu chubanshe, n.d.]).*

Figure 8 *Wu Changshi (1844–1927),* Blooming Flowers, *1916 (from* Zhongguohua *1980, p. 29).*

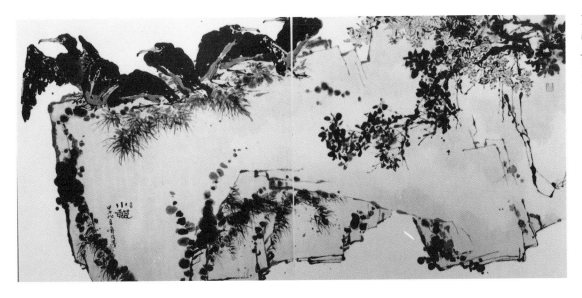

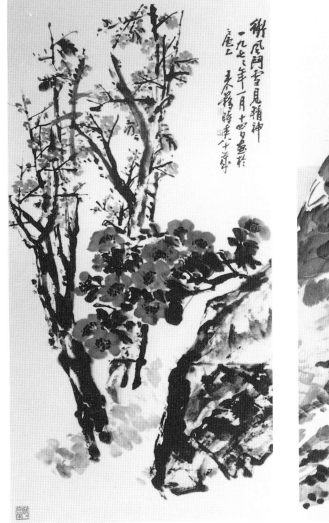

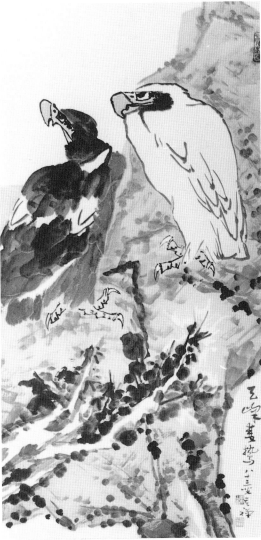

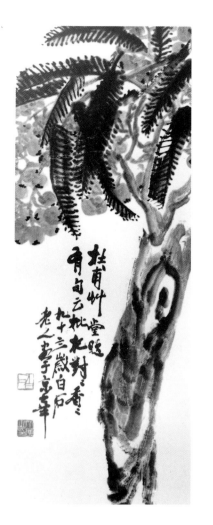

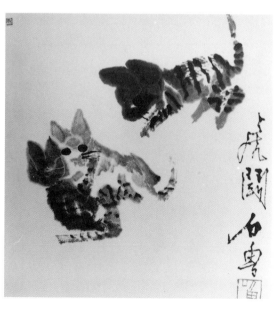

however, for the sophisticated simplicity he achieved in his *xieyi* paintings.

A painting of Qi Baishi's ninety-fourth year bears some similarities to Yani's *Gathering Loquats,* not the least of which is the subject of the fruit-laden loquat tree (fig. 12). Furthermore, for each artist, age is an issue. Qi Baishi identified himself in his colophon as "ninety-four-year-old Baishi," using a childlike and unconventional Chinese character 亖 for "four," instead of the more usual 四. Yani uses the same character on this painting and in other inscriptions written during her fourth year. Whereas Qi Baishi's apparent naïveté belies an extraordinary technical facility, viewers may find a directness and charm in both the works of the prodigiously aged Qi Baishi and the prodigiously young Wang Yani.

Most early twentieth-century *xieyi* style painters concentrated on botanical subjects. Artists trained in Western art, however, such as Xu Beihong (see fig. 3), who studied in France but

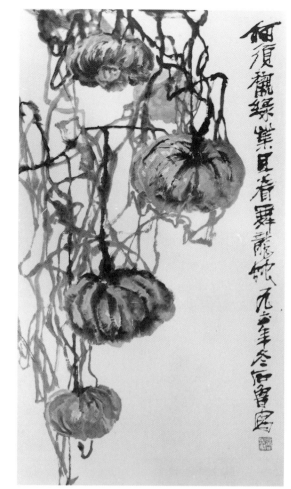

was an ardent admirer of Ren Yi, adapted *xieyi* techniques for a new kind of animal painting.[13] Horses became for Xu Beihong both a nationalistic symbol of China's strength and a vehicle for his artistic goal of combining the best of Eastern and Western art.[14] Xu Beihong's Belgian-trained student Wu Zuoren has been known since the late 1950s and early 1960s for paintings of camels that evoke the effects of Ren Yi in a Westernized spatial setting (see fig. 5).

During the late 1950s and early 1960s artists such as Shi Lu (1919–1982) largely abandoned socialist realism to paint ordinary scenes from daily life in the *xieyi* manner (figs. 13–14). Shi Lu's art-historical influence extends beyond the painted image. Recent appreciation for his elegantly eccentric inscriptions has coincided with a revival among Chinese artists of unconventional calligraphic techniques.[15]

A somewhat different example of eccentric writing appears on *Rain on the Li River*, painted by Li Keran (born 1907; fig. 15) in 1962. The artist used pale, wet ink for both the colophon and misty mountains. The inscription is thus filled with accidental, uncontrolled effects that give the amusing but presumably false impression that the artist had been drenched by a sudden shower as he wrote. Wang Yani's childish handwriting, through no plan of her own, has parallels in the work of progressive Chinese artists of the periods immediately preceding and following the Cultural Revolution, some of whom expressed strong primitivist inclinations.

Recognition of Yani's Talent

In 1976, when Wang Yani was one year old, an event of profound importance occurred—the death of Mao Zedong. Yani's earliest artistic efforts, at the age of two and one-half, thus corresponded with the first tentative steps taken by the Chinese art world in the uncertain environment of post-Mao culture.[16] Public recognition and appreciation of Wang Yani's remarkable talent may only have been possible because of the gradual loosening of government controls over art that followed Mao's death. Her emergence coincided with the severe disillusionment of many older artists in socialist realist art and with a desire to promote experimentation and

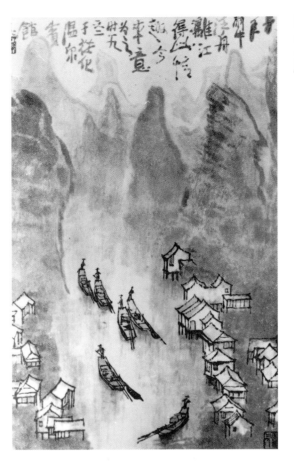

Figure 15 *Li Keran (born 1907)*, Rain on the Li River, *1962 (from* Meishu, *no. 1* [*1963*]: 62).

exploration of other forms. The paintings of a child who knew nothing of politics offered a fresh vision that many artists sought in their own work.

During the last decade of his rule, 1966–76, Mao Zedong served not only as chairman of the Chinese Communist party but also as the spiritual leader of the Great Proletarian Cultural Revolution. This movement ruthlessly suppressed many of China's greatest artists and artistic traditions in the name of revolutionary culture. Subjects and styles for art were strictly limited by the administrators of the Cultural Revolution government, foremost of whom was Mao's wife, Jiang Qing.

Youngsters who painted during this period, like all artists, were rigidly regulated in the subjects and styles permitted to them and particularly by the requirement that all art be suitable to political interpretation. Small children might be encouraged to draw pictures of Tian'an Men, the old palace gate in central Beijing on

top of which Chairman Mao had declared the establishment of the People's Republic in 1949, from which he had greeted the Red Guard in 1966, and which was eulogized in the children's song "I Love Tian'an Men." As they grew older they would be encouraged to copy the approved propaganda paintings of the period, works that were designated as models by the revolutionary committee in charge of administering China's art.

Instructions were available as to the correct pigments and combinations of pigments to use in copying the models; very frequently, a student began by drawing a pencil grid over a model so as to enlarge it flawlessly. Needless to say, this didactic method did not inspire great creativity.

Mature artists were similarly restricted. Most were condemned to extended periods of heavy manual labor, which left little time for painting. Some were allowed to paint, but their works, like those of the children, were required to follow strict thematic and stylistic standards. Others spent their days painting billboard-sized enlargements of regulation pictures depicting the revolutionary career of Chairman Mao.

A brief but ultimately painful respite was given in 1972 as China began a tentative opening to the West. On the orders of Premier Zhou Enlai some older artists were requested to produce decorative paintings for use in the hotels, train stations, and airports frequented by foreign visitors. The opportunity to paint works intended to be beautiful rather than political was met with great enthusiasm by some artists. Unfortunately, they became the victims of a high-level power struggle when Jiang Qing organized the Beijing *Black Painting Exhibition* of 1974 in symbolic opposition to Zhou's policies. The Beijing event, accompanied by public meetings to criticize and discredit artists who had participated in the creation of nonpolitical pictures, was soon emulated by the leadership in Shanghai and other cities, who castigated an even wider spectrum of artists.[17] The victims were effectively prohibited from activity in the Chinese art world from 1974 until as late as 1979.[18]

It was thus with great hope and relief that most older artists greeted the arrest of Jiang Qing in 1976. Nevertheless, change in the art

world did not come quickly, for it was unclear how much deviation from established standards would be permitted. Major national exhibitions in Beijing tended to be filled with socialist realist paintings offering new iconography but very little change in style. Portraits of the chairman of the Chinese Communist party, Hua Guofeng, were simply substituted for those of the deceased Chairman Mao. Official art journals continued to publish socialist realist works in the Cultural Revolution style.

Elsewhere in China the official criticisms of certain policies of the Cultural Revolution inspired tentative explorations of nonpolitical art by local artists. Late in 1976, for example, the Xujiahui District Cultural Palace in Shanghai made the daring decision to hold an unofficial exhibition of watercolors.[19] A young staff artist and a few of his artist-friends, fired with enthusiasm, scoured the metropolitan area for talented artists willing to participate. The exhibition, held in January 1977, included landscapes, still lifes, and figure studies by elderly artists such as Guan Liang (1900–1986; fig. 16) and Zhu Qizhan (born 1892; fig. 17), whose typical works are here illustrated, as well as many paintings by young artists. Because the exhibition was unofficial, publicity was spread by word of

Figure 16 *Guan Liang* (1900–1986), A Scene from "The Wild Boar Forest," 1980 (*from* Contemporary Chinese Painting 1982, *pl.* 27)

mouth, but it was extremely well attended nevertheless.[20]

To eyes jaded by the propaganda paintings of the Cultural Revolution, the exhibited works appeared fresh and new, even though many were executed in Western fashions almost a hundred years old or in relatively traditional Chinese styles. When the Shanghai authorities failed to criticize the organizers of the unsanctioned, nonpolitical exhibition, other unofficial painting displays followed. One such exhibition, held at the Luwan District Cultural Palace in the spring of 1977, included works by several older artists who had been out of favor since the antirightist movement of 1957.

These local tests of the limits of expression permitted in art after the Cultural Revolution occurred all over China, and on the basis of the momentum they established, 1979 was a year of great artistic activity. Explorations of alternatives to the formularization of Cultural Revolution art were the order of the day. Western styles, ranging from those of eighteenth-century French academicism to twentieth-century cubism, simultaneously burst into the open. As a reaction to the highly political ink and color figure paintings of 1966–76, relatively traditional pictures of birds, flowers, animals, bamboo, and landscapes poured forth from the brushes of older artists.

Wang Yani's art spoke the same language as the paintings of the older artists but with greater freshness. In her fascination with monkeys, the most anthropomorphic of animals, Yani recorded the ordinary pleasures of daily life. Such simple themes as eating, drinking, and friendship were treated naïvely but provided welcome relief for battle-weary older artists.

In the first few years after the Cultural Revolution art teachers and professors were inspired with optimism not only for their own artistic endeavors but for the future of the younger generation. In her native Guangxi, Yani came to the attention of an art educator who had been trained in Shanghai.[21] He sent some of her pictures to Meng Guang, a friend at the Shanghai Art School who was particularly interested in encouraging the artistic development of the very young and in recognizing the child prodigy at an early stage. Through his efforts

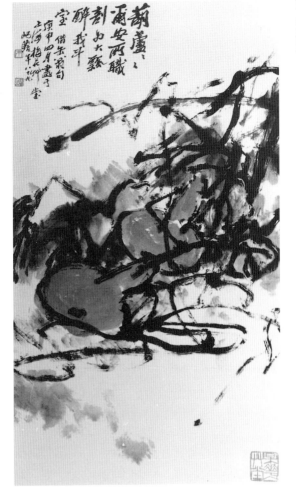

Figure 17 *Zhu Qizhan (born 1892),* Bottle Gourds, *1979 (from* Contemporary Chinese Painting *1982, pl. 26).*

Yani visited Shanghai and called on many senior artists. Although there is no indication of mutual artistic influence, it is interesting that two of the artists she met, Guan Liang and Zhu Qizhan (see figs. 16–17), are famous for painting styles that reject both the realism associated with China's modern political art and the refined techniques of traditional Chinese painting. After decades of resisting conventional styles, the paintings of their advanced years possessed some of the fresh, naïve, and childlike effects that came naturally from Yani's brush.

Through the efforts of her admirers in Shanghai, Yani was invited to mount a solo exhibition in Fuxing Park and to give painting demonstrations, including one at the International Club. Thus, at the age of four, Yani became known to the Chinese art world and to the foreign diplomatic community alike.

Yani's Landscapes

The modern *xieyi* tradition, which may be traced to the late nineteenth-century Shanghai painters, places great emphasis on the controlled accidents that occur when ink and pigment are combined on the brush or applied one after the other on wet paper. This was Wang Yani's artistic birth-right, as we have seen, but in her more recent works she has expanded the scope of *xieyi* beyond animal painting and into the realm of the landscape.

One of the goals of Chinese landscape painting after 1949 has been to free the genre from what was believed to be an excessive emphasis on standard techniques developed in earlier periods. In particular, artists were encouraged by art administrators to develop new and more realistic ways of using brush and ink and to avoid using conventionalized brushstrokes associated with artists of the past.

Another innovation in contemporary Chinese landscape painting is in subject matter. Since the early 1950s artists have been urged to paint scenes from their own experience rather than the imaginary or conventionalized landscapes so common in earlier periods. As an aid to their accurate portrayal of the natural beauties of their homeland, painters have been sent at government expense to visit China's scenic sites. Of the three most frequently painted, the Yangzi gorges, the Huangshan mountain range, and the Li River near Guilin, the latter, one of China's most beautiful places, is in Yani's native province.

The artist who has best succeeded at the task of creating a totally new landscape style is Li Keran, a southerner who has lived in Beijing for many years. After experimenting with a very linear, sketchlike landscape style in the 1950s, he began exploring use of the ink-wash technique that he had long used in his *xieyi* buffalo paintings to depict the Chinese landscape. In so doing he not only invented a new technique for painting mountains and streams but created unusually strong effects of reflected light and an unprecedented sense of drama (fig. 18).

As she has grown older Yani has turned to painting the beauties of the Li River landscape near her home. In these more recent works the compositional facility she demonstrated in early childhood has served her well as she shifts from

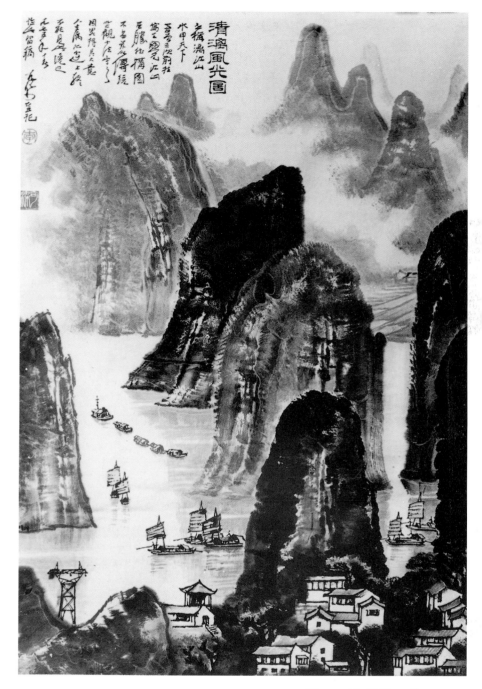

Figure 18 *Li Keran (born 1907)*, Scenery of the Li River, *1975 (from Zhong-guohua 1980, p. 76)*.

48

the shallow spaces of her monkey pictures to landscape panoramas (see no. 37). Although her landscape paintings are characteristically fresh, particularly in their exuberant use of color, it is only natural that as she sees more paintings by contemporary artists some of her work comes more closely in line with the paintings of her elders.

The influence of Li Keran has been so widespread in contemporary China that his innovations have become conventions. Moreover, because many of his most successful works have been devoted to the scenery of the Li River region (see figs. 15, 18), his work is an unavoidable prototype for any artist who approaches the region's beauties. Yani, as she transformed her *xieyi* method of depicting flowers, fruit, and animals into a landscape technique, has naturally fallen into the tradition of Li Keran and his followers.

In early landscapes such as *You Can Never Finish Painting the Mountains and Rivers in Guilin* (no. 37), completed when Yani was eight, she undertook a broad panorama with mountains defined in the wet *xieyi* manner. Yani's *Small Village* (no. 44) includes a device favored by Li Keran: the white walls of village dwellings are emphasized by their textural contrast with the dense, wet ink that surrounds them.

Yani's use of color is very different from that of Li Keran, who principally relies on ink rather than pigment to achieve his rich effects. Just as Qi Baishi's fruit, flower, and still-life paintings provide useful insights into Yani's monkey pictures, so do Qi Baishi's personal and rather playful landscapes illuminate Yani's paintings in this traditional genre. Although it may be inappropriate to attribute direct influence on Yani from an artist who died almost twenty years before she was born, traces of Qi Baishi's style are identifiable in many of her landscapes. For

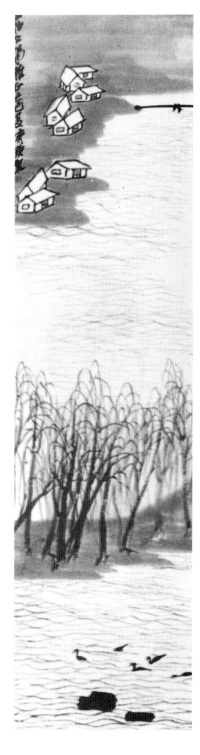

Figure 19 *Qi Baishi (1863–1957)*, Landscape, 1929 (from Qi Baishi shuhua ji: Beijingshi wenwu shangdian cangpin *[Painting and calligraphy by Qi Baishi: The Collection of the Beijing Municipal Cultural Relics Store] [Beijing: People's Art Press, 1986], no. 2).*

example, while the mountain forms in Yani's *Pretty Riverbanks* (no. 43) are closely related to those in Li River landscapes by Li Keran, the painting's compositional unity and pictorial appeal may be attributed to the painting's surface-covering wave patterns. Qi Baishi made brilliantly effective use of this same motif in his *Landscape* (fig. 19), contrasting the linear textures of the waves with the flat washes of color with which he constructed the riverbanks.

Yani's landscapes of the Li River make clear that she is in the mainstream of contemporary Chinese painting and is developing her own voice. At this stage in her career her work possesses a youthful lack of inhibition, which may enrich the tradition from which it springs. It is tempting, but perhaps unnecessary, to speculate on the future course of Yani's painting. The works presented here, landscapes and monkey scenes alike, are already a twofold stimulus to the viewer's eye and mind. Most obvious is that Yani's art presents to our view something of her world and daily life, her interests and travels. Equally intriguing, especially to the historian, is that her ever-widening artistic interests allow us to see with fresh eyes important artistic moments of twentieth-century China. The contributions of master artists of earlier generations are selected and filtered to a unique purity through the eyes of a child.

NOTES

1. I wish to thank my husband, Han Xin, for first introducing me to Wang Yani's paintings and for research assistance, particularly in arranging interviews. The painting reproduced in figure 1 is dedicated to the oil painter Chen Yifei, who now lives in New York.

2. For some examples of symbolic imagery, specifically plum blossoms, see Maggie Bickford, *Bones of Jade, Soul of Ice: The Flowering Plum in Chinese Art* (New Haven: Yale University Press, 1985).

3. For a list of Wen Riguan's grape paintings see James Cahill, *An Index of Early Chinese Painters and Paintings: T'ang, Sung, And Yüan* (Berkeley: University of California Press, 1980), p. 186.

4. For good examples of Xugu's work see *The Shanghai Museum of Art*, ed. Shen Zhiyu (1981; New York: Abrams, 1983), pls. 153−54, and François Fourcade, *Art Treasures of the Peking Museum* (New York: Abrams, n.d), pl. 35.

5. See Shen 1981, pl. 163.

6. For another example see Shen 1981, pl. 165.

7. English-language publications that survey major trends in twentieth-century Chinese painting include: Michael Sullivan, *Chinese Art in the Twentieth Century* (Berkeley: University of California Press, 1959); Chu-tsing Li, *Trends in Modern Chinese Painting: The C. A. Drenowatz Collection* (Zurich: Artibus Asiae, 1979); Arnold Chang, *Painting in the People's Republic of China: The Politics of Style* (Boulder, Colo.: Westview, 1980); *Contemporary Chinese Painting: An Exhibition from the People's Republic of China*, ed. Lucy Lim (San Francisco: Chinese Culture Foundation of San Francisco, 1983); Joan Lebold Cohen, *The New Chinese Painting: 1949−1986* (New York: Abrams, 1987); Robert Hatfield Ellsworth, *Later Chinese Painting and Calligraphy, 1800−1950* (New York: Random House, 1987); Mayching Kao, ed., *Twentieth-Century Chinese Painting* (Hong Kong: Oxford University Press, 1988); Ellen Johnston Laing, *The Winking Owl: Art in the People's Republic of China* (Berkeley: University of California Press, 1988).

8. For a discussion of Sun Long see James F. Cahill, *Parting at the Shore: Painting of the Early and Middle Ming Dynasty, 1368−1580* (New York and Tokyo: Weatherhill, 1978), pp. 136−38.

9. For other good examples of Ren Yi's work see Shen 1981, pls. 157−58.

10. For a discussion of traditional inks and pigments see Jerome Silbergeld, *Chinese Painting Style: Media, Methods, and Principles of Form* (Seattle and London: University of Washington Press, 1982).

11. Several eighteenth-century Yangzhou artists, including Jin Nong, Luo Ping, and Li Shan, experimented with nontraditional uses of color. For some of their work see Ju-hsi Chou and Claudia Brown, *The Elegant Brush: Chinese Painting under the Qianlong Emperor, 1735−1795* (Phoenix: Phoenix Art Museum, 1985), and *Painting by Yangzhou Artists of the Qing Dynasty from the Palace Museum* (Hong Kong: Art Gallery, Institute of Chinese Studies, Chinese University of Hong Kong, 1985). For a similar opinion see Ellsworth 1987, vol. 1, p. 8.

12. For other works see Shen 1981, pls. 159−62, and Fourcade n.d., pl. 50.

13. In addition to adopting some stylistic characteristics of Ren's portraits for his own, Xu, in 1950, wrote a laudatory biographical account of Ren Yi. See *Ren Bonian yanjiu* (Research on Ren Bonian), ed. Gong Chanxin (Tianjin: People's Art Press, 1982), pp. 1−3; reprinted from *Ren Bonian huaji* (Collected paintings of Ren Bonian), ed. Chen Zongrui (Hong Kong: N.p., n.d.).

14. The painting illustrated in figure 3 was created to commemorate a victory for the Chinese military forces in the war against Japan. See Li Song, ed., *Xu Beihong nianpu: 1895−1953* (Chronology of Xu Beihong: 1895−1953) (Beijing: People's Art Press, 1985), p. 79.

15. This trend is widespread not only in the People's Republic of China but also in Taiwan and Hong Kong. For two such examples, see Cohen 1987, figs. 98, 228.

16. Because at least two accounts have been published in English about Wang Yani's relationship with her artist-father, Wang Shiqiang, his influence will not be discussed here. See Wang Shiqiang, "Yani as I See Her," in *Wang Yani: Pictures by a Young Chinese Girl* (Munich: Prestel-Verlag, 1987), pp. 15−24, and Huang Qingyun, "The Heart of a Child," in *Yani's Monkeys*, 1st ed., ed. Shufen Li and Cheng'an Jiang (Beijing: Foreign Languages Press, 1984), n.p.

17. Some of the artists in the Shanghai *Black Painting Exhibition* were not involved with the hotel-decoration projects, such as Han Xin, who was nineteen at the time (interview with author, January 1988).

18. For later criticisms of the *Black Painting Exhibitions* see articles published in *Meishu* (Art), nos. 1−2 (1978).

19. Information on the Shanghai exhibition activities of 1976 and 1977 is from interviews with Han Xin, January 1988.

20. An "unofficial" exhibition in the context of the Chinese art world of the late 1970s refers to an exhibition that indeed had approval from at least one local government official, the person who had authority over the building used for the exhibition. The event was not initiated by higher authorities and may not necessarily have been approved by them.

21. Meng Guang, Shanghai art professor, telephone interview with Han Xin, March 21, 1988.

Wang Yani has been triply blessed: first, with an extraordinary gift for painting; second, with parents who cherish her special talents and are committed to their development; and third, with living in a culture that reveres the arts and values those who are able to give voice to expressions of the aesthetic. The story of Yani's remarkable artistry is the story of how these three blessings serendipitously coincided and then were carefully harnessed to yield a rare and wonderful phenomenon: a prodigy who gives life to a child's images with the brush of a skilled adult.

Child prodigies have dazzled and astounded the world for millennia. In earlier times in the Orient, they were considered to be "superpower children" bestowed with exceptional talents by the gods. In Western cultures, prodigies were associated with a tradition of prophecy and portent. Manifesting abilities "out of the usual course of nature," prodigies were thought to signal impending changes in world order. Modern prodigies are no longer considered to be messengers from the gods, but even without the power of divine intervention their achievements are still awesome and sometimes a little frightening.[1]

Young Yani painted furry monkey babies riding happily atop striding parents at an age when most children can barely draw recognizable figures. Like other children, she had first relied on an all-purpose "tadpole formula"—a large head with legs trailing down—to depict monkeys, cats, and people, but she quickly became frustrated and annoyed that her pictures bore no resemblance to real creatures. With concentrated determination, close critical observation, and a sure hand, Yani managed to condense many years of artistic development into less than twelve months' time. We can speculate about factors contributing to her rapid mastery, but we do not know for sure (and probably never will) how this three-year-old girl learned to coax such mature images from her brush and paper. Some of the deepest secrets of Yani's creativity defy explanation, only to be glimpsed in the works themselves. Nonetheless, exploring some of the dimensions of her talent neither does disrespect to the enormity of her gift nor renders it any less awesome or marvelous: the night sky is no less beautiful because

Wang Yani
Gifts Well Given

LYNN T. GOLDSMITH AND
DAVID HENRY FELDMAN

astronomers seek to discover the laws governing celestial movement. In fact, when one thinks about the complexity and delicacy of the process involved in the realization of a talent like Yani's, her paintings should seem all the more wonderful.

Perhaps it is surprising that the long and honored tradition of painting in China has yielded remarkably few noteworthy child prodigies. The time-honored methods of artistic training, however, are not philosophically oriented to respond to precocious talent. While Western cultures emphasize the fresh, energetic works of youth, the Orient looks toward the measured wisdom of the mature practitioner. Westerners tend to believe that individuals are at the height of their creative powers in early and middle adulthood, while the Chinese tend to view creative activity as the privileged endpoint of a long and illustrious career. Within this philosophical and psychological context child artists in China have neither been expected nor especially encouraged. Mastery of visual art forms has traditionally been assumed to require long apprenticeship, patient study of the masters, a thorough understanding of the potentials inherent in the painting materials—brush, ink, and paper—and a strong, well-trained visual sense.

These traditional views have changed somewhat in recent years and with that change has come an increased attention to the expressions of talent by young children. Yani's celebrity within her own country and in the West is one indication of these changing values. There is now a nationwide effort to begin instruction in traditional Chinese painting and in schematic drawing techniques at around age three. Complex criteria have been developed to identify talented children and programs have been established to provide gifted children with additional instruction and experience.[2] This effort has uncovered a number of children who display unusual talent in traditional brush and ink painting. Unlike Yani, however, the majority of China's gifted young painters specialize in a single traditional form—for example, flowers or birds, butterflies, shrimp, or bamboo—rather than displaying a broadly ranging talent.[3]

In the West, where there has been more emphasis historically on youthful accomplishment, there have nonetheless been few well-known child artists. While virtually every notable Western musician and composer of the last several hundred years has demonstrated extraordinary musical abilities as a young child, this has not been true for visual artists. Relatively few seem to have displayed unusually mature talent as young children. Vasari, the sixteenth-century biographer of artists, reported that painters Cimabue, Giotto, Fra Filippo Lippi, Masaccio, Michelangelo, and Raphael all demonstrated keen interest and unusual artistic abilities as young boys. So, too, eighteenth-century portraitist Elisabeth Vigée-Lebrun, nineteenth-century British painters Edwin Landseer and John Everett Millais, and the twentieth-century giant Pablo Picasso were all reported to have demonstrated significant graphic mastery by the age of ten or eleven.[4]

There recently has been a most fascinating and puzzling case of prodigious drawing ability in a young retarded and autistic Ukranian girl named Nadia Chomyn. By the age of three or four Nadia demonstrated a control of line, perspective, and proportion worthy of art-school students. Nadia's talent is all the more extraordinary because her drawing ability, astounding by any standards, is entirely inconsistent with her severely limited overall functioning.[5]

Figure 2 *Horses' heads in different orientations drawn by Nadia Chomyn, about age five (from Selfe 1977, pls. 16–17; reproduced with permission of Academic Press).*

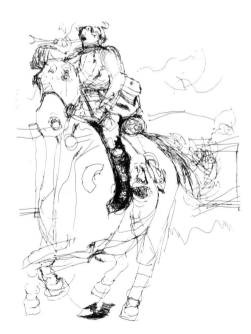

Figure 1 *A horse and rider drawn by Nadia Chomyn, about age five (from Selfe 1977, pl. 24; reproduced with permission of Academic Press).*

By comparing Yani's childhood works with those of other child artists we can find points of common experience and expertise as well as ways in which this young Chinese painter seems to be in a class of her own. Both Yani and Nadia have made art history by the sheer precocity of their accomplishments. We know of no other cases, either documented or mythological, of child artists who displayed such unusual talent at so very young an age. Both, too, are girls. While this is surely self-evident it is not trivial, in terms either of prodigious achievement or of the recognition of women's talents in the visual arts. The overwhelming majority of known child prodigies have been boys. So, too, men have unquestionably dominated the artistic community. The substantial underrepresentation of women is the result of multiple and complex causes, ranging from societal emphasis on different areas of accomplishment for men and women to differential cultural recognition of men's and women's achievements.

Societal values and expectations, for example, have often dictated different paths for the personal and professional development of boys and girls. As a result, there have traditionally been different educational and career opportunities available to those boys and girls who might have initially shown similar levels of talent. This differential channeling of boys' and girls' interests and activities occurs at all levels of the society: within families, by teachers, in schools, clubs, and professional organizations. Furthermore, cultural values influence the extent and type of media attention that a talented individual receives. If it is considered unseemly, for example, for a girl to aspire to a career as a writer, literary critics may be unwilling to review her work favorably or even to direct serious critical attention toward her at all. It is not by accident that several nineteenth-century women writers felt that they would be paid more attention if they affected male personas.

There are other subtle processes at work in the differential encouragement of talents as well. The different kinds of personal characteristics valued and inculcated in boys and girls help shape different interests and abilities. In a culture that trains girls to be diffident and deferent, it will be more difficult for women to establish themselves in professions where asser-tiveness and a strong sense of self-confidence are needed for success. Similarly, if young girls are taught to value marriage and child rearing, it will be more difficult for them to assume careers that conflict with these goals by requiring long hours and intense, solitary work.

We must also consider the possibility that some of the differences between boys' and girls' interests and abilities are less the product of socialization than they are of individual talent and proclivity. It is the interaction of individual talent and interest, family values and traditions, and culturally sanctioned opportunities for the development of talent that has been responsible for the dominance of male achievement in the arts and in many other fields as well. It is no small matter, then, that the two most precocious artistic prodigies we know of today are both girls. Among other things, recognition of their talents reflects broad societal changes, including a growing interest and attention to the extraordinary abilities of girls as well as boys.[6]

Beyond similarities of age and gender, however, Yani and Nadia part company. In a number of other respects the young Chinese painter more closely resembles those young artists who continued to develop into mature practitioners. Like Landseer, Millais, Picasso, Raphael, and Vigée-Lebrun, for example, Yani's contact with painting began in her infancy. She was born into a family where painting was as much a part of daily life as eating or sleeping. Her father, Wang Shiqiang, has written that Yani "entered the world accompanied by the smell of oil paint, inseparable from our profession."[7] A painter himself, he describes his remarkable daughter with an artist's eye, demonstrating keen observational skills, a love for the beauty of his home region, a lyrical pen, and a passion for his art. From her earliest days Yani's father provided a model for what it means to think and work as a painter.

It is common for prodigies to come from families where other members also show a talent and interest in the particular domain. Both "nature" and "nurture" contribute to this relationship. Surely the prodigy's talent is partly a biological gift, inherited from forebears. It is also a gift of the environment, which provides the child's natural talent with the sustenance it needs to grow. Families deriving pleasure and satisfac-

Figures 3—4 *Typical drawings by a five year old: horse and rider and horses on a walk, by Betsy Feldman.*

tion from the exercise of a special talent create a milieu suffused with its lore and practice. Children growing up in such families can experience the domain at its higher levels of mastery unobtrusively, gaining an understanding and a feel for the power and range of expression that it can produce. They can become conversant with the values, vocabulary, and methods of its practice in the natural course of daily life, without necessarily receiving formal instruction. And they come to think of the domain—music, painting, or poetry, for example—as an integral part of their lives. The potential for prodigious achievement is not only in the child's blood but very often in the family values and way of life.

The Wangs provided their eldest child with not only a biological legacy for artistry but a homelife where the aesthetic is a central value and where painting, in particular, is both a profession and a passion. From all accounts Yani was welcomed into her father's world of brushes and paints from the very beginning, and her interest and curiosity in the tools of his craft were interpreted in the context of an artist's life. Consider, for example, the following description of Yani's introduction into her father's world:

One day [when she was not yet three] Yani happened to be playing in her father's workroom, and every now and then she stopped to watch him at his painting. As she did so, she imitated her father, painting on the snow-white wall with a piece of charcoal. After drawing a few circles, she rubbed over the charcoal with her handkerchief, then moved back a little to survey the work. With her arms akimbo and head tilted to one side, she looked at her own "masterpiece" with great attention before she went forward to add a few strokes to her not-yet-perfect work.

"Yani, are you a painter?" The laughing voice of an aunt who lived next door came through the open window.

Only then did Yani's father realize that Yani was also painting while he was. . . . "Does she really wish to learn painting?" he wondered. The idea seemed to lighten his mind. "Yani, you are really Papa's treasure," he said, kissing his daughter on her cheeks because he was unable to hide his feelings of satisfaction.[8]

Since that time Wang Shiqiang has been Yani's constant companion, teacher, and adviser. Because he feels strongly that Yani must be allowed to maintain her spontaneity and freedom of expression, he does not emphasize his own role in her development. Despite this pedagogical position, it is clear from his writings that he is always available gently to guide, suggest, observe, or model the techniques and themes of the artist. Although Yani's talent is awesome, she has not reinvented painting all on her own. She has been taught, for example, to hold a brush, control the thickness of her strokes, and vary the intensity of an ink wash, although her instruction in such matters may have been largely casual and spontaneous. Such lessons, and many more subtle ones, have doubtless been part of a natural, unpressured interchange between father and daughter.

Besides coming from a family of painters, Yani shares a number of other characteristics with those child artists who continued to paint into adulthood. Yani demonstrates a deep passion for her work and intense commitment to painting. She is a careful observer yet has a strong personal sense of how best to translate and elaborate her observations into works of art. She also displays enormous energy, seemingly boundless powers of concentration, and the patience to develop her talent. In some of these qualities Yani may be more exceptional to the Western observer than to the Chinese, for even three- and four-year-old children in China are expected to apply themselves to everyday tasks with focus and concentration.[9] Whatever the cultural differences, Yani's production of four thousand paintings in three years (between the ages of three and six) is quite exceptional by either Chinese or Western standards.

These kinds of personal characteristics, coupled with the capacity for sustained, intense, and focused activity, provide the substrate and sustenance for the development of truly remarkable young talent. They are the matrix supporting the crystalline brilliance of the prodigy's talent. Without a true love of the work and the capacity for dedicated study and practice even the most lavish individual gift will fail to flourish.[10] Yani, like other child prodigies, has both the talent and commitment to develop as an artist.

In at least one other respect, however, Yani seems to stand in a class of her own among prodigious child artists. Most children who have demonstrated mature artistry before the age of eleven or twelve have distinguished themselves in terms of the technical rendering of form. They

are able to copy accurately other works of art or draw with unusual precision. To our knowledge none have distinguished themselves by producing strikingly original compositions while still young children. Here, Wang Yani stands apart from every other artistic prodigy of whom we know. Her paintings are far more than accurately rendered sketches of single figures or copies from life or from masterpieces. From the age of five or six she produced sophisticated works demonstrating uncanny maturity in the arrangement of figures, creation of proportional relations, establishment of visual tension and balance, and use of negative space. She created lively compositions using a variety of subjects, generating works that are both visually and psychologically rich. In this respect Yani is like a composer who creates a new piece of music, while other child artists are more like instrumentalists interpreting someone else's compositions.

In fact, from a Western perspective Yani's draftsmanship seems fairly unremarkable. None of her paintings, including those completed quite recently, render figures with the same three-dimensional realism found in the youthful drawings of Landseer, Millais, or Picasso. We must also remember that Western child artists draw primarily with pencil or pen, while Yani has used a paintbrush from the first. The various possibilities for rendering inherent in these different mediums may account for some of the differences in technical proficiency. So, too, the distinct painting traditions of East and West contribute to this difference. Western painting emphasizes three-dimensional modeling of form, using light and shadow to yield the illusion of solidity and depth, while the Chinese tradition concentrates on capturing the essence of images and resonant textural qualities of form.

Thus, it may be that comparing Yani's early work with that of Western prodigies is a bit like comparing apples and oranges. The technical sophistication of her work lies in different dimensions from those preoccupying Western

child artists. Nevertheless, from the time Yani was four or five her drawing was advanced far beyond the standard for her age. She was able to create accurate and realistic representations of figures and to render them from different viewpoints. Beyond this, she was able to depict energy and activity in her images and to control texture in a manner usually requiring years of study and practice. Her baby monkeys are fuzzy and cuddly but with smooth, skinlike hands; her birds have solid beaks and legs, and their bodies are covered with soft, downy feathers. Yani, furthermore, seems to have been uniquely gifted in her ability to take this technical skill one remarkable step further and to integrate these figures into a unified work of art. This is what makes her a visual composer as well as a performer.

As members of Yani's appreciative audience, we recognize her talent as a rare and extraordinary gift. But we suspect that Yani herself is less awed by her own skill than she is intent on developing her talent even further. We have seen in other prodigies a singleness of purpose, coupled with a most matter-of-fact recognition that they are impelled to exercise and extend their special gift. There is little arrogance or puffery about most true prodigies, including, it seems, young Yani. By all accounts the images spill unselfconsciously from her brush onto paper, quickly and assuredly, seemingly without reflection or hesitation. It is presumptuous to claim a full understanding of the source of another's creative vision or purpose, but we can reflect on some of the clues to the rich and wonderful worlds so brilliantly portrayed by Yani.

Revealing a Child's World with an Adult's Brush

Child prodigies have been characterized as displaying an unusual mixture of adult and childlike abilities.[11] This mixture may offer a key to Yani's creativity. She explores the delights and desires of childhood in lively, imaginative compositions while expressing her youthful spontaneity and exuberance with an extraordinarily mature mastery of her chosen medium. Yani paints her childhood world with the brush of a much older observer.

Wang Shiqiang has written that "year after year [Yani's] pictures record her thoughts and feelings of the moment, like the pages of a diary."[12] Her images may resemble those of a mature artist, but the thoughts and feelings she records are those of other children her age. She expresses common childhood themes in her work, not the issues and preoccupations of adulthood. Straightforward and without layers of symbolic intent, her paintings are about friends and family relationships, exploring the world, doing naughty things, feeling happy, celebrating, playing, growing up. Characteristic, too, of young children was Yani's initial intense exploration of a single theme that served to organize and focus her early development. Who does not know of some young child whose expertise about dinosaurs, insects, or sports teams puts one's own knowledge of the subject to shame?

Three-year-old Yani first became mesmerized by monkeys at the zoo. She delighted in their antics, happily watching them by the hour. What distinguishes her from other children is that she felt compelled to capture them on paper. Nor was she satisfied with simple, childish images of her animal friends; she wanted to paint monkeys that were as lively and interesting as the real ones at the zoo. Here, the mystery of Yani's

talent remains unplumbed. We do not know how she was able to perfect her technical skill so quickly and so thoroughly. An unerring eye and facile hand are part of the formula, but other critical ingredients remain unknown. Yani somehow learned to paint the monkeys of her memory and imagination.

Soon, according to her father, nearly everything in her life was filtered through a monkey lens; yet this lens possessed a child's focal point. Yani's early development seems to have been driven by classically childlike thinking. For example, she "fed" her beloved ink monkeys with fruit, in the process creating wonderful compositions of monkeys plucking, scrambling, and yearning for food. Sometimes her father would even hear her chiding the painted images to behave, because she was about to share (that is, paint) their fruit. So, too, her paintings became populated with peacocks, cranes, and butterflies to amuse and befriend the monkeys. Again, according to Wang Shiqiang, these companions appeared in her compositions only after Yani's own social world had expanded to include friends and experiences beyond the family constellation.

Rather than depicting the objective world in slavish detail, Yani's paintings reflect the universe of her own imagination and understanding. This is perhaps most clearly illustrated by her father's tale of the leafless fruit trees. Noting that Yani omitted leaves from her paintings of fruit trees, Wang took his daughter to an orchard so she could observe trees from nature. Yani, however, casually dismissed the arboreal reality, claiming that she did not paint leaves on her trees because monkeys did not like their taste. Some time later Yani listened carefully as a botanist explained how leaves help supply energy to the tree, thereby allowing its fruit to grow. This sensible explanation was apparently sufficient for Yani to reconsider leaves on her trees. Despite her familiarity with how real fruit trees looked, the botanist's explanation was so compelling that she painted the fruit growing directly from the leaves themselves. This kind of personal interpretation of nature and emphasis on important functional relationships is characteristic of the thinking of all young children.[13]

The maturing of Yani's work is, therefore, the joint development of her style and mind. We can read her oeuvre like a diary, tracing changes in the themes and thoughts that occupy her attention. She shares these kinds of changes with children the world over.

Yani's work makes a significant shift when she is about six or seven. Marked in part by a relinquishing of her intense identification with the monkeys that had occupied center stage for so long, this period can be characterized by explorations of a broader range of technical and thematic issues.

By the age of seven or eight Yani seems to have exhausted much of the imaginative potential of her monkey theme. In addition, she began substituting more elaborate, varied, and realistic explorations of the world around her for her earlier unbridled flights of fantasy. Yani began to paint landscapes, people, lions, and horses. This kind of thematic change is consistent with the psychological development observed in all children. Sometime after the age of five or six children begin interpreting the world less in terms of their own specific interests and actions and more in terms of an objective reality. They begin to look beyond their own experiences, seeking to understand the natural world of objects and the social and psychological worlds of people. By age six or seven Yani was ready to establish a new relation to her work. It became time to stop playing with the joyful monkeys that ran from her brush and cavorted across her paper; she began to take a new, less personalized view of the world. With her unfailing eye and greater technical control, she was ready to explore more objective ways to represent the world around her.

At seven Yani became a schoolgirl. Little is said about her formal schooling, either in the arts or in basic skills. We would not be much surprised to hear that this young artist actually spends little time in a regular classroom. We must assume, however, that her school experiences have at least introduced Yani to the complex social world of friends and classmates, requiring her to negotiate in real life the parties and playmates she once only painted for her monkeys. Her paintings reflect these changes with the appearance of pretty girls, angels, and dancers as subject.

Unlike Yani's earliest paintings, where monkeys served as playmates or even substitutes for Yani

and her family, the subjects of her more recent work seem to reflect specific and realistic explorations of the social world. Her travels to major cities in China and to Japan and West Germany have also provided her with a rich visual catalogue of new places and people to explore with brush and ink. The discipline and structure evident in the elegant landscapes of this later period have only become possible as Yani has begun to look at the world more objectively. Her more recent works still reflect her signature liveliness and inventiveness but within a balanced and controlled structure. The purpose of her painting is the same—to express her thoughts and feelings—but those thoughts and feelings have undergone a transformation. This is reflected in Yani's broader choice of themes, greater interest in detail, and stylistic development.

By age seven or eight she could create an integrated composition using only formal elements, no longer relying on psychological activity among the figures to generate interest and coherence. Her style became more fluid and painterly,[14] and she was able to command large spaces with a minimum of color. Her ability to create a variety of textures in monochrome is particularly noteworthy, given the predilection of young children for the expressive qualities of color.

Just as Yani displays significant mastery over techniques for applying ink to paper, she has ventured into compositions of different formats. The handscroll is particularly demanding, for the painting is intended to be viewed sequentially as the scroll is rolled out, rather than all at once. This requires that the composition be integrated from start to finish, yet also strong enough to sustain prolonged inspection at any given point, should the viewer choose to stop for more intensive examination and study. Yani's handscrolls represent a technical tour de force for a child of eight or nine. *You Can Never Finish Painting the Mountains and Rivers in Guilin* (no. 37), completed when she was eight, offers a panoramic landscape extending more than eighteen feet. She returns to her familiar friends, the monkeys, to provide the energy that impels the viewer's eye along more than thirty-four delightful and ebullient feet of *A Hundred Monkeys* (no. 28), painted when she was nine.

Whatever Yani has given up in terms of expressive fantasy has, to our minds, been more than fairly returned by her further mastery of the medium and an expanded and enriched range of subjects. Her development has thus far provided a clear example of the mix of childlike and adultlike qualities that is the hallmark of the child prodigy. It is likely that Yani's art will soon display the preoccupying themes and thoughts characteristic of adolescence. We would hazard a prediction that Yani will make another major shift in her art during her teenage years, one that will again reflect underlying psychological changes in her ways of thinking and relating to the world. In particular, we could expect to find increasing attention to technique and to the exploration of a theme and its variations. For a time, some of the spontaneity and imaginative quality of her work will probably become secondary to the more formal and technical aspects of style. Her father has written that when Yani was a young girl she would walk through the pine forest near their home as if she were on a fantastic journey: pebbles became monkeys, pinecones were fearsome dragons, and shreds of bark were transmuted into old men on dangerous quests. We can expect that for the next few years Yani's walks through her forest will not stimulate her fantasy as much as they will lead her to explore formal properties and relations of objects in nature.

Art educators often bemoan adolescence for the waning of childhood creativity, calling for ways to encourage and preserve the freedom and spontaneity of early childhood productions.[15] Although spontaneity and imaginativeness may recede during adolescence, this should not necessarily be equated with the demise of artistic development. Adolescence is the time of the flowering of logical thinking and the flexing of intellectual muscles.[16] Children become fascinated with possibility and potentiality, spending enormous amounts of time and energy reflecting on possible outcomes of events, considering alternatives, and trying to understand the structures of situations. That we would find these kinds of changes reflected in children's artistic development—be they prodigies or more "average" artists—is to be anticipated and prepared for rather than dreaded as the confirmation of lost innocence or imagination.[17]

Even as we would expect Yani's art to enter a new stage, we would hope that an emphasis on exploring the formal properties of painting would ultimately prove to be liberating, allowing her to interpret and represent the world in even more arresting and powerful ways. There is no reason to expect that Yani will permanently surrender the spontaneity and exuberant play-fulness that enliven her work and her life, but it may become muted for a time. Other great artists have managed to strike a balance between formal control and imaginative exploration in their mature works—Picasso and Calder, Miró and Klee come immediately to mind—and we would expect that Yani would be able to do the same.

Yani's Three Blessings

The story of Yani's future artistic development will be written in part by those who teach her. Her first blessing was to be born with an immense talent and with the drive and desire to express her gift. Her second blessing was to be born into a family that recognized, cherished, nurtured, and sacrificed for her talent. Had Yani been born into the household of a day laborer, primary-school teacher, or government bu-reaucrat her talent may have gone entirely undetected or might have languished for lack of an adequate teacher. By the luck of "co—incidence,"[18] Wang Shiqiang was not only a painter himself but an extraordinarily sensitive observer of his daughter's development. In addi-tion, he has been a loving and dedicated teacher with a strong pedagogical sensibility. All of this has been crucial to Yani's development.

The current Chinese art-education curriculum involves teaching children very specific tech-niques for drawing and painting in a "correct" style. Conformity to presented models is lauded and efforts at individual expression largely dis-couraged. Teachers often correct children's work, sometimes guiding their hands as they paint or draw or simply making the desired image for them.[19] It is within this educational context that Wang Shiqiang has overseen Yani's artistic educa-tion. When he writes that he has never disturbed or interfered with her work, we assume that he

means that he has not taught her painting as it is taught in the schools. Unlike primary-school art teachers, Wang Shiqiang has probably never actively sought to change Yani's paintings unless she asked for guidance. He has probably never guided her brush over paper for the sole purpose of improving her work. Yet he has not been simply a passive observer of Yani's unfolding talent. It is clear from his writing that at the very least they have discussed her paintings in great detail. It is hard to imagine that these discussions have not involved his initiating questions, sug-gestions, observations, practice exercises, and even walks in the woods for the purpose of guiding her work.

Yani's parents have also bestowed on her the gift of their dedication. Virtually nothing is written of Yani's mother. One can be sure, however, that she has played a significant role in her daughter's development. While it appears that she has not taken an assertive role in Yani's artistic training, at the very least she has played an important part by supporting her husband's and daughter's commitment to the painter's life.

For his part, Wang Shiqiang has made the ultimate professional sacrifice, setting aside his own brushes to assist in the full flowering of Yani's talent. He has said that he does not want to influence her style with examples of his own; perhaps he also feels that he is of most service to her calling if he serves as guide and adviser without the encumbrances of his own artistic preoccupations.

This kind of dedication and sacrifice for the prodigy is found in the few documented cases that have been studied.[20] Those parents who are willing to renegotiate their own professional aspirations are often best able to make the enormous effort required to guide their children along the path of prodigious mastery. Cultural support for such a decision also seems to be greater in China than in the West. While Western cultures value individual success and personal satisfaction, the Chinese take a more collective (or at least more family-oriented) view of individual purpose and responsibility. Chinese parents are expected to value their children's accomplishments and abilities at least as highly as they do their own, and it is assumed that children's needs will take priority in family

decisions and distribution of resources. Within this context Wang Shiqiang's commitment may seem somewhat less remarkable. Even so, it cannot have been easy to relinquish his own commitment to making art even if it were in Yani's best interest.

Traditional Chinese values may have underscored Wang Shiqiang's commitment to his daughter's development as a painter, but traditional artistic training would not have facilitated such rapid mastery. Yani's third great blessing is to have been born at a time when her country is reexamining its educational goals and practices and appears eager to understand and learn from powerful early expressions of talent such as Yani's.

The making of a prodigy is a delicate process. The child's natural talent must be carefully nurtured and supported by family, friends, teachers. The cultural zeitgeist must also be receptive to the prodigy's talent. If any part of this formula is missing, the potential for prodigious achievement will remain just that— potential rather than realized achievement. [21] Were Yani to have been born twenty years earlier, in the midst of the Cultural Revolution, we suspect that the world would not know of her unique gift. Had she been born in her small hometown of Gongcheng two hundred years ago, she might have been denied special training because she was a girl. Even if her extraordinary talent would have won her the opportunity to study painting with the local artists, her imagination would have been as closely trained as her brush and she would never have been allowed to lose herself in lively compositions of her own creation.

As luck would have it, Yani's China has reaffirmed traditional aesthetic values even as it allows more individual, personal expression. Wang Shiqiang's pedagogical vision of painting as the spontaneous expression of thoughts and feelings has been made possible in large part by newly emerging cultural norms and philosophy. His point of view may still be unusual among the rank-and-file art educators in China, but it is not without support from other artists. [22] While Yani's artistic training has been closely supervised by her father, she is a national treasure, and people come from great distances to watch her at work. We expect that she has been given the opportunity to meet and learn from other artists and master teachers. Were the educational bureaucracy to disapprove of Wang Shiqiang's teaching, it is possible that Yani's future development would remain less firmly in her father's hands.

Wang Yani is thus both the product and herald of change in the fabric of Chinese culture: change that places greater value on individual uniqueness and creative expression; that looks for harmony in diversity; that seeks a new spirituality in a secular world. Yani's own gift is protean, yet we may never have known of her paintings had she not been further blessed by having been born into a painter's family at an auspicious moment in history. Her gift for painting has been given twice over by her parents; once as sheer individual talent and again as the opportunity to live, work, and learn within a painter's milieu. And her gift has been given, in a way, by the accumulated traditions of her country in the form of an ancient tradition of reverence and recognition for the painter's craft and a contemporary emphasis on the discovery and development of individual talent. In this last respect Yani herself fulfills some of the prodigy's ancient role of prophecy by reflecting a cultural shift in China toward appreciation of individuality, personal transformation, and creativity.

We must not forget that behind such metaphors stands a fourteen-year-old girl with a paintbrush in her hand. While observers may find Yani's talent awesome and incomprehensible, it seems to be natural for her: she loves to paint. Her richly playful imagery, virtuoso compositions, and sophisticated technique are, in some way, beside the point. For Yani herself, the greatest gift is simply the opportunity to do what she loves best; and she returns that gift by sharing with all of us her most extraordinary painted diary.

NOTES

1. For an extended discussion of prodigies and a presentation of six case studies of children with exceptional talent see David Henry Feldman with Lynn T. Goldsmith, *Nature's Gambit: Child Prodigies and the Development of Human Potential* (New York: Basic Books, 1986). For information about Chinese theories of child prodigies see Qin Huang et al., *Chinese Early Childhood Educational History*, trans. Jie-Qi Chen (Beijing, 1982).

2. This view of recent Chinese programs for arts education comes from the paper "Notes from China," by Howard Gardner and Ellen Winner of Project Zero at Harvard University. Professors Gardner and Winner traveled in China for three months in 1987 as distinguished guests of the government, lecturing and consulting on artistic development in China and the United States.

3. Wai-Ching Ho, personal communication with authors, April 8, 1988. As a very young girl, Yani, too, specialized almost exclusively in painting monkeys. By the time she was five or six, however, her repertoire had expanded to include peacocks, cranes, butterflies, and fruit trees. Most other gifted young Chinese artists still show a more restricted range of subject matter at this young age.

4. For biographies of artists who displayed precocious talents as youngsters see Luisa Becherucci, "Raphael and Painting," in *The Complete Works of Raphael*, ed. Mario Salmi (New York: Harrison House, 1978); on Landseer see Frank Getlein, "A Sentimental Victorian Painter Is Back in Style," *Smithsonian* 12, no. 8 (1981): 62–71; William Helm, *Vigée-LeBrun, 1755– 1842: Her Life, Works, and Friendships* (London: Hutchinson, 1908); Roland Penrose, *Picasso: His Life and Work*, rev. ed. (New York: Harper & Row, 1973); Charles de Tolnay, "The Historic and Artistic Personality of Michelangelo," in *The Complete Works of Michelangelo*, ed. Mario Salmi (New York: Reynal, 1978); Giorgio Vasari, *Lives of the Artists*, trans. George Bull (New York: Penguin, 1971); Malcolm Warner, "John Everett Millais: Drawings from Seven to Eighteen Years," in *Six Children Draw*, ed. Sheila Paine (New York: Academic Press, 1981).

5. Lorna Selfe describes Nadia's particularly puzzling profile of abilities and disabilities in *Nadia: A Case of Extraordinary Drawing Ability in an Autistic Child* (London: Academic Press, 1977); and in "Nadia Chomyn: Drawings from Three to Eleven Years," in Paine 1981.

6. For discussions of gender differences in early prodigious achievement see Feldman with Goldsmith 1986 and Lynn T. Goldsmith, "Girl Prodigies: Some Evidence and Some Speculations," *Roeper Review* 10 (1981): 74–82. The increased interest in girls' achievements was also the topic of a recent article in *Time* magazine about young female violinists (Michael Walsh, "Siren Songs at Center Stage," April 11, 1988, pp. 70–71).

7. Quoted in Wang Shiqiang, "Yani as I See Her," in *Wang Yani: Pictures by a Young Chinese Girl* (Munich: Prestel-Verlag, 1987), p. 15.

8. Quoted in *Yani's Monkeys*, ed. Shufen Li and Cheng'an Jiang (Beijing: Foreign Languages Press, 1983), pp. 3–4.

9. Ellen Winner, "How Can Chinese Children Draw So Well?" *Journal of Aesthetic Education* (in press).

10. See, for example, Feldman with Goldsmith 1986; Kathleen Montour, "William James Sidis: The Broken Twig," *American Psychologist* 32 (1972): 265–79; Amy Wallace, *The Prodigy* (New York: Dutton, 1986). Montour and Wallace present the case of mathematical wunderkind William James Sidis, one of the most promising young mathematicians of the twentieth century who nonetheless failed to make any significant contribution to the field and died in obscurity.

11. Franziska Baumgarten, *Wunderkinder psychologische Untersuchungen* (Leipzig: Johann Ambrosius Barth, 1930); Feldman with Goldsmith 1986.

12. Quoted in Wang Shiqiang 1987, p. 16.

13. These stories about Yani's paintings are from Wang Shiqiang 1987. For a discussion of children's general intellectual development see Jean Piaget and Bärbel Inhelder, *The Psychology of the Child* (New York: Basic Books, 1969). Rudolf Arnheim discusses children's artistic growth in *Art and Visual Perception* (Berkeley: University of California Press, 1969).

14. Heinze Götze, Introduction to Wang Shiqiang 1987.

15. For discussions of artistic development during adolescence see Viktor Lowenfeld and William Brittain, *Creative and Mental Growth*, 5th ed. (New York: Macmillan, 1970), and Ellen Winner, *Invented Worlds: The Psychology of the Arts* (Cambridge, Mass.: Harvard University Press, 1982). For papers dealing specifically with the adolescent works of adult artists see Ann Gordon, "Childhood Works of Artists," *Israel Museum Journal* (1987): 75–82, and David Pariser, "The Juvenile Drawings of Klee, Toulouse-Lautrec, and Picasso," *Visual Arts Research* 13 (1987): 53–67.

16. For a discussion of the major "stages" of children's thinking see Piaget and Inhelder 1969; for a presentation of characteristic "profiles" of prodigies' intellectual strengths see David Henry Feldman, *Beyond Universals in Cognitive Development* (Norwood, N.J.: Ablex, 1980).

17. It should be noted, however, that adolescence can be a particularly perilous time for the continued development of child prodigies. Social pressures for conformity, exhaustion from years of intensive study,

and intellectual changes that sometimes require developing substantially new means of approaching one's special field often slow or even halt a child's previously stellar progress. The need for the prodigy to relearn the practice of the domain according to more formal rules and structures, in particular, can contribute to a crisis of confidence. The added vulnerability that prodigies often feel during adolescence in relation to their own special talents has led researcher Jeanne Bamberger to posit that many child prodigies experience a "midlife crisis" sometime during their teens or early twenties.

One cannot predict with any certainty how an individual child will weather the vagaries of adolescence, but we can surely hope that Yani will not be one of the casualties of this potentially trying period of life. From all accounts she possesses the drive and determination as well as the extraordinary talent to transform her teenage experiences into fuel for future growth.

For discussions of prodigy "burn out" see Jeanne Bamberger, "Growing-up Prodigies: The Mid-life Crisis," in *Developmental Approaches to Giftedness and Creativity*, ed. David Henry Feldman (San Francisco: Jossey-Bass, 1982.)

18. The term *co–incidence* is used to describe the initial serendipitous co-occurence and subsequent carefully orchestrated coordination of factors contributing to the development of early talent (see Feldman with Goldsmith 1986).

19. Gardner and Winner 1987.

20. See Feldman with Goldsmith 1986.

21. Feldman with Goldsmith 1986.

22. Gardner and Winner 1987.

Yani
The Brush
of Innocence

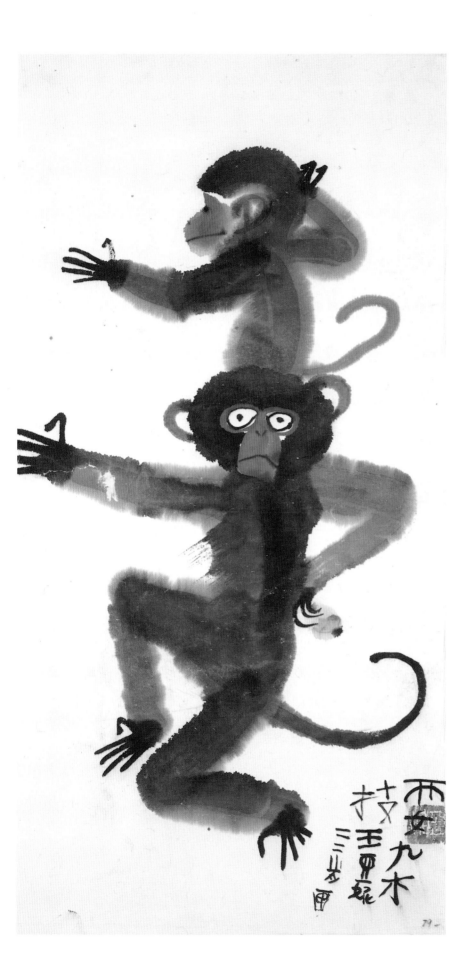

1

Performing Acrobatics
1979—80
Age four

Inscribed:
Performing acrobatics. Painted by Wang Yani at age four.

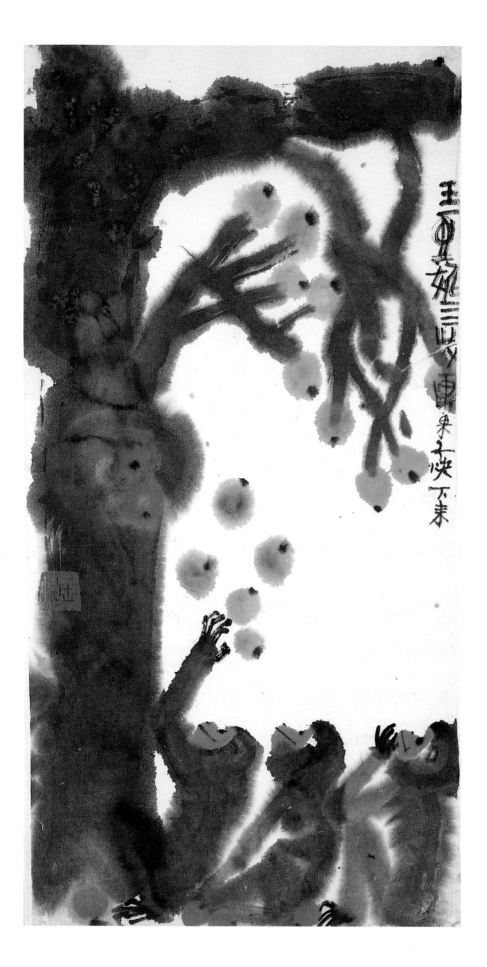

2

The Fruit Will Be Down Soon!

1979–80

Age four

Inscribed:
*Painted by Yani at age four. The
fruit will be down soon.*

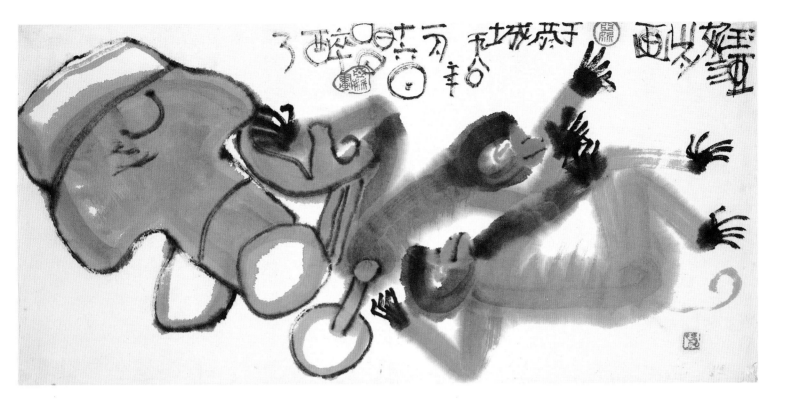

3

Drunk

1980

Age four

Inscribed:
*Painted by Wang Yani at age four
in Gongcheng on January 16,
1980. Drunk.*

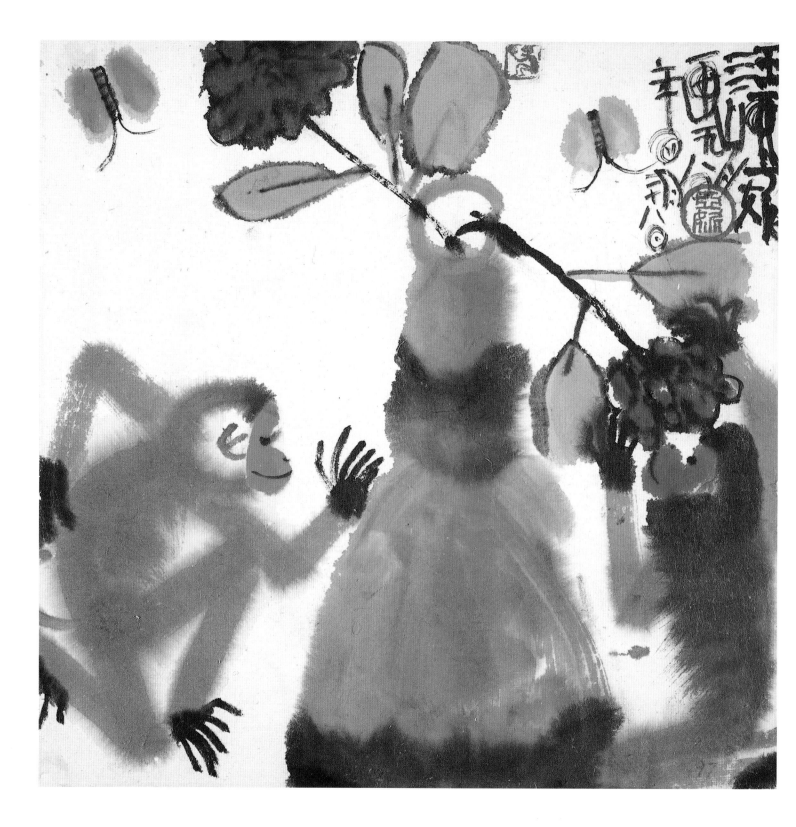

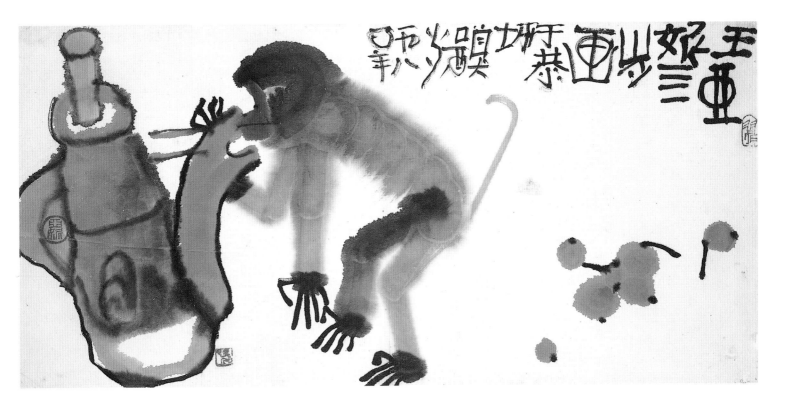

4

Let Me Smell the Flower

1980

Age four

Inscribed:
Painted by Wang Yani at age four on April 28, 1980.

5

Sniffing the Wine

1980

Age four

Inscribed:
Painted by Wang Yani at age four in Gongcheng, 1980. Sniffing the wine.

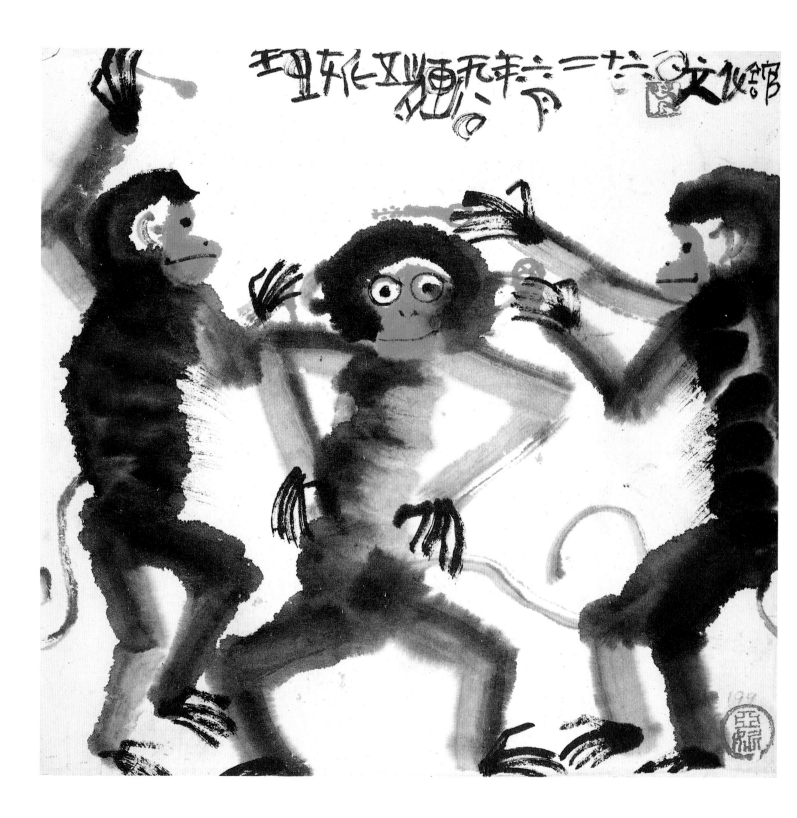

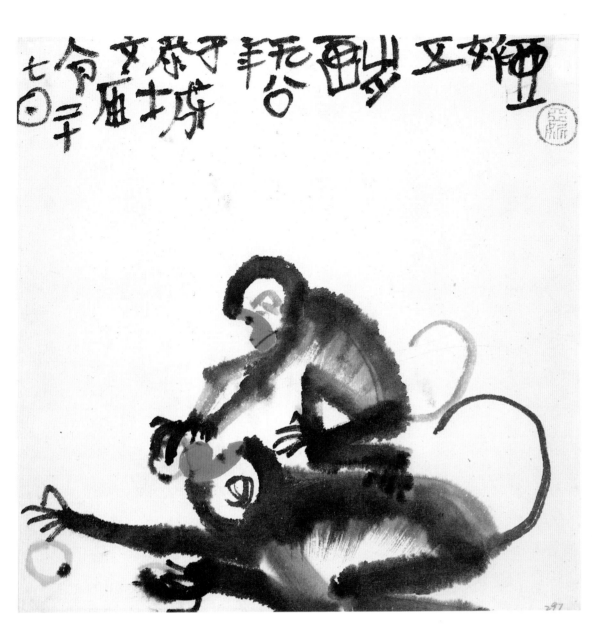

6

I Am Not Scared! (Inoculation)

1980

Age five

Inscribed:
*Painted by Wang Yani at age five
on June 26, 1980, at the Cultural
Center.*

7

This Is for Mommy

1980

Age five

Inscribed:
*Painted by Yani at age five on
August 27, 1980, at the
Gongcheng Wen-Miao [Confucius
Temple].*

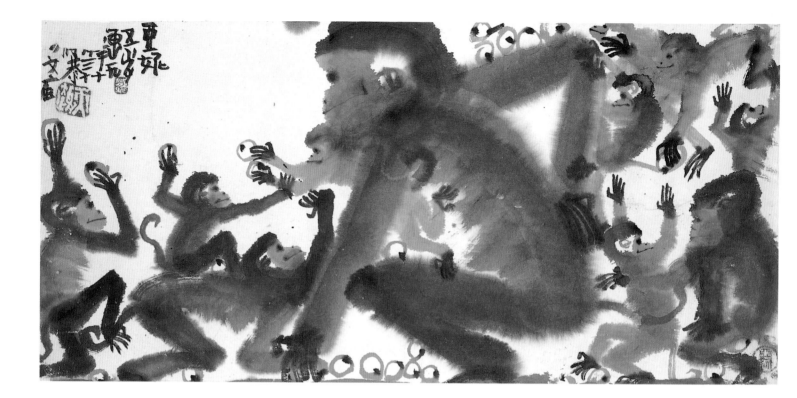

8

Handing Out Fruit for Mommy

1980

Age five

Inscribed:
Painted by Yani at age five on October 30, 19[80], at the Gongcheng Wen-Miao [Confucius Temple].

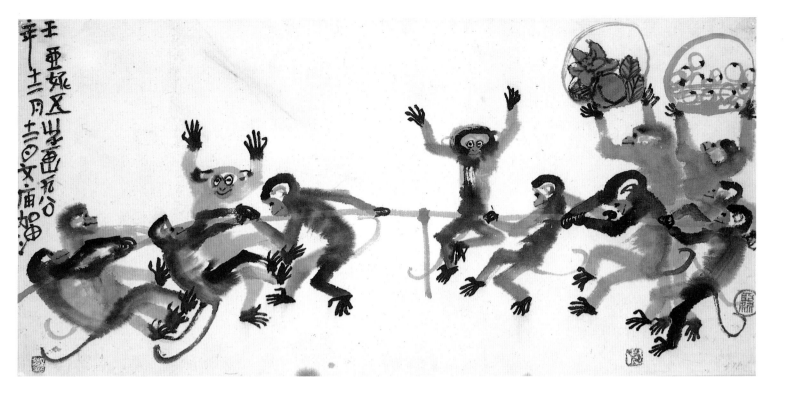

9

Pull Harder!

1980

Age five

Inscribed:
*Painted by Wang Yani at age five
on December 12, 1980, at the
Wen-Miao [Confucius Temple].
Pull Harder.*

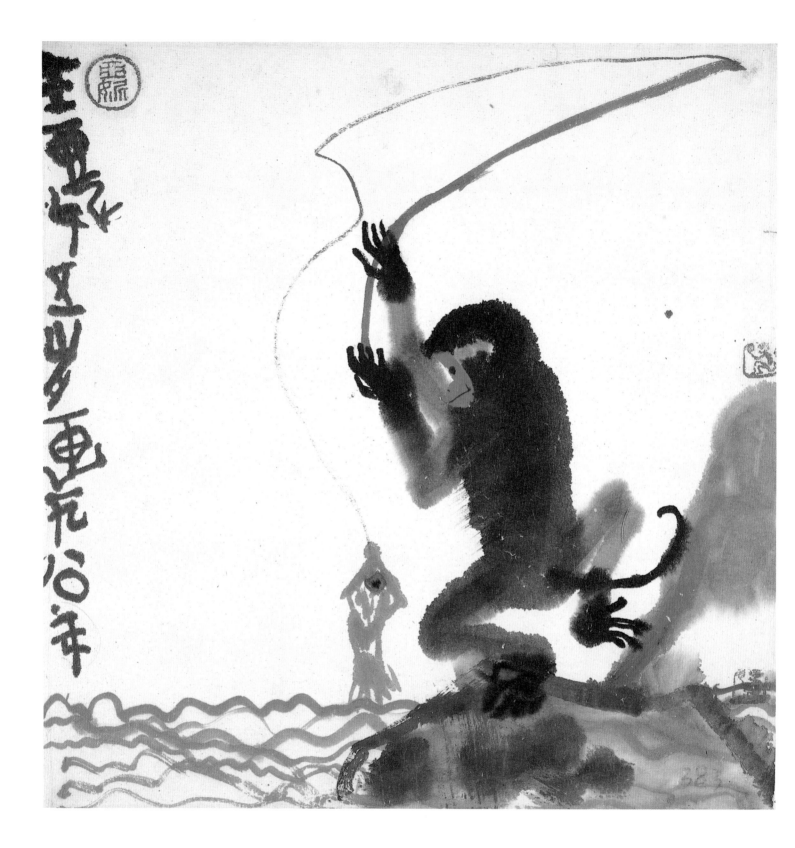

10

Fishing

1980

Age five

Inscribed:
*Painted by Wang Yani at age five
in 1980.*

11

These Fruit Are Not Yours

1980–81

Age five

Inscribed:
Painted by Yani at age five.

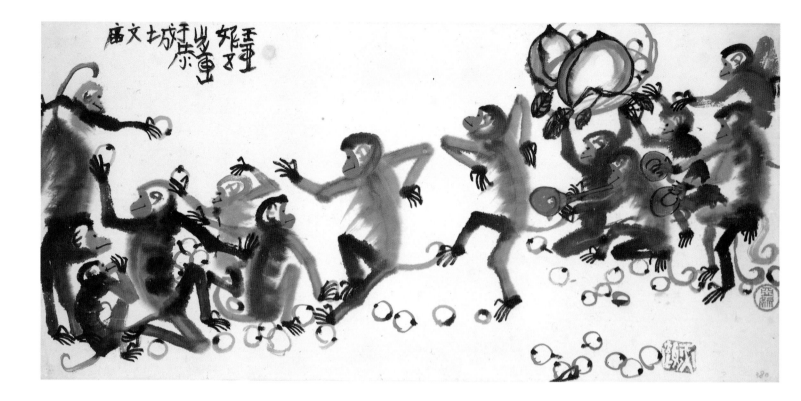

12

Let's Have a Party

1980—81

Age five

Inscribed:
*Painted by Wang Yani at age five
at the Gongcheng Wen-Miao
[Confucius Temple]*

OPPOSITE:

13

Arriving at Butterflies' House

1980—81

Age five

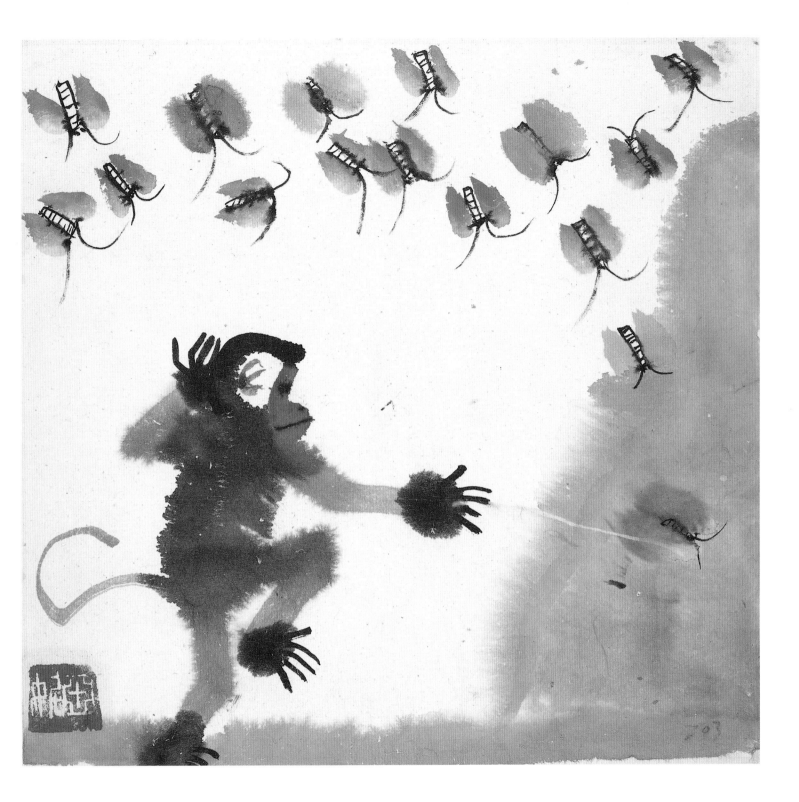

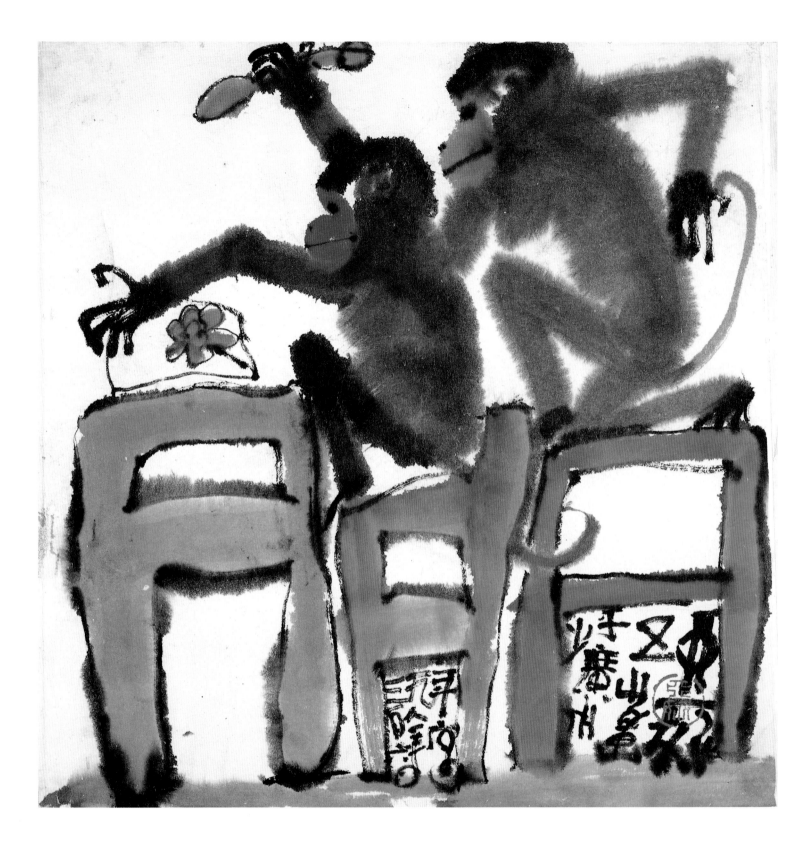

OPPOSITE:

14

Let Me Paint Something

1981

Age five

Inscribed:
Painted by Yani at age five on March 6, 1981, at the Guangzhou Youth Palace.

15

Hurry Home!

1981

Age six

Inscribed:
Painted by Yani at age six on July 20, 1981, in Gongcheng.

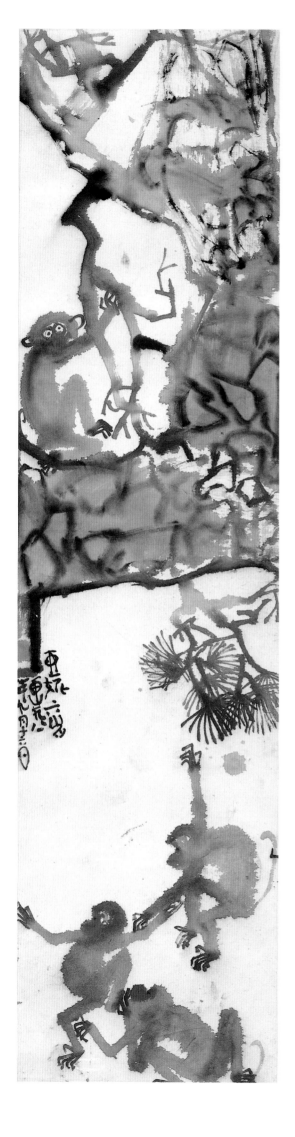

16

Hurry Down!

1981

Age six

Inscribed:
Painted by Yani at age six on September 16, 1981.

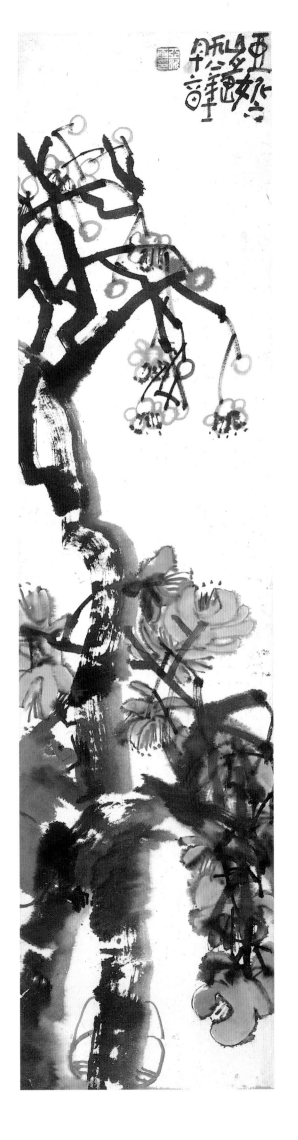

17

My Flowers Are Blooming!

1981

Age six

Inscribed:
*Painted by Yani at age six on
November 16, 1981.*

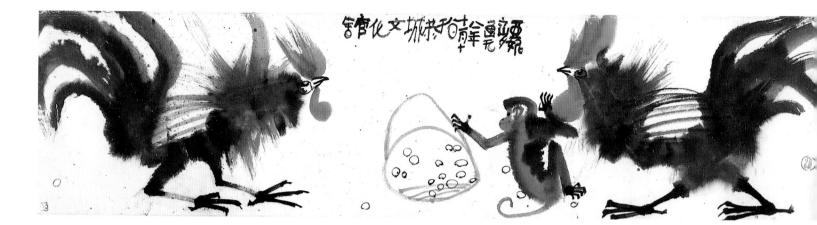

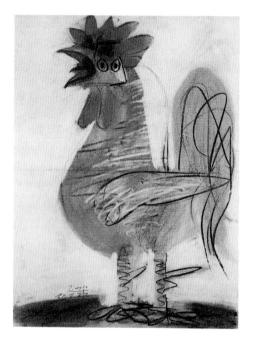

Pablo Picasso (1881–1973), The Rooster, *1938, pastel. Private collection. Reproduced with permission of Artists Rights Society, Inc. © 1989 ARS N.Y./SPADEM.*

18

Don't Fight!

1981

Age six

Inscribed:
Painted by Yani at age six on November 18, 1981, at the Gongcheng Cultural Center.

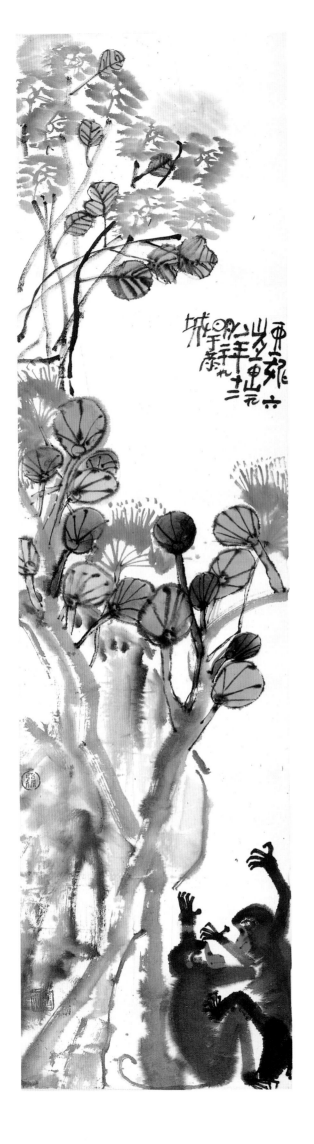

19

These Flowers Are Mine!

1981

Age six

Inscribed:
*Painted by Yani at age six on
December 29, 1981, in Gongcheng.*

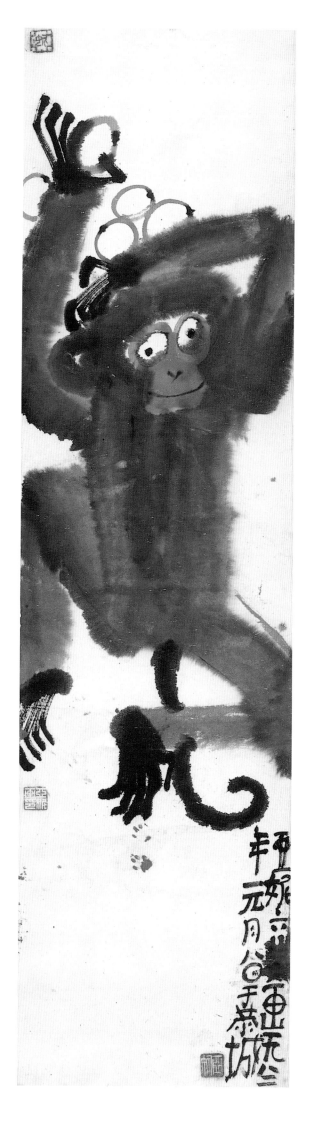

20

I Have Some Fruit

1982

Age six

Inscribed:
*Painted by Yani at age six on
January 8, 1982, in Gongcheng.*

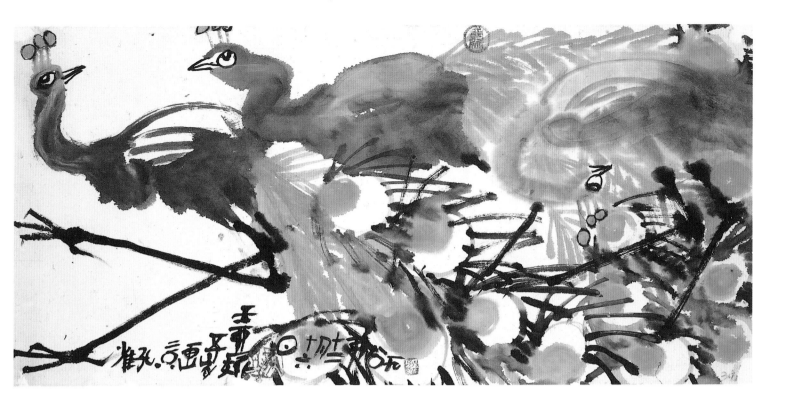

21

Three Peacocks

1980

Age five

Inscribed:
*Painted by Wang Yani at age five
on December 16, 1980. Three
peacocks.*

22

A Big Coconut Just Fell Down!

1982

Age six

Inscribed:
*Painted by Yani at age six on
January 29, 1982.*

23
Kitty
1978—79
Age three

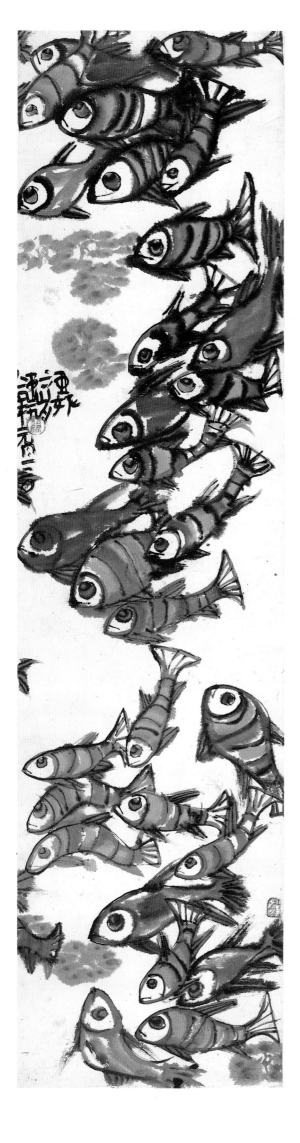

24

A Happy Troop!

1982

Age six

Inscribed:
*Painted by Yani at age six on
January 3, 1982.*

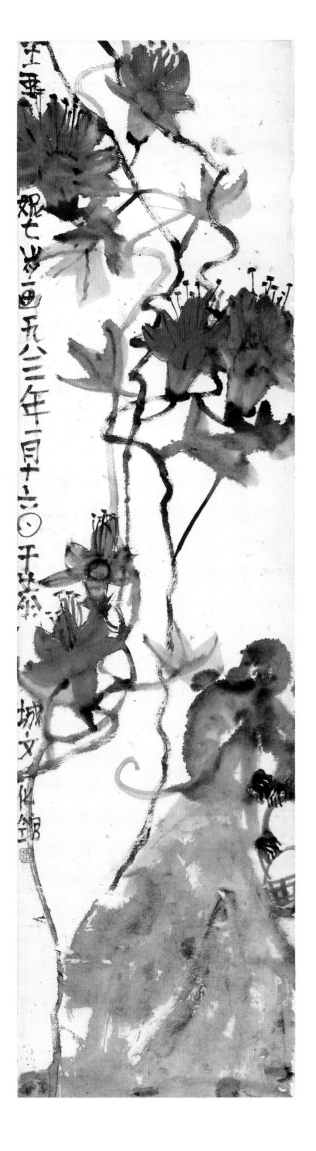

25

Whose Flowers Are So Pretty?
1983
Age seven

Inscribed:
Painted by Wang Yani at age seven on January 16, 1983, at the Gongcheng Cultural Center.

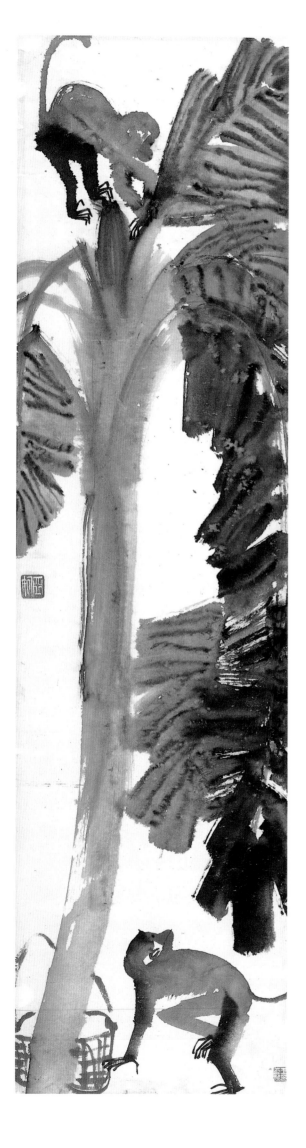

26
*The Bananas Have Not Come
Out Yet*
1983—84
Age eight

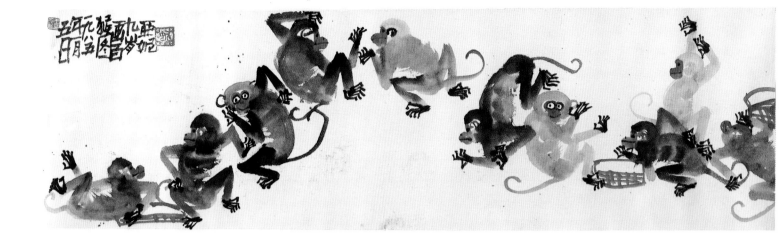

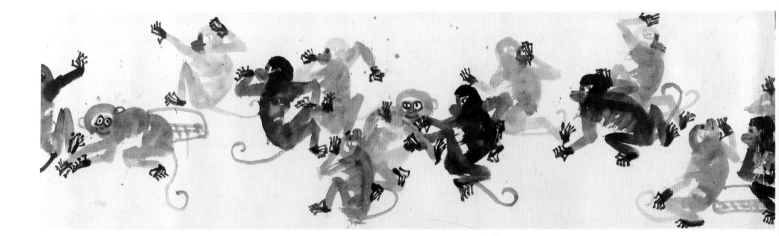

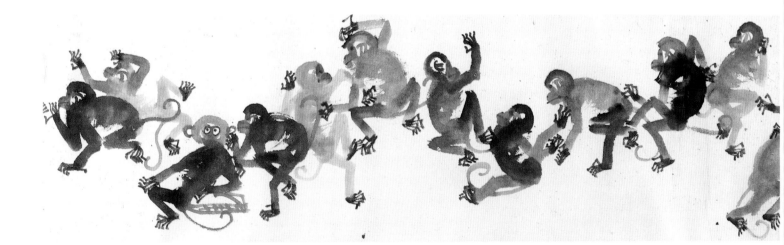

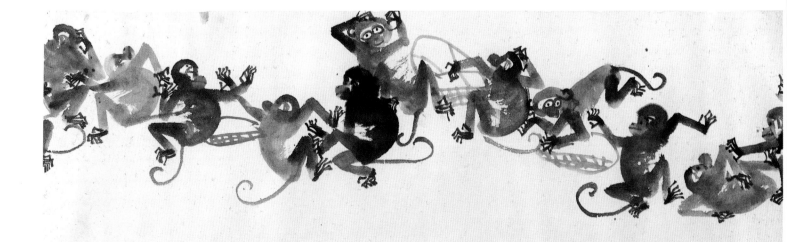

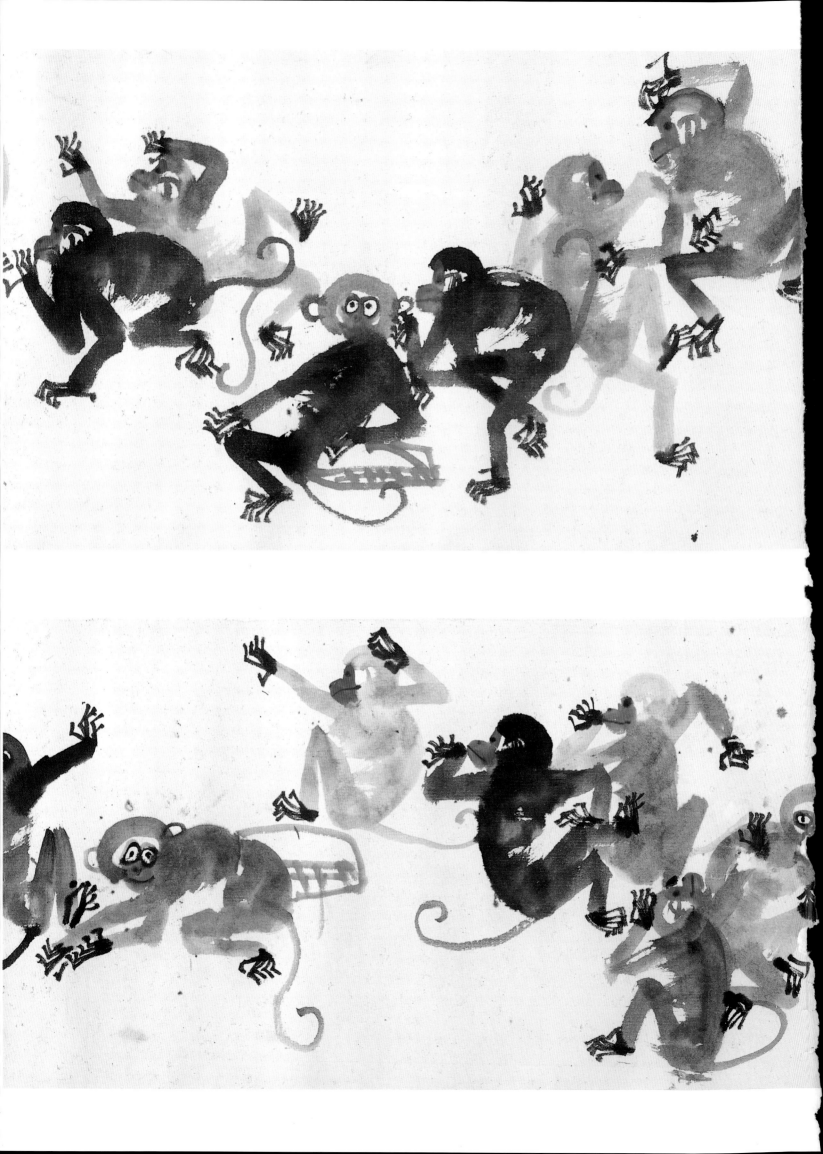

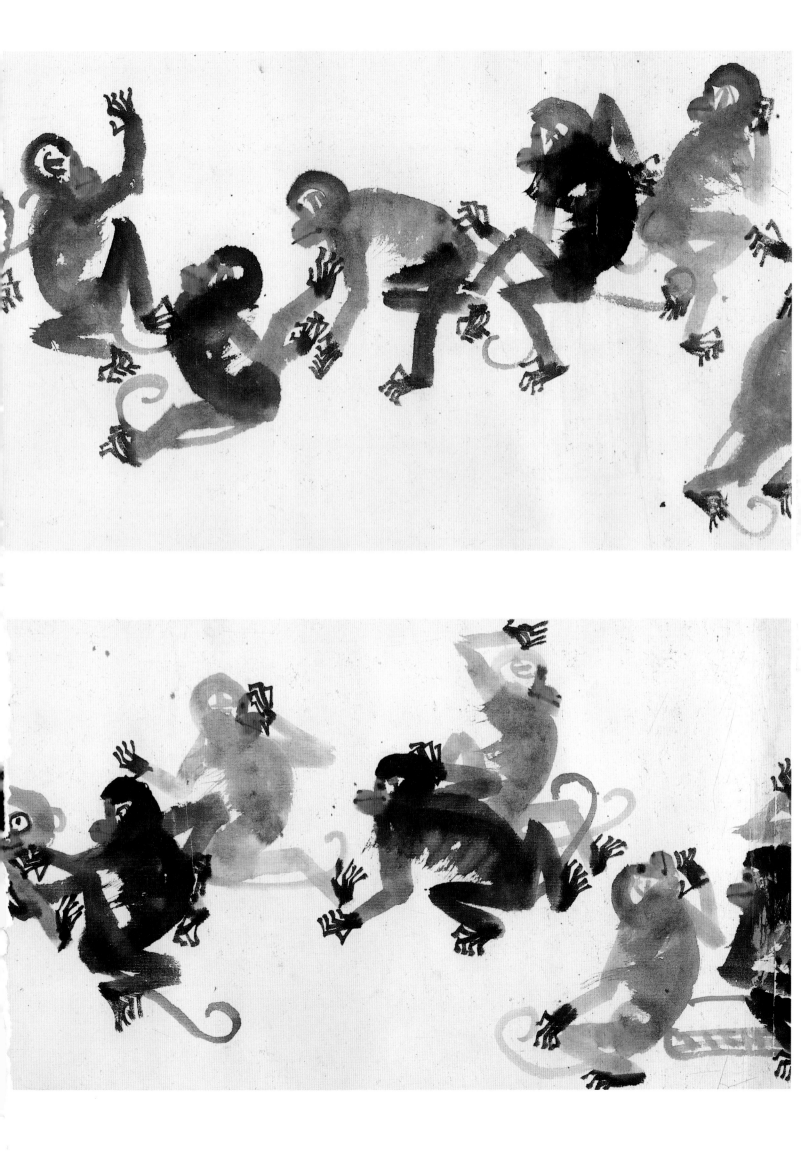

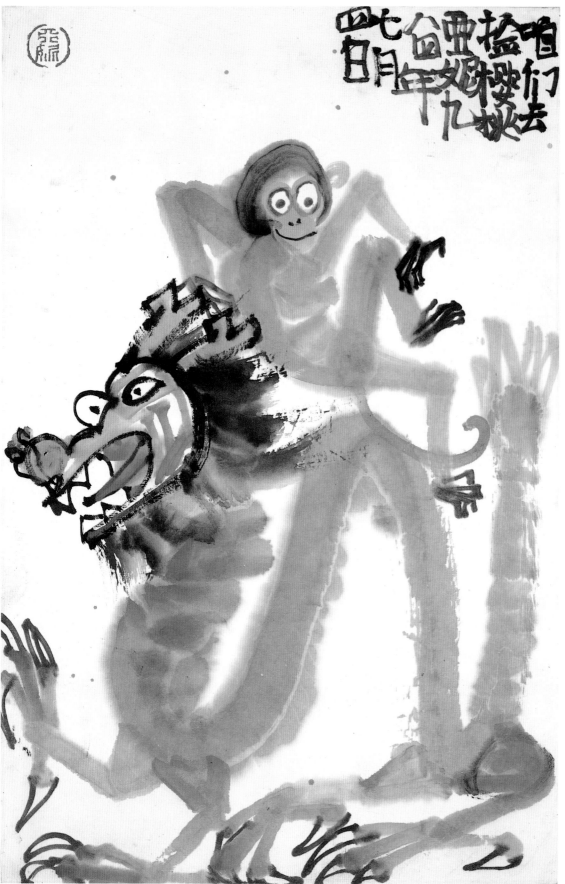

27

Let's Go Pick Some Cherries

1984

Age nine

Inscribed:
Let's go pick some cherries. Painted by Yani on July 4, [1]984.

RIGHT:

28

A Hundred Monkeys

1985

Age nine

Inscribed:
Painted by Yani at age nine on January 5, 1985. A Hundred Monkeys.

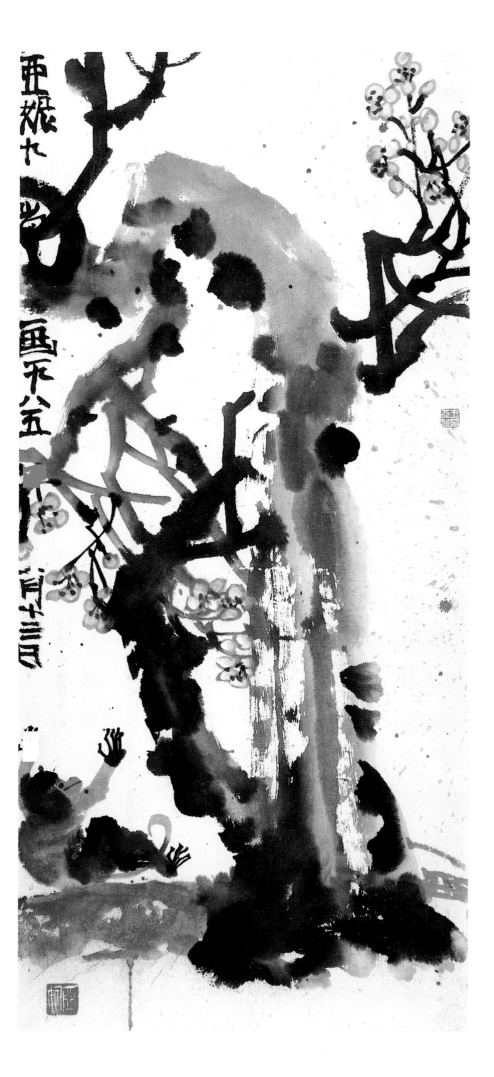

29

Wow! (What a Beautiful Morning!)

1985

Age ten

Inscribed:
Painted by Yani at age nine [ten] on August 13, 1985.

30

Good Harvest!

1986

Age eleven

Inscribed:
Good harvest. Painted by Yani at age eleven in 1986.

OPPOSITE:

31

Early Morning

1982

Age seven

Inscribed:
Painted by Yani at age seven on September 28, 1982, in Gongcheng.

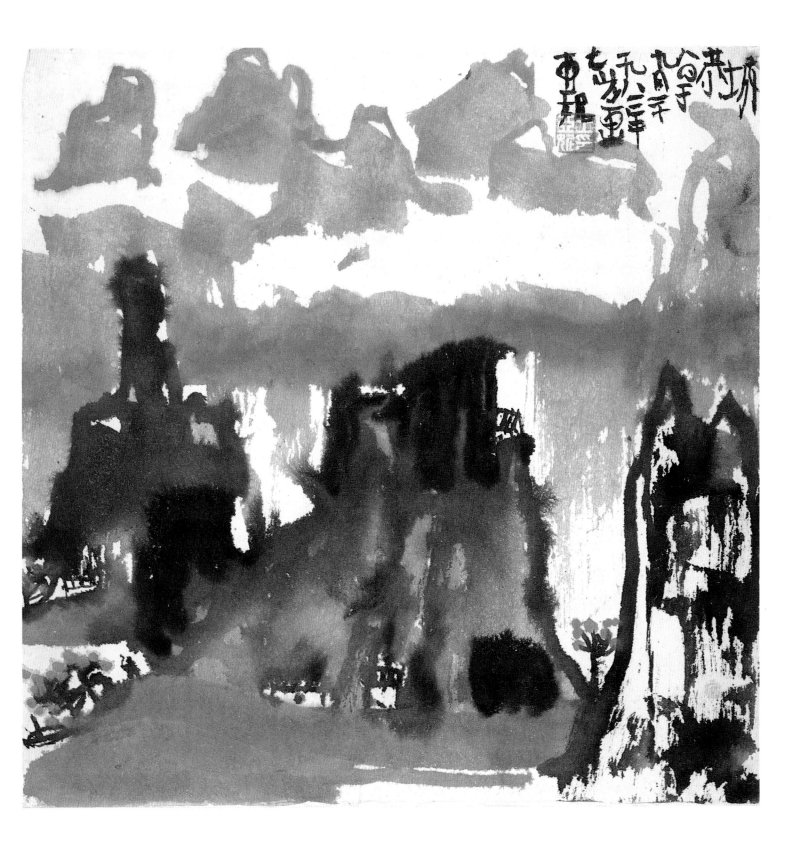

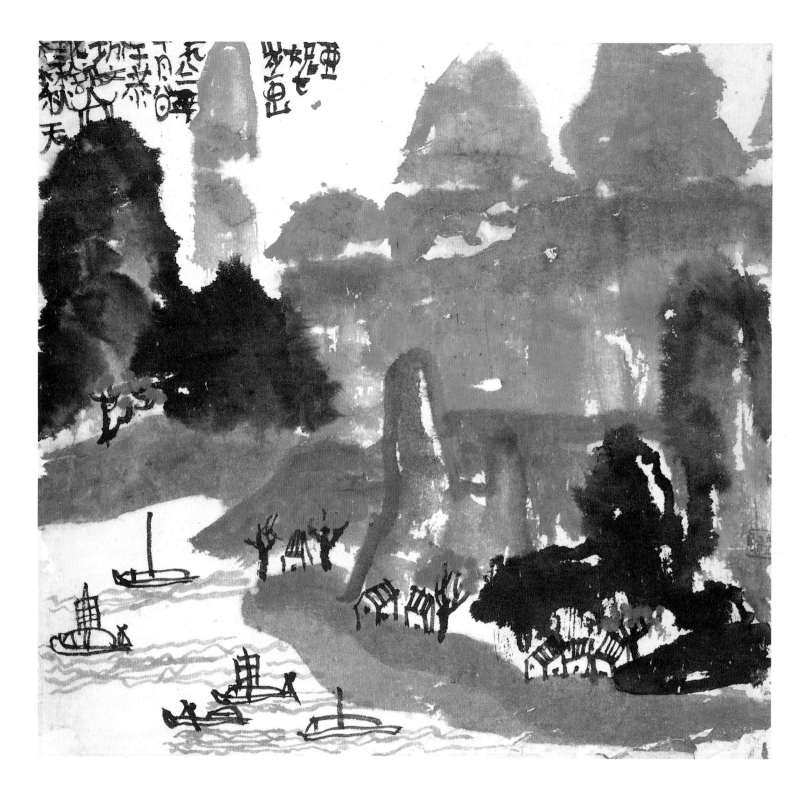

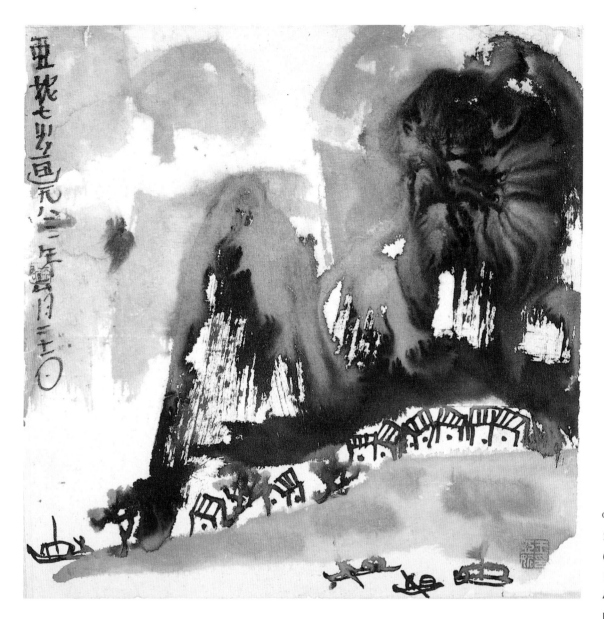

OPPOSITE:

32

Guilin's Autumn

1982

Age seven

Inscribed:
Painted by Yani at age seven on October 8, 1982, at the Gongcheng Cultural Center. Guilin's autumn.

33

Lion Mountain

1983

Age eight

Inscribed:
Painted by Yani at age seven [eight] on June 21, 1983.

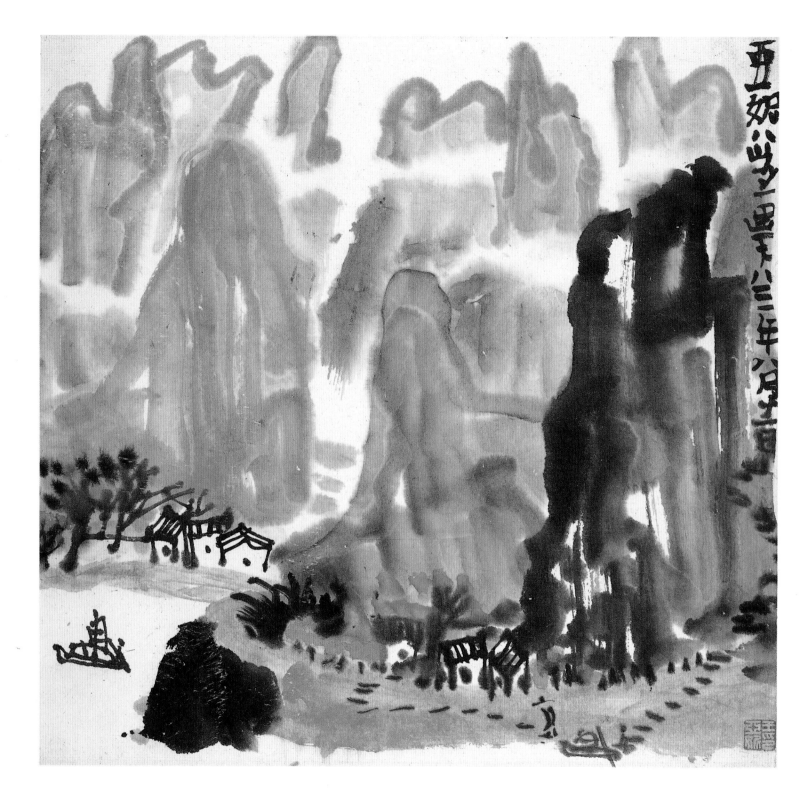

100

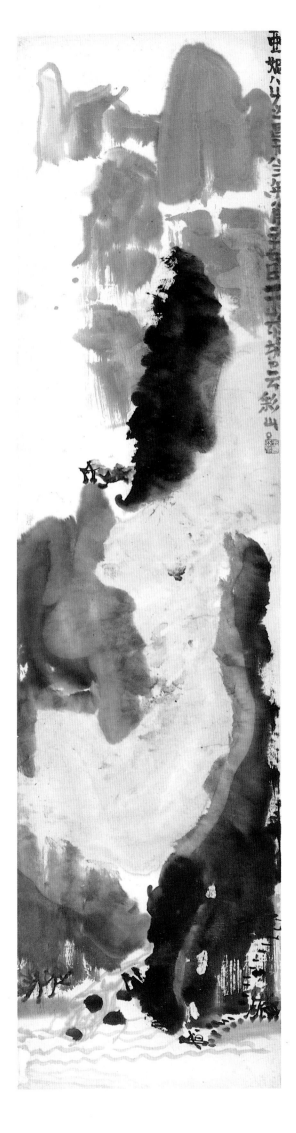

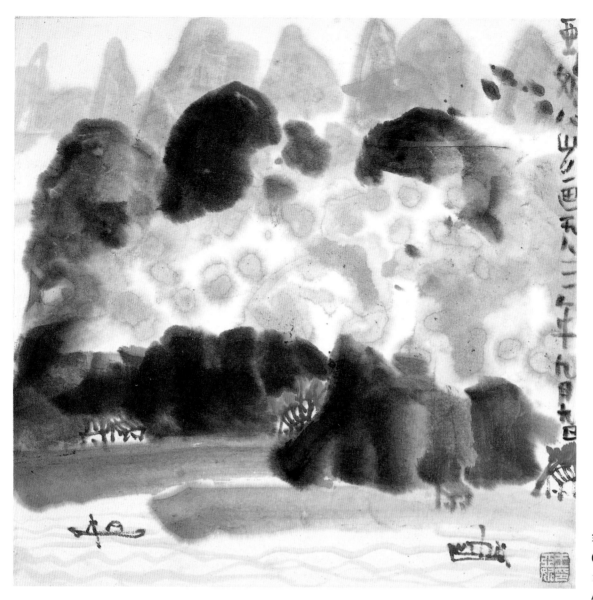

36

Clearing after Rain

1983

Age eight

Inscribed:
Painted by Yani at age eight on
September 9, 1983.

OPPOSITE:

37

You Can Never Finish Painting
the Mountains and Rivers in
Guilin

1983

Age eight

Inscribed:
[You] can never finish painting
Guilin's mountains and rivers.
Painted by Yani at age eight on
September 12, 1983, in Gongcheng

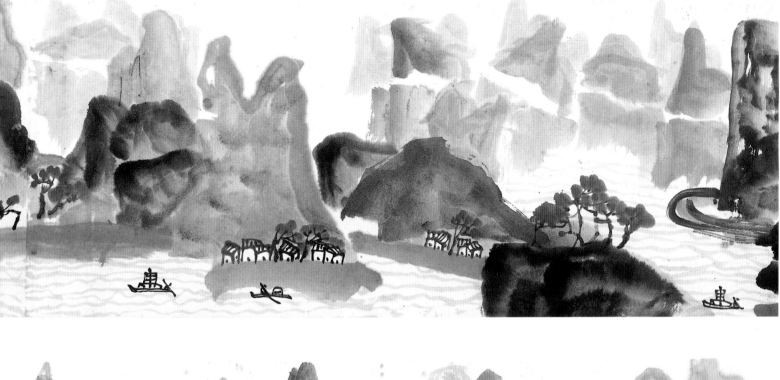

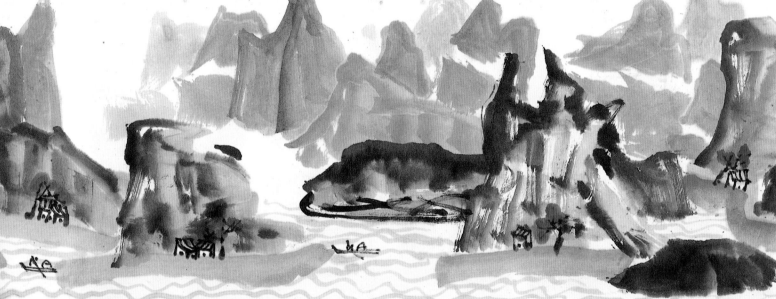

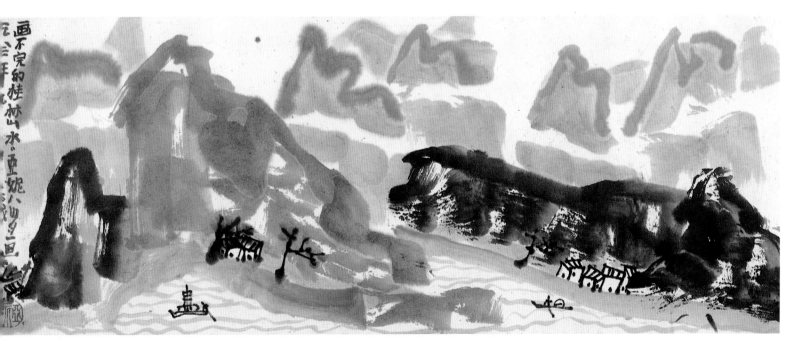

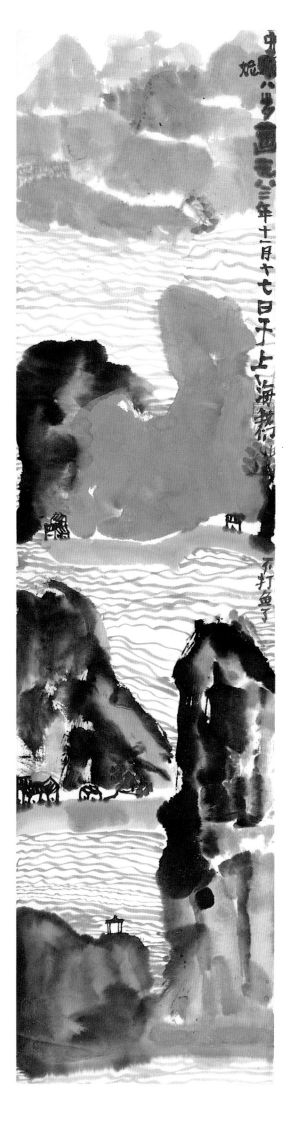

38

No More Fishing

1983

Age eight

Inscribed:
*Painted by Yani at age eight on
November 17, 1983, in Shanghai.
No more fishing.*

OPPOSITE:

39

Noon in the Autumn

1983

Age eight

Inscribed:
*Painted by Yani at age eight in
1983.*

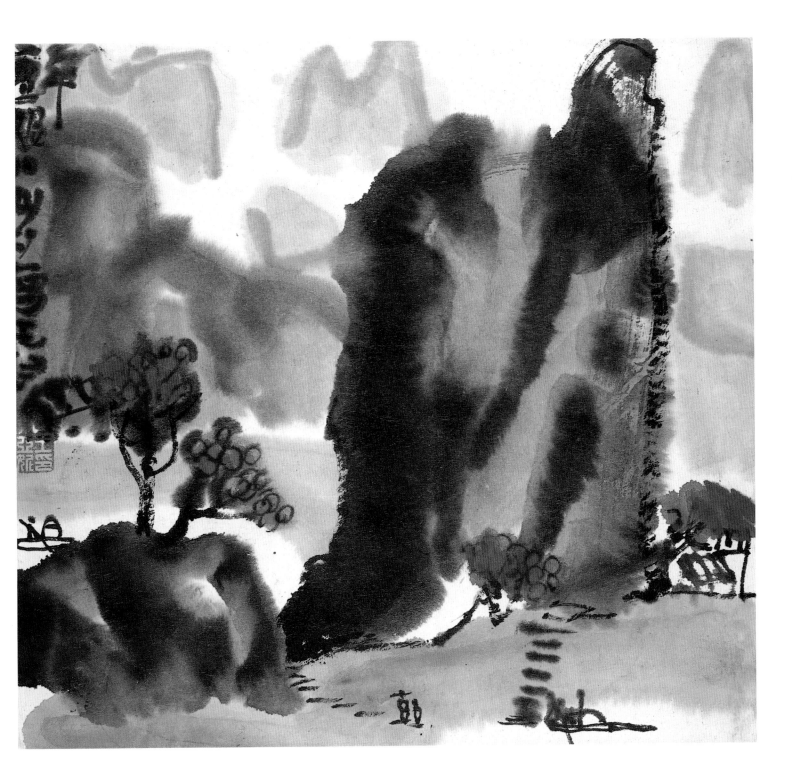

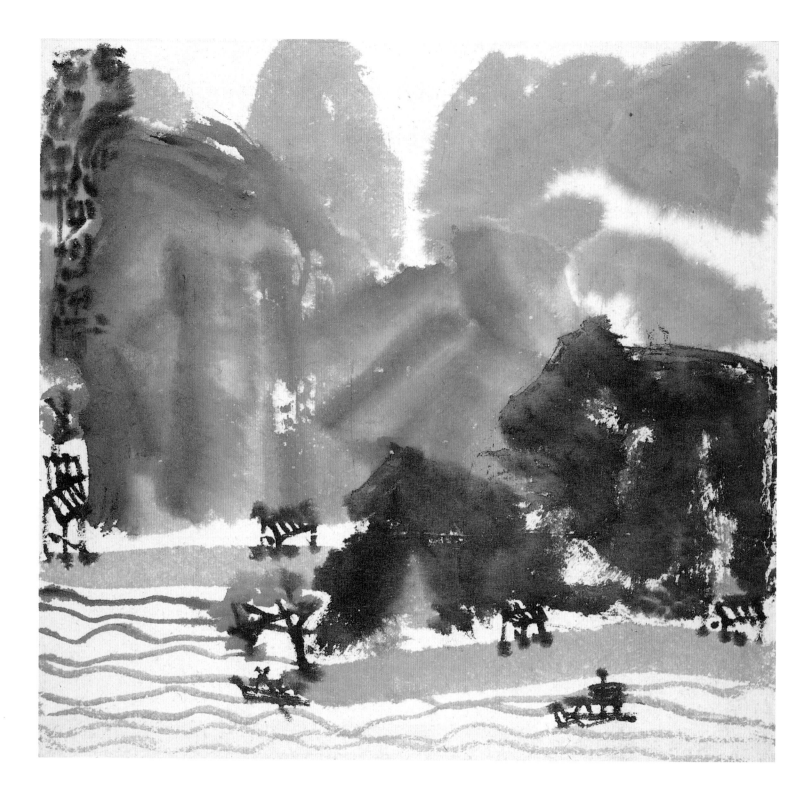

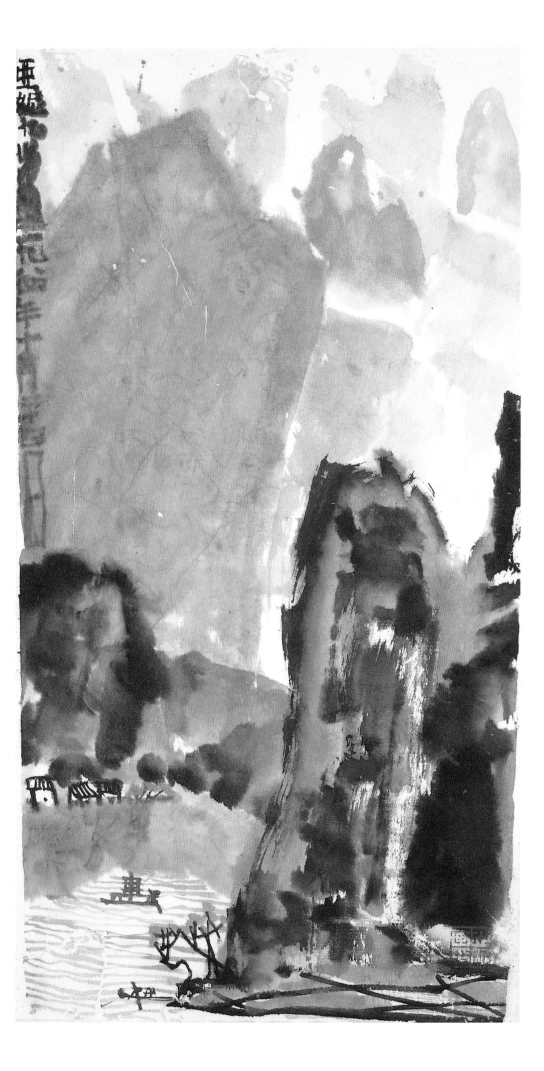

40

Little Mountain

1984

Age eight

Inscribed:
*Painted by Yani at age eight in
1984.*

41

Spring

1984

Age nine

Inscribed:
*Painted by Yani at age nine on
October 24, 1984.*

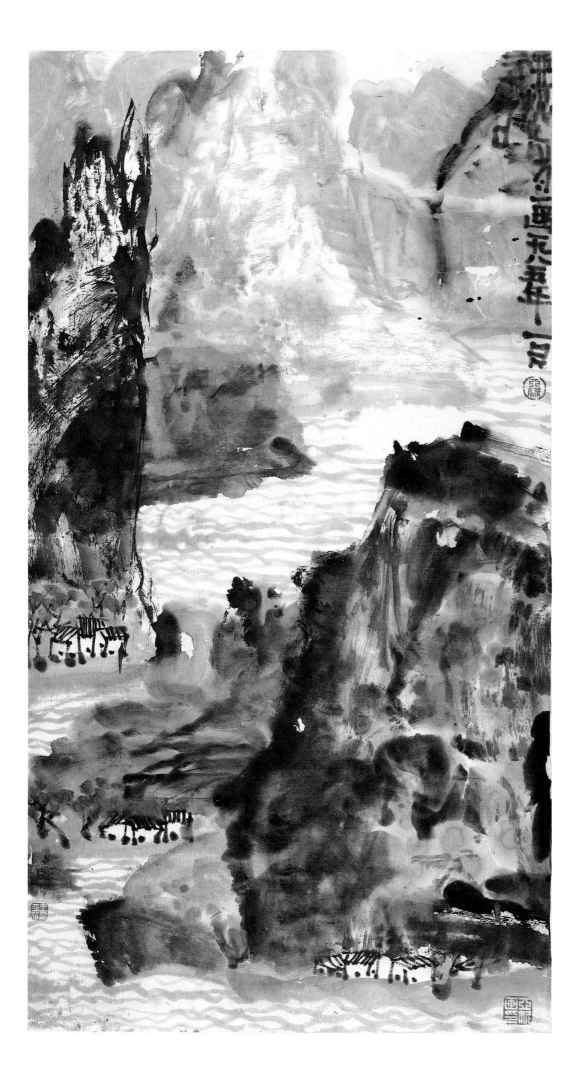

42

Autumn in a Hamlet

1985

Age nine

Inscribed:
*Painted by Yani at age nine on
January 20, 1985.*

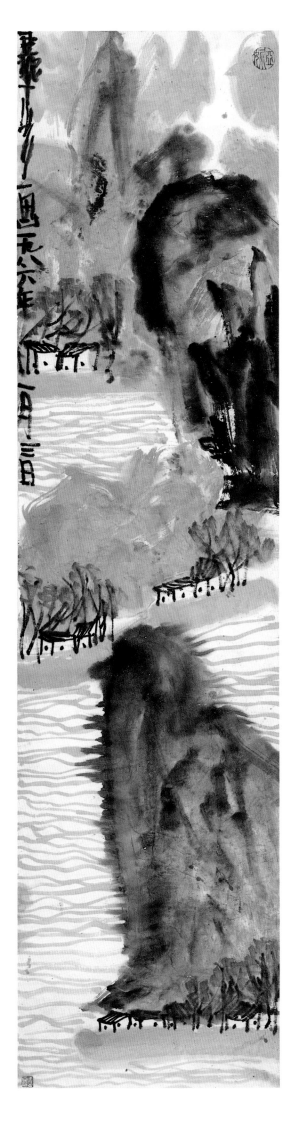

43

Pretty Riverbanks

1986

Age ten

Inscribed:
*Painted by Yani at age ten on
January 3, 1986.*

44

A Small Village

1986

Age ten

Inscribed:
Painted by Yani at age ten on
January 12, 1986.

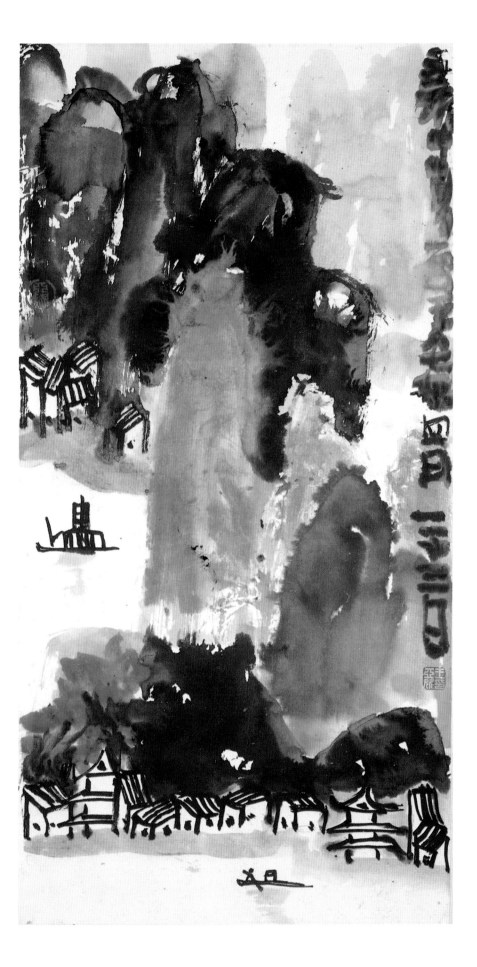

45

A Sunny Day

1987

Age eleven

Inscribed:
*Painted by Yani at age eleven on
April 23, 1987.*

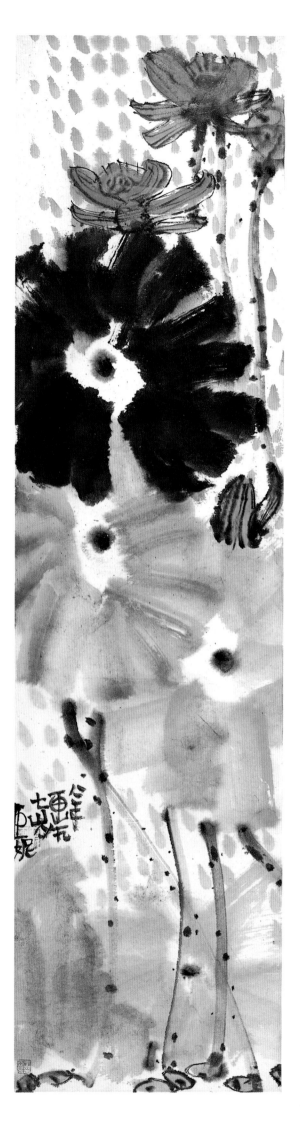

46

Raining on the Lotus Pond

1982

Age seven

Inscribed:
Painted by Yani at age seven in 1982.

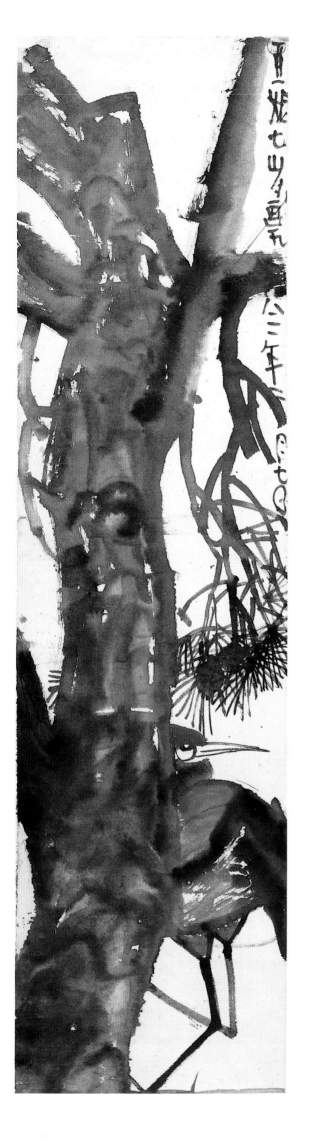

47

Where's That Little Monkey?

1983

Age seven

Inscribed:
Painted by Yani at age seven on February 7, 1983.

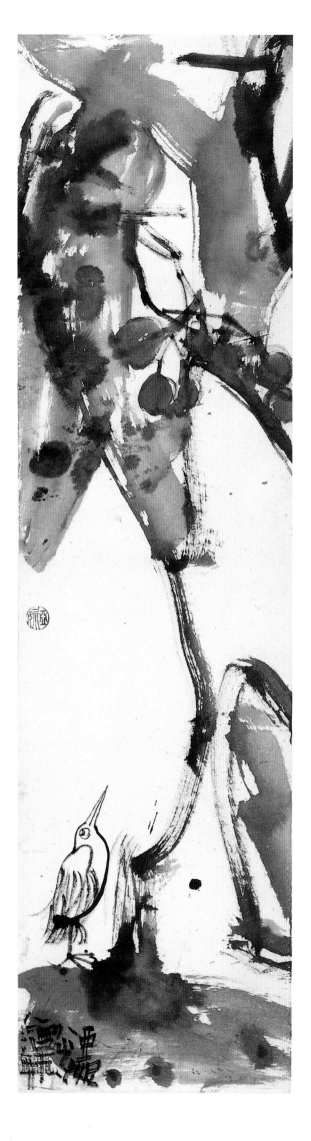

48

I Love Maple Leaves

1983

Age eight

Inscribed:
Painted by Yani at age eight in 1983.

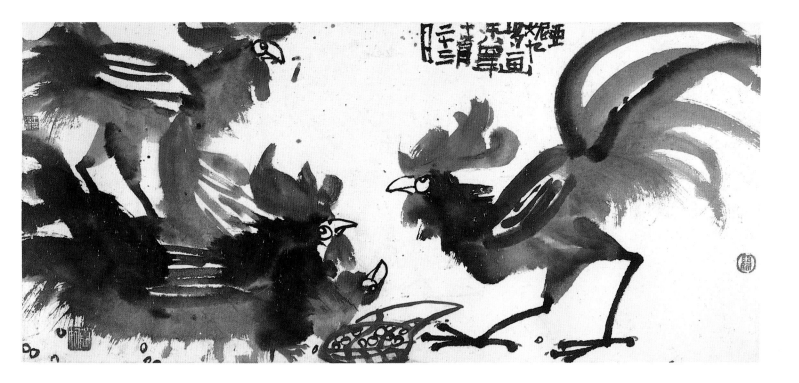

49

The Meeting

1984

Age nine

Inscribed:
Painted by Yani at age nine on December 23, 1984.

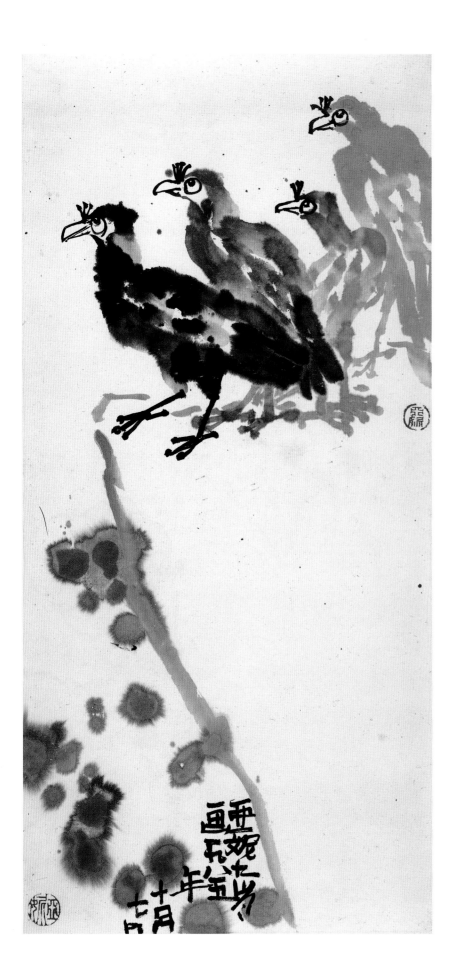

50

Waiting (for the Young Ones)
1985
Age ten

Inscribed:
Painted by Yani at age nine [ten]
on October 7, 1985.

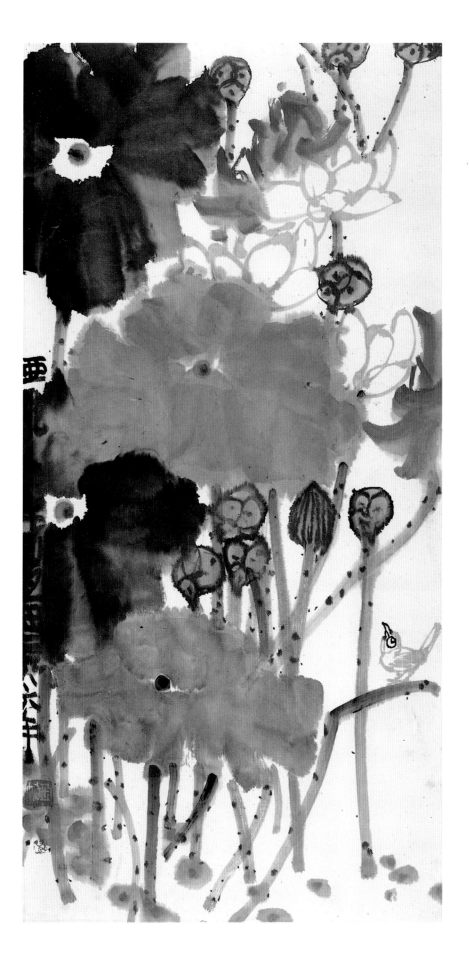

51

The Lotus Flowers Are So Pretty!

1986

Age ten

Inscribed:
Painted by Yani at age ten in 1986.

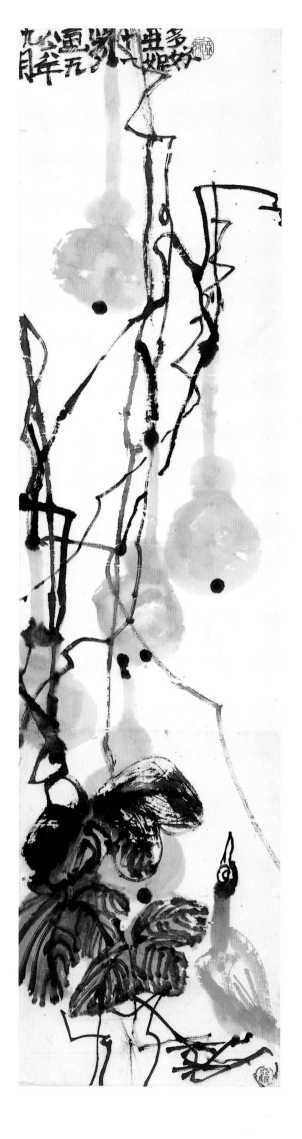

52

How Nice!

1986

Age eleven

Inscribed:
How Nice. Painted by Yani at age eleven in September 1986.

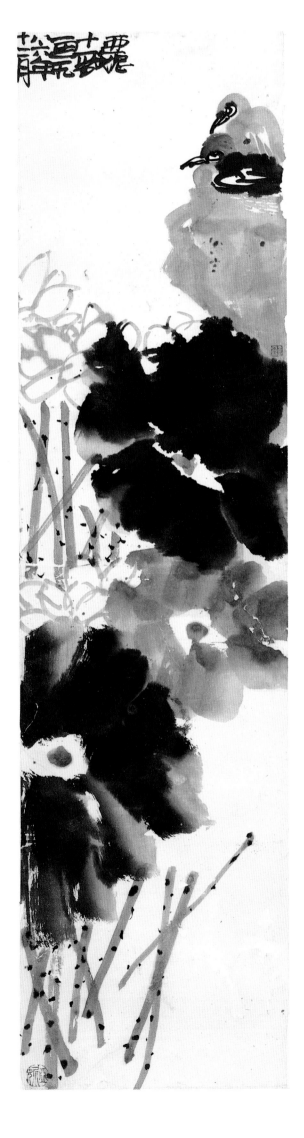

53

Oh! It Smells So Good!

1986

Age eleven

Inscribed:
*Painted by Yani at age eleven in
December 1986.*

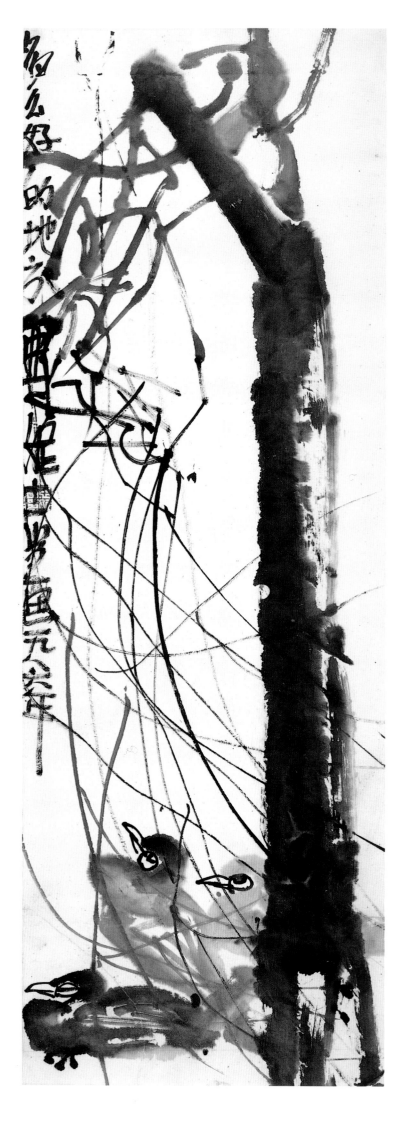

54

What a Nice Place!

1986

Age eleven

Inscribed:
*What a nice place. Painted by
Yani at age eleven in 1986.*

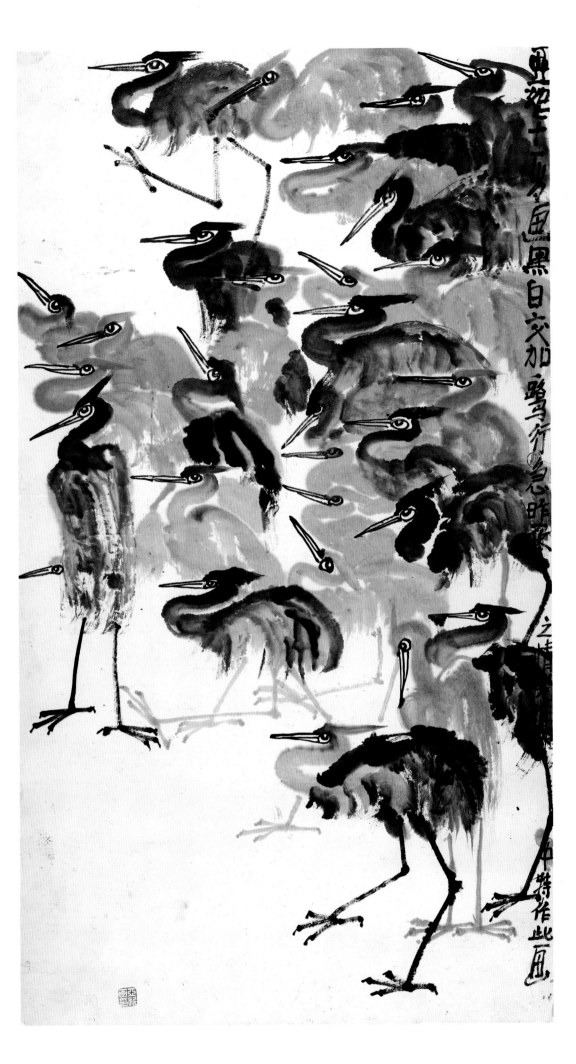

55

Last Night I Dreamt I Saw the Racing Egrets

1986–87

Age eleven

Inscribed:
Painted by Yani at age eleven. Weaving in a pattern of black and white, the egrets moved in a great hurry. Last night's vision was still vivid in my mind, so I painted this especially.

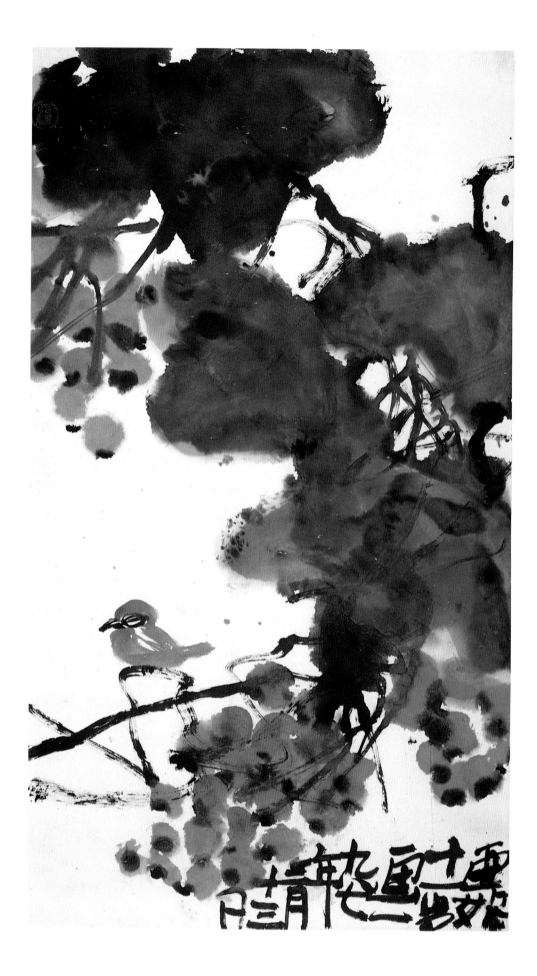

56

Taking a Nap
1987
Age eleven

Inscribed:
Painted by Yani at age eleven on
March 13, 1987.

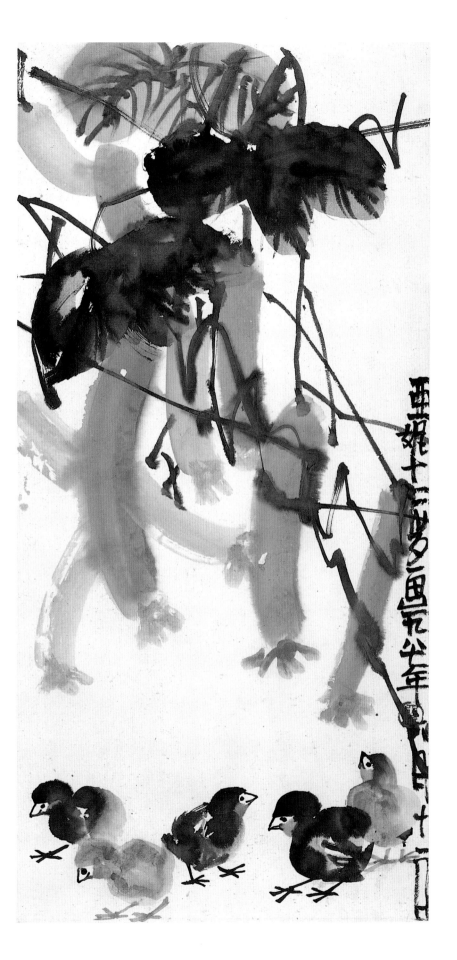

57

A Small World

1987

Age twelve

Inscribed:
*Painted by Yani at age twelve on
June 11, 1987.*

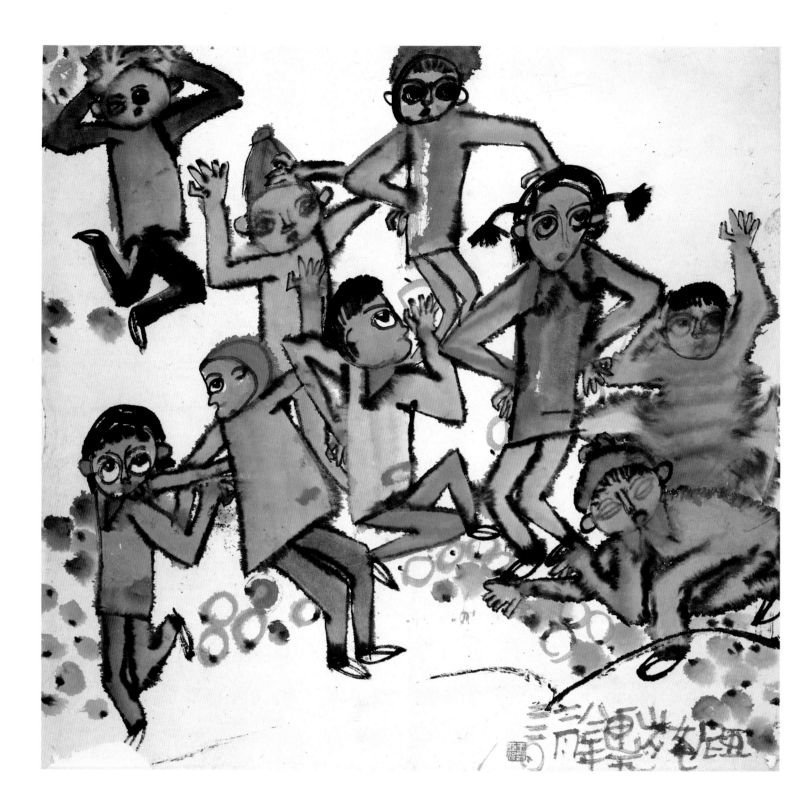

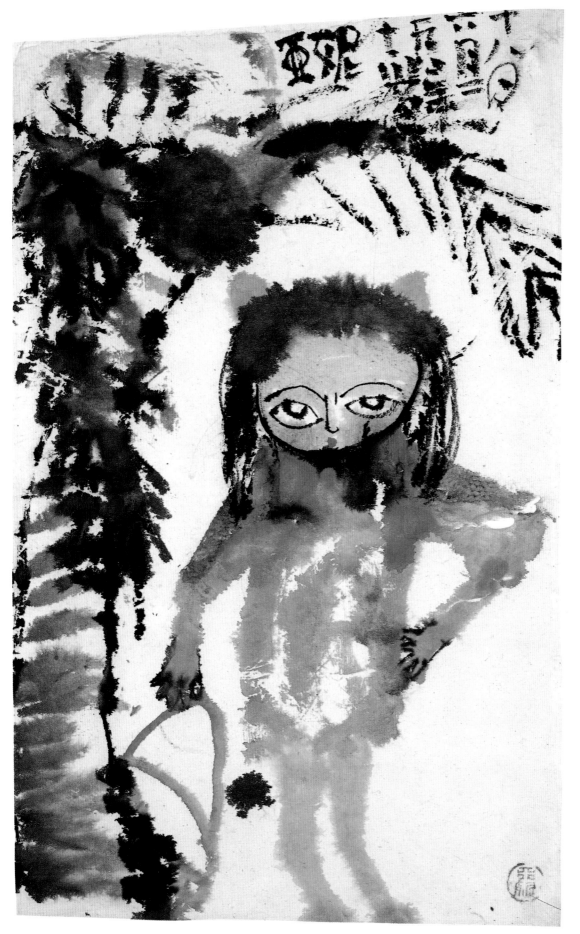

OPPOSITE:

58

Yani's Party

1982

Age seven

Inscribed:
Painted by Yani at age seven on February 4, 1982.

59

The Little Mushroom Picker

1982

Age seven

Inscribed:
Painted by Yani at age seven on June 28, 1982.

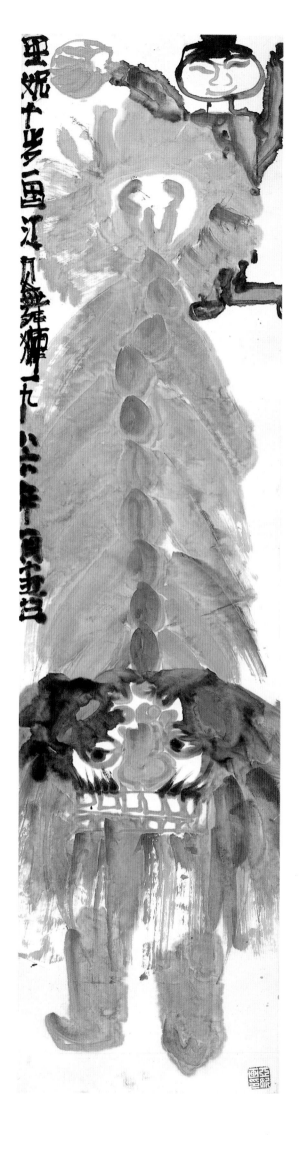

60

Lion Dance

1986

Age ten

Inscribed:
Painted by Yani at age ten on January 15, 1986. Lion dance performed in Jiang Bei.

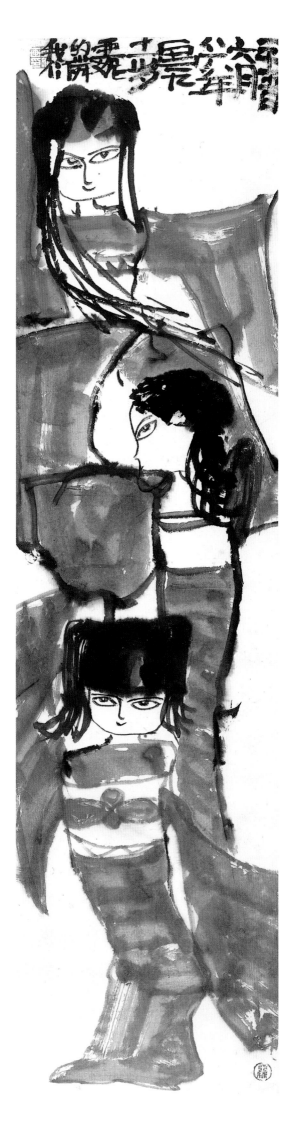

61

Our Dance

1986

Age eleven

Inscribed:
Our dance. Painted by Yani at age eleven on June 25, 1986.

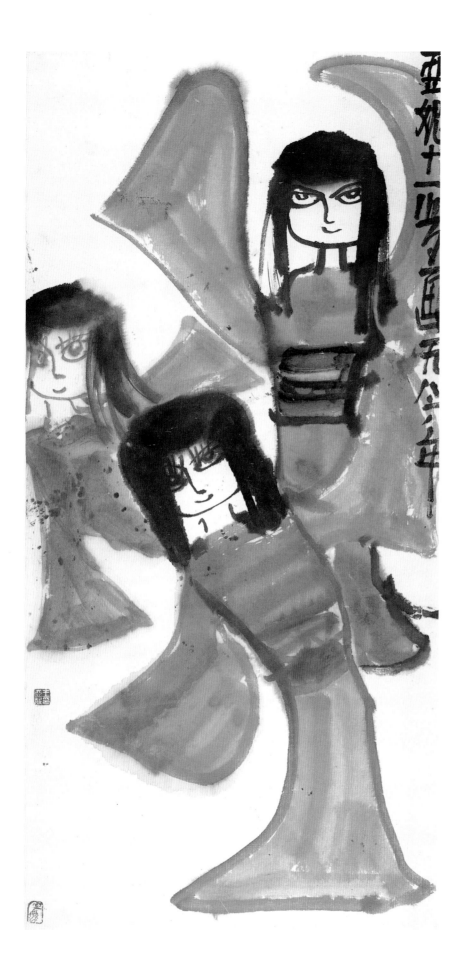

62

A Beautiful Dance

1986

Age eleven

Inscribed:
*Painted by Yani at age eleven in
1986.*

OPPOSITE:

63

The Lion Is Awake!

1983

Age eight

Inscribed:
*A lion lay sleeping on the road.
Several little monkeys saw it. One
said: "Let's climb on its back." All
the monkeys climbed up except for
two which were too scared to do
so. One said: "Let's throw some
fruit up there." Painted by Yani at
age eight on July 28, 1983, in
Shanghai.*

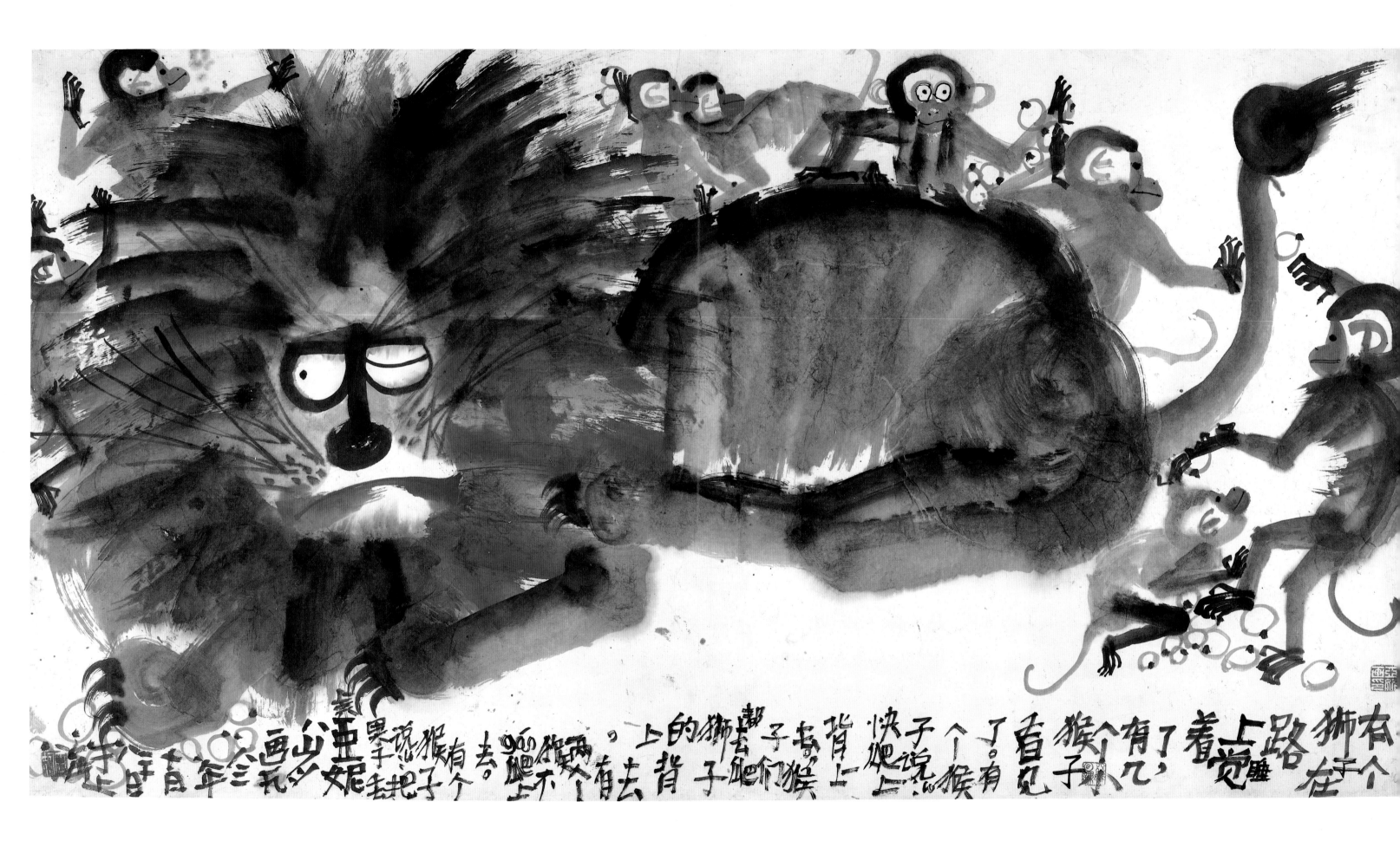

狮子和猴子
有一个猴子，看见路上有一个狮子睡着了，猴子说有一个猴子背上去了，说爬上去，子，他们猴子背上去爬不上个，有去背子去把子个。狮墨恐猴有去，画少妮亚令年个时节

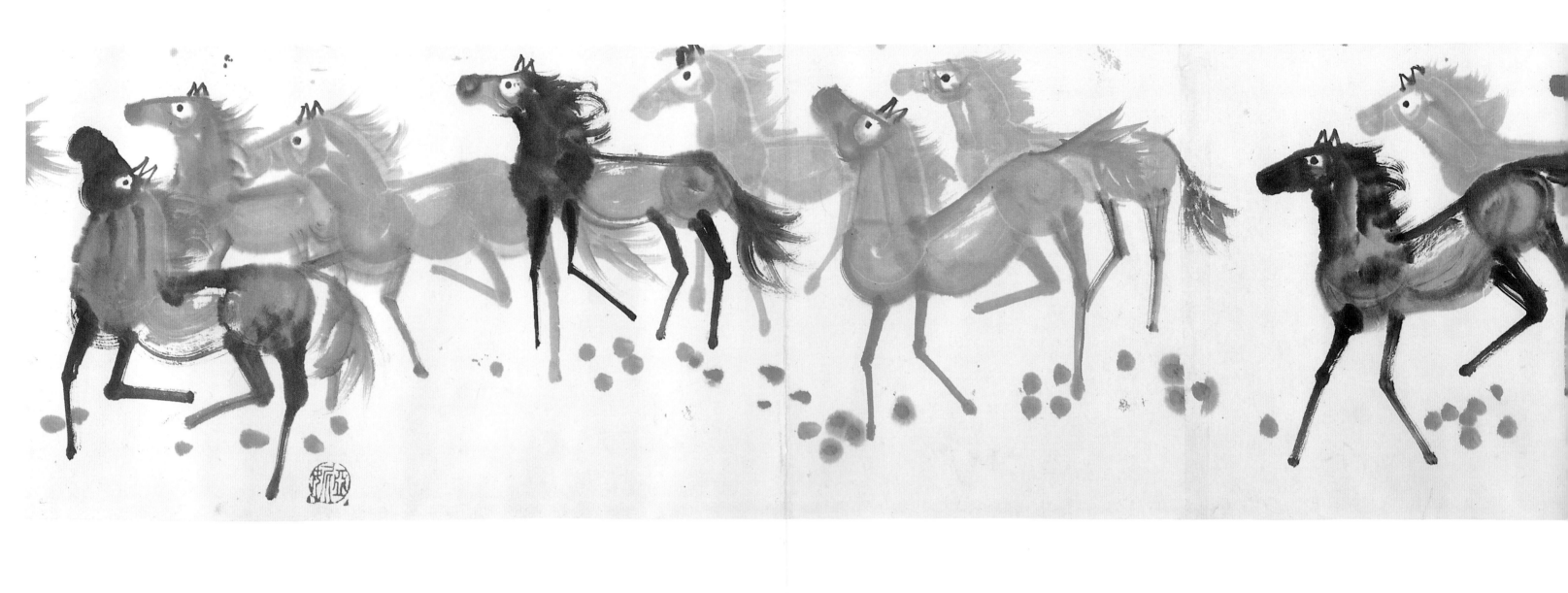

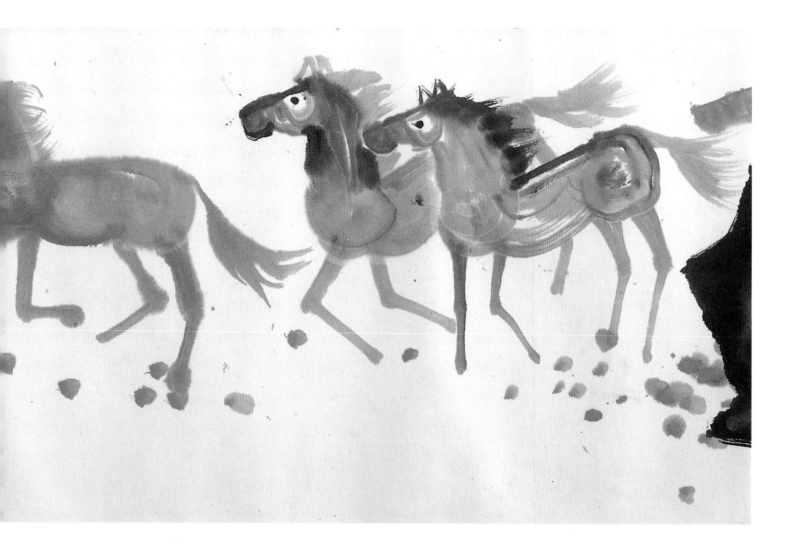

64

Horses

1984

Age eight

Inscribed:
*Painted by Wang Yani at age eight
on March 24, 1984, at the
Gongcheng Cultural Center. A
herd of horses on the grass.*

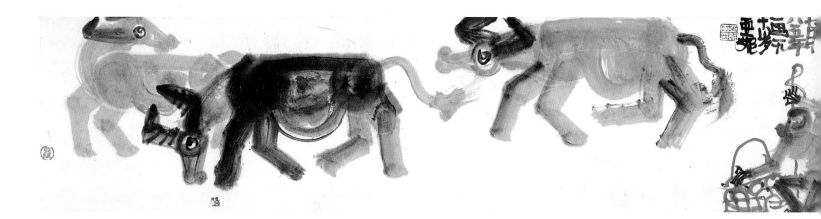

65
There's Better Grass on the Hill
1985
Age ten

Inscribed:
Painted by Yani at age ten on July 14, 1985.

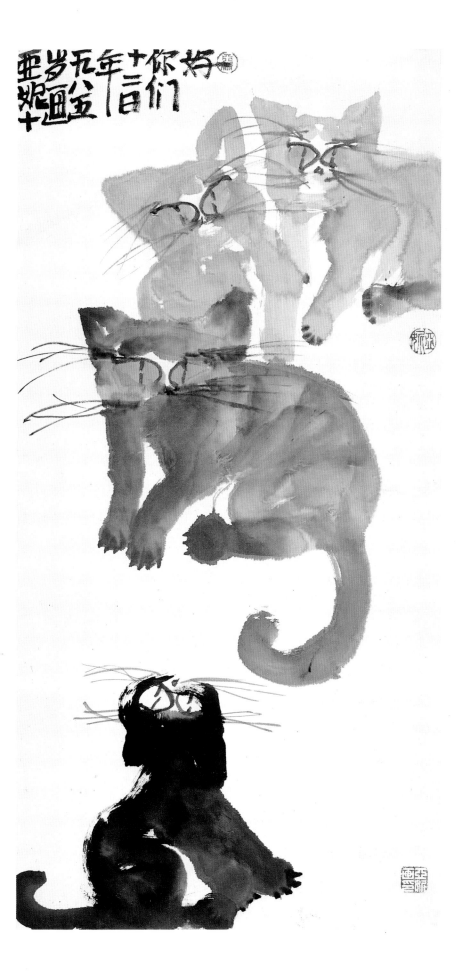

66

How Are You? (Said the Black Cat)

1985

Age ten

Inscribed:
Painted by Yani at age ten on the twelfth in 1985. How are you.

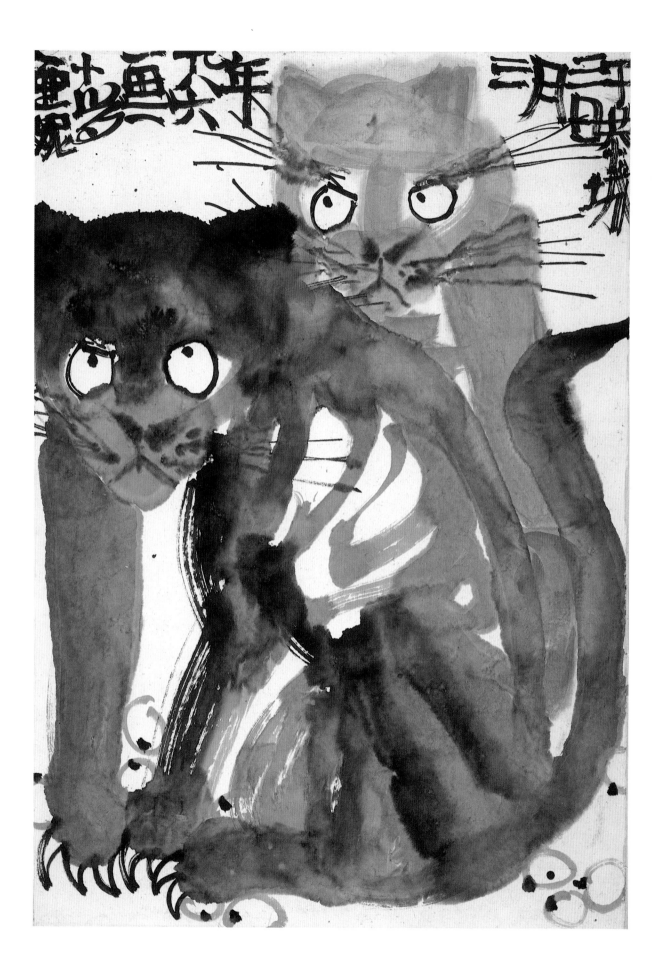

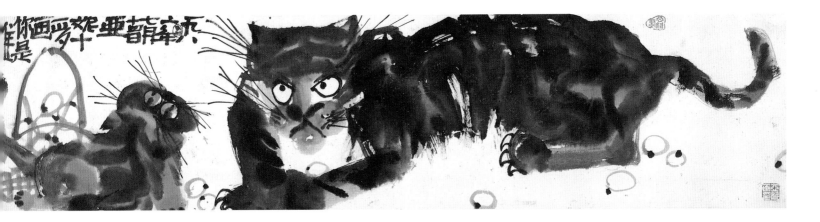

OPPOSITE

67

Close Brothers

1986

Age ten

Inscribed:
*Painted by Yani at age ten on
March 3, 1986, in Gongcheng.*

68

*Who Are You? (Kitty Asked
the Tiger)*

1986

Age eleven

Inscribed:
*Painted by Yani at age eleven on
July 14, 1986. Who Are You.*

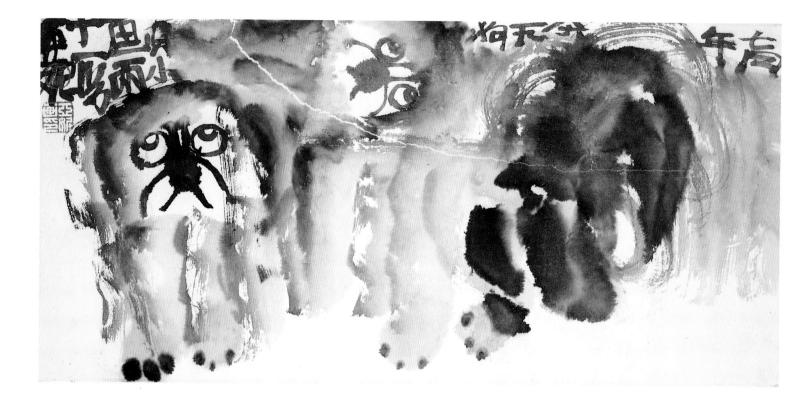

69
Two Little Dogs
1986
Age eleven

Inscribed:
Painted by Yani at age eleven in July 1986. Two little dogs.

All works are in ink and color on paper and are from a private collection.

Dimensions are given in inches (and centimeters), height × width. Measurements are of the paintings themselves and do not include the mountings.

The date and Yani's age when each painting was executed are given according to the inscription. When there is no inscription or no date is given in the inscription, or the inscription is incorrect, date and age have been provided by Yani's father, Wang Shiqiang.

Entries are grouped according to the two themes of the exhibition: the World of Monkeys, 1978–82 (nos. 1–24), and the Horizon Beyond, 1982–87 (nos. 25–69). Within each of these categories, entries are further grouped chronologically within each subject: monkey, landscape, flower and bird, figure painting, animal, and fish.

The code at the end of each entry consists of four parts:

Part 1 The first two numerals refer to the checklist number.

Part 2 The letter refers to the period when the painting was executed:
　M The World of Monkeys
　N The Horizon Beyond
The numeral represents Yani's age at the time the painting was executed. (Thus, M4 means that the painting belongs to the World of Monkeys period and was executed when Yani was four years old.)

Part 3 The letter refers to the subject of the painting:
　A Monkey
　B Landscape
　C Flower and bird
　D Figure painting
　E Animal
　F Fish
The numerals represent the number of the painting in this exhibition in its subject category. (Thus, A01 means that the painting is the first one in this exhibition in the monkey category.)

Part 4 The letter refers to the format of the painting:
　H Horizontal
　V Vertical
　S Square
　HS Handscroll

In summary, the code for the first painting (01 M4 A01 V) indicates that it is the first painting in the exhibition checklist; it belongs to the World of Monkeys period and was executed when Yani was four years old; it is chronologically the first painting in this exhibition in the monkey category; the format is vertical.

The World of Monkeys

1
Performing Acrobatics, 1979–80
(age four)
27¼ × 13½ (69.2 × 34.3)
Inscribed: *Performing acrobatics. Painted by Wang Yani at age four.*
01 M4 A01 V

2
The Fruit Will Be Down Soon! 1979–80 (age four)
26¾ × 13¼ (67.9 × 33.7)
Inscribed: *Painted by Yani at age four. The fruit will be down soon.*
02 M4 A02 V

3
Drunk, 1980 (age four)
13¼ × 27 (33.7 × 68.6)
Inscribed: *Painted by Wang Yani at age four in Gongcheng on January 16, 1980. Drunk.*
03 M4 A03 H

4
Let Me Smell the Flower, 1980
(age four)
13 × 13 (33.0 × 33.0)
Inscribed: *Painted by Wang Yani at age four on April 28, 1980.*
04 M4 A04 S

5
Sniffing the Wine, 1980 (age four)
13⅜ × 26¾ (34.0 × 67.9)
Inscribed: *Painted by Wang Yani at age four in Gongcheng, 1980. Sniffing the wine.*
05 M4 A05 H

6
I Am Not Scared! (Inoculation), 1980 (age five)
13 × 13½ (33.0 × 34.3)
Inscribed: *Painted by Wang Yani at age five on June 26, 1980, at the Cultural Center.*
06 M5 A06 S

7
This Is for Mommy, 1980 (age five)
13¼ × 13 (33.7 × 33.0)
Inscribed: *Painted by Yani at age five on August 27, 1980, at the Gongcheng Wen-Miao [Confucius Temple].*
07 M5 A07 S

8
Handing Out Fruit for Mommy, 1980 (age five)
13 × 27 (33.0 × 68.6)
Inscribed: *Painted by Yani at age five on October 30, 19[80], at the Gongcheng Wen-Miao [Confucius Temple].*
08 M5 A08 H

9
Pull Harder! 1980 (age five)
13 × 27 (33.0 × 68.6)
Inscribed: *Painted by Wang Yani at age five on December 12, 1980, at the Wen-Miao [Confucius Temple]. Pull Harder.*
09 M5 A09 H

Checklist of the Exhibition

10

Fishing, 1980 (age five)
13½ × 13 (34.3 × 33.0)
Inscribed: *Painted by Wang Yani at age five in 1980.*
10 M5 A10 S

11

These Fruit Are Not Yours, 1980–81 (age five)
27 × 13 (68.6 × 33.0)
Inscribed: *Painted by Yani at age five.*
11 M5 A11 V

12

Let's Have a Party, 1980–81 (age five)
13 × 27 (33.0 × 68.6)
Inscribed: *Painted by Wang Yani at age five at the Gongcheng Wen-Miao [Confucius Temple].*
12 M5 A12 H

13

Arriving at Butterflies' House, 1980–81 (age five)
12½ × 13 (31.8 × 33.0)
Not inscribed
13 M5 A13 S

14

Let Me Paint Something, 1981 (age five)
13½ × 13 (34.3 × 33.0)
Inscribed: *Painted by Yani at age five on March 6, 1981, at the Guangzhou Youth Palace.*
14 M5 A14 S

15

Hurry Home! 1981 (age six)
52 × 13½ (132.1 × 34.3)
Inscribed: *Painted by Yani at age six on July 20, 1981, in Gongcheng.*
15 M6 A15 V

16

Hurry Down! 1981 (age six)
52¼ × 13 (132.7 × 33.0)
Inscribed: *Painted by Yani at age six on September 16, 1981.*
16 M6 A16 V

17

My Flowers Are Blooming! 1981 (age six)
52 × 12¾ (132.1 × 32.4)
Inscribed: *Painted by Yani at age six on November 16, 1981.*
17 M6 A17 V

18

Don't Fight! 1981 (age six)
13½ × 51½ (34.3 × 130.8)
Inscribed: *Painted by Yani at age six on November 18, 1981, at the Gongcheng Cultural Center.*
18 M6 A18 H

19

These Flowers Are Mine! 1981 (age six)
52¼ × 13½ (132.7 × 34.3)
Inscribed: *Painted by Yani at age six on December 29, 1981, in Gongcheng.*
19 M6 A19 V

20

I Have Some Fruit, 1982 (age six)
52 × 13½ (132.1 × 34.3)
Inscribed: *Painted by Yani at age six on January 8, 1982, in Gongcheng.*
20 M6 A20 V

21

Three Peacocks, 1980 (age five)
13¼ × 27¼ (33.7 × 69.2)
Inscribed: *Painted by Wang Yani at age five on December 16, 1980. Three peacocks.*
21 M5 C01 H

22

A Big Coconut Just Fell Down! 1982 (age six)
52 × 13 (132.1 × 33.0)
Inscribed: *Painted by Yani at age six on January 29, 1982.*
22 M6 D01 V

23

Kitty, 1978–79 (age three)
9¾ × 6 (24.8 × 15.2)
Not inscribed
23 M3 E01 V

24

A Happy Troop! 1982 (age six)
52½ × 13½ (133.4 × 34.3)
Inscribed: *Painted by Yani at age six on January 3, 1982.*
24 M6 F01 V

The Horizon Beyond

25

Whose Flowers Are So Pretty? 1983 (age seven)
51¾ × 13¾ (131.4 × 34.9)
Inscribed: *Painted by Wang Yani at age seven on January 16, 1983, at the Gongcheng Cultural Center.*
25 N7 A21 V

26

The Bananas Have Not Come Out Yet, 1983–84 (age eight)
52½ × 13¾ (133.4 × 34.9)
Not inscribed
26 N8 A22 V

27

Let's Go Pick Some Cherries, 1984 (age nine)
19 × 12⅜ (48.3 × 31.4)
Inscribed: *Let's go pick some cherries. Painted by Yani on July 4, [1]984.*
27 N9 A23 V

28

A Hundred Monkeys, 1985 (age nine)
12⅝ × 417⅜ (32.1 × 1060.1)
Inscribed: *Painted by Yani at age nine on January 5, 1985. A Hundred Monkeys.*
28 N9 A24 HS

29

Wow! (What a Beautiful Morning!), 1985 (age ten)
36½ × 17 (92.7 × 43.2)
Inscribed: *Painted by Yani at age nine [ten] on August 13, 1985.*
29 N10 A25 V

30

Good Harvest! 1986 (age eleven)
13½ × 23¾ (34.3 × 60.3)
Inscribed: *Good harvest. Painted by Yani at age eleven in 1986.*
30 N11 A26 H

31

Early Morning, 1982 (age seven)
13½ × 13¼ (34.3 × 33.7)
Inscribed: *Painted by Yani at age seven on September 28, 1982, in Gongcheng.*
31 N7 B01 S

32

Guilin's Autumn, 1982 (age seven)
13 × 13½ (33.0 × 34.3)
Inscribed: *Painted by Yani at age seven on October 8, 1982, at the Gongcheng Cultural Center. Guilin's autumn.*
32 N7 B02 S

33

Lion Mountain, 1983 (age eight)
13¾ × 13⅜ (34.9 × 34.0)
Inscribed: *Painted by Yani at age seven [eight] on June 21, 1983.*
33 N8 B03 S

34

My Beautiful Hometown, 1983 (age eight)
13⅜ × 13¾ (34.0 × 34.9)
Inscribed: *Painted by Yani at age eight on August 12, 1983.*
34 N8 B04 S

35

Yun Cai Mountain, 1983 (age eight)
54 × 13½ (137.2 × 34.3)
Inscribed: *Painted by Yani at age eight on August 27, 1983, in Gongcheng. Yun Cai Mountain.*
35 N8 B05 V

36

Clearing after Rain, 1983 (age eight)
13½ × 13½ (34.3 × 34.3)
Inscribed: *Painted by Yani at age eight on September 9, 1983.*
36 N8 B06 S

37

You Can Never Finish Painting the Mountains and Rivers in Guilin, 1983 (age eight)
13⅜ × 216½ (34.0 × 549.9)
Inscribed: *[You] can never finish painting Guilin's mountains and rivers. Painted by Yani at age eight on September 12, 1983, in Gongcheng.*
37 N8 B07 HS

38

No More Fishing, 1983 (age eight)
52¾ × 13 (134.0 × 33.0)
Inscribed: *Painted by Yani at age eight on November 17, 1983, in Shanghai. No more fishing.*
38 N8 B08 V

39

Noon in the Autumn, 1983 (age eight)
13 × 13½ (33.0 × 34.3)
Inscribed: *Painted by Yani at age eight in 1983.*
39 N8 B09 S

40

Little Mountain, 1984 (age eight)
13 × 13⅜ (33.0 × 34.0)
Inscribed: *Painted by Yani at age eight in 1984.*
40 N8 B10 S

41
Spring, 1984 (age nine)
27 × 14¼ (68.6 × 36.2)
Inscribed: *Painted by Yani at age nine on October 24, 1984.*
41 N9 B11 V

42
Autumn in a Hamlet, 1985 (age nine)
40½ × 22 (102.9 × 55.9)
Inscribed: *Painted by Yani at age nine on January 20, 1985.*
42 N9 B12 V

43
Pretty Riverbanks, 1986 (age ten)
53½ × 13½ (135.9 × 34.3)
Inscribed: *Painted by Yani at age ten on January 3, 1986.*
43 N10 B13 V

44
A Small Village, 1986 (age ten)
54¼ × 13½ (137.8 × 34.3)
Inscribed: *Painted by Yani at age ten on January 12, 1986.*
44 N10 B14 V

45
A Sunny Day, 1987 (age eleven)
27½ × 13½ (69.9 × 34.3)
Inscribed: *Painted by Yani at age eleven on April 23, 1987.*
45 N11 B15 V

46
Raining on the Lotus Pond, 1982 (age seven)
52 × 13½ (132.1 × 34.3)
Inscribed: *Painted by Yani at age seven in 1982.*
46 N7 C02 V

47
Where's That Little Monkey? 1983 (age seven)
52¼ × 13½ (132.7 × 34.3)
Inscribed: *Painted by Yani at age seven on February 7, 1983.*
47 N7 C03 V

48
I Love Maple Leaves, 1983 (age eight)
52 × 13¾ (132.1 × 34.9)
Inscribed: *Painted by Yani at age eight in 1983.*
48 N8 C04 V

49
The Meeting, 1984 (age nine)
16¾ × 36½ (42.5 × 92.7)
Inscribed: *Painted by Yani at age nine on December 23, 1984.*
49 N9 C05 H

50
Waiting (for the Young Ones), 1985 (age ten)
31½ × 15 (80.0 × 38.1)
Inscribed: *Painted by Yani at age nine [ten] on October 7, 1985.*
50 N10 C06 V

51
The Lotus Flowers Are So Pretty! 1986 (age ten)
39 × 18½ (99.1 × 47.0)
Inscribed: *Painted by Yani at age ten in 1986.*
51 N10 C07 V

52
How Nice! 1986 (age eleven)
53 × 13¼ (134.6 × 33.7)
Inscribed: *How Nice. Painted by Yani at age eleven in September 1986.*
52 N11 C08 V

53
Oh! It Smells So Good! 1986 (age eleven)
53½ × 13¾ (135.9 × 34.9)
Inscribed: *Painted by Yani at age eleven in December 1986.*
53 N11 C09 V

54
What a Nice Place! 1986 (age eleven)
48 × 16½ (121.9 × 41.9)
Inscribed: *What a nice place. Painted by Yani at age eleven in 1986.*
54 N11 C10 V

55
Last Night I Dreamt I Saw the Racing Egrets, 1986–87 (age eleven)
60¾ × 33 (154.3 × 83.8)
Inscribed: *Painted by Yani at age eleven. Weaving in a pattern of black and white, the egrets moved in a great hurry. Last night's vision was still vivid in my mind, so I painted this especially.*
55 N11 C11 V

56
Taking a Nap, 1987 (age eleven)
30 × 16¾ (76.2 × 42.5)
Inscribed: *Painted by Yani at age eleven on March 13, 1987.*
56 N11 C12 V

57
A Small World, 1987 (age twelve)
32½ × 15¼ (82.6 × 38.7)
Inscribed: *Painted by Yani at age twelve on June 11, 1987.*
57 N12 C13 V

58
Yani's Party, 1982 (age seven)
26 × 26¾ (66.0 × 67.9)
Inscribed: *Painted by Yani at age seven on February 4, 1982.*
58 N7 D02 S

59
The Little Mushroom Picker, 1982 (age seven)
22½ × 13½ (57.2 × 34.3)
Inscribed: *Painted by Yani at age seven on June 28, 1982.*
59 N7 D03 V

60
Lion Dance, 1986 (age ten)
54 × 13½ (137.2 × 34.3)
Inscribed: *Painted by Yani at age ten on January 15, 1986. Lion dance performed in Jiang Bei.*
60 N10 D04 V

61
Our Dance, 1986 (age eleven)
54¼ × 13¾ (137.8 × 34.9)
Inscribed: *Our dance. Painted by Yani at age eleven on June 25, 1986.*
61 N11 D05 V

62
A Beautiful Dance, 1986 (age eleven)
38¾ × 18½ (98.4 × 47.0)
Inscribed: *Painted by Yani at age eleven in 1986.*
62 N11 D06 V

63
The Lion Is Awake! 1983 (age eight)
33 × 61 (83.8 × 154.9)
Inscribed: *A lion lay sleeping on the road. Several little monkeys saw it. One said: "Let's climb on its back." All the monkeys climbed up except for two which were too scared to do so. One said: "Let's throw some fruit up there." Painted by Yani at age eight on July 28, 1983, in Shanghai.*
63 N8 E02 H

64
Horses, 1984 (age eight)
13⅜ × 160¼ (34.0 × 407.0)
Inscribed: *Painted by Wang Yani at age eight on March 24, 1984, at the Gongcheng Cultural Center. A herd of horses on the grass.*
64 N8 E03 HS

65
There's Better Grass on the Hill, 1985 (age ten)
13½ × 53¾ (34.3 × 136.5)
Inscribed: *Painted by Yani at age ten on July 14, 1985.*
65 N10 E04 H

66
How Are You? (Said the Black Cat), 1985 (age ten)
39 × 19 (99.1 × 48.3)
Inscribed: *Painted by Yani at age ten on the twelfth in 1985. How are you.*
66 N10 E05 V

67
Close Brothers, 1986 (age ten)
27¼ × 18½ (69.2 × 47.0)
Inscribed: *Painted by Yani at age ten on March 3, 1986, in Gongcheng.*
67 N10 E06 V

68
Who Are You? (Kitty Asked the Tiger), 1986 (age eleven)
13½ × 54¾ (34.3 × 139.1)
Inscribed: *Painted by Yani at age eleven on July 14, 1986. Who Are You.*
68 N11 E07 H

69
Two Little Dogs, 1986 (age eleven)
13½ × 27¾ (34.3 × 70.5)
Inscribed: *Painted by Yani at age eleven in July 1986. Two little dogs.*
69 N11 E08 H

Index